extreme surf

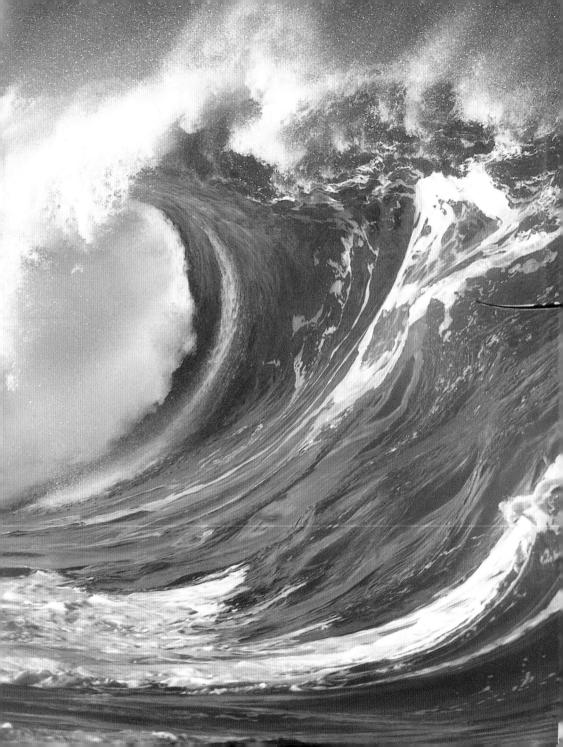

extreme surf

Benjamin Marcus

PAVILION

This edition published in 2011 by Pavilion Books

An imprint of Anova Books Company Ltd
10 Southcombe Street,
London, W14 0RA

First published in the United Kingdom in 2008
by Pavilion Books

An imprint of Anova Books Company Ltd
10 Southcombe Street,
London, W14 0RA

Editor: Frank Hopkinson
Design: John Heritage
Jacket Design: Georgina Hewitt
Production: Rebekah Cheyne

The moral right of the author has been asserted

ISBN-13: 978-1-86205-916-0

A CIP catalogue record for this book is available
from the British Library

Colour reproduction by Dot Gradations Ltd, UK
Printed and bound by Toppan Leefung Printing
Ltd, China

10 9 8 7 6 5 4 3 2 1

www.anovabooks.com

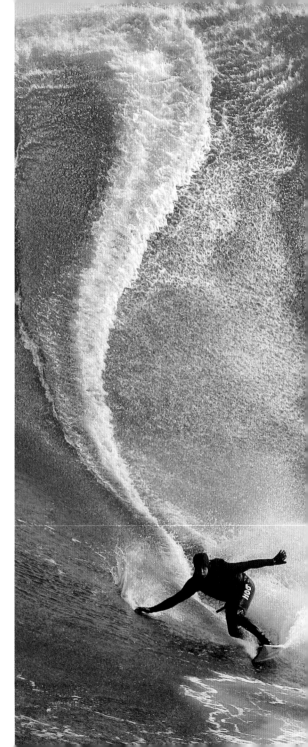

Page 1: Garrett McNamara, going big at Jaws,
Maui, 2003.
Pages 2–3: An empty surfboard gives it big air at
Waimea Bay, Oahu, Hawaii.
Page 4: South African big wave surfer Mickey
Duffus surfs a huge wave at Dungeons off Cape
Town, South Africa, 2006.

CONTENTS

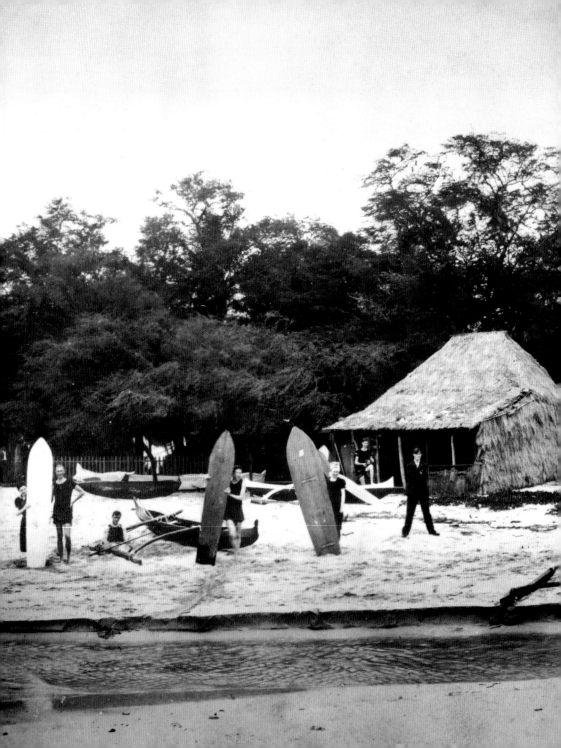

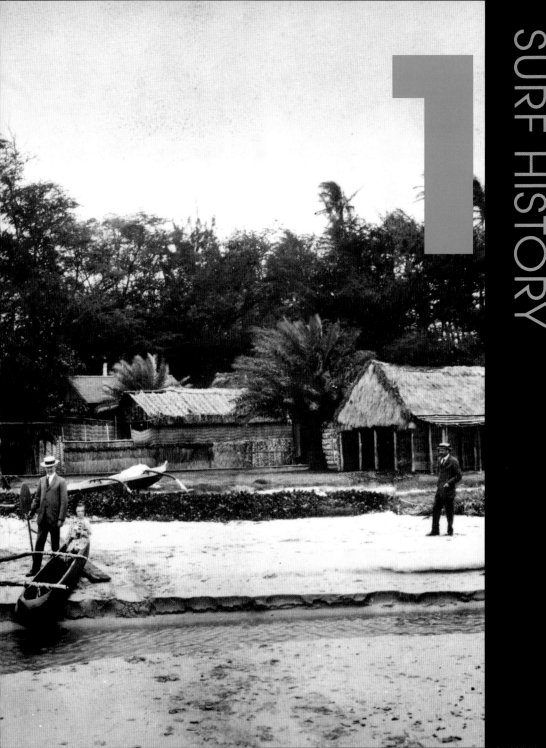

THE MOST SUPREME PLEASURE

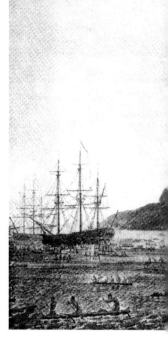

IT TOOK CAPTAIN JAMES COOK 17 months to do what the Polynesians needed 17 centuries to accomplish: stumble into the Hawaiian Islands. Cook sailed from London in July 1776 as Captain of the *Resolution*, accompanied by the *Discovery*. This was Cook's third voyage into the Great South Sea. The stated purpose of the voyage was to return home a Tahitian named Omai, but the covert mission was to find the fabled Northwest Passage which would provide an easy link from the Atlantic to the Pacific Ocean, and avoid that horrible business of rounding the Horn.

Cook had become familiar with Polynesian culture during his first two voyages, visiting the Society Islands (Tahiti), the Friendly Islands (Tonga) and New Zealand (Aoteroa). On this third voyage, Cook visited Easter Island and the Marquesas for the first time, but it was in Tahiti that Cook noted a native man riding waves in his canoe, seemingly just for kicks:

> "At first I imagined that he had stolen something from one of the ships, and was pursued; but, on waiting patiently, saw him repeat his amusement. He went out from the shore till he was near the place where the swell begins to take its rise; and, watching its first motion very attentively, paddled before it with great quickness, till he found that it overlooked him, and had acquired sufficient force to carry his canoe before it without passing underneath. He then sat motionless, and was carried along at the same swift rate as the wave, till it landed him upon the beach. Then he started out, emptied his canoe, and went in search of another swell. I could not help concluding that this man felt the most supreme pleasure while he was driven on so fast and so smoothly by the sea . . ."

Cook thus provided the first documented description of the Polynesian's love of wave-riding. Theft of items small and large by the Hawaiians was a constant irritation to Cook, but when Hawaiians stole one of the ship's small sailing "cutters" – which were essential for exploration and the security of his ships – Cook went ashore with nine Marines to kidnap chief Kalaniʻopuʻu and ransom him for the return of the cutter. The ploy went awry. Cook and the Marines were attacked on the beach and four Marines were killed with Cook beaten to death in front of his crew.

Command of the *Resolution* and *Discovery* passed to Captain Charles Clerke and Captain James King. Within a month after Cook's death, Captain King set down in his log a lengthy description of surf riding on surfboards:

PREVIOUS PAGE Alexander Hume Ford founded the Outrigger Canoe Club on Waikiki Beach. Ford was an adventurer and former newspaperman from Chicago who saw that Waikiki needed a club to provide structure and facilities for water sports like surfing and canoeing. Ford's idea found sponsorship and in 1908 he founded the Outrigger Canoe Club under this charter: "We wish to have a place where surfboard riding may be revived and those who live away from the water front may keep their surfboards."

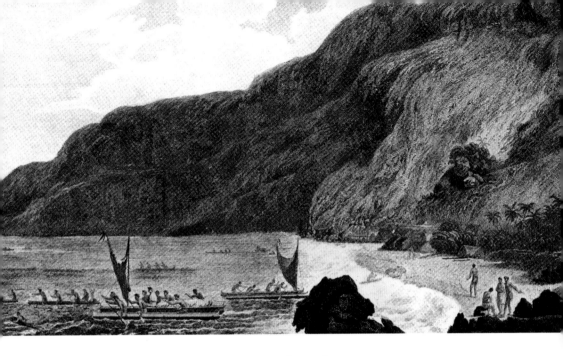

"Whenever, from stormy weather, or any extraordinary swell at sea, the impetuosity of the surf is increased to its utmost height, they choose that time for this amusement, which is performed in the following manner: Twenty or thirty of the natives, taking each a long narrow board, rounded at the ends, set out together from the shore. The first wave they meet, they plunge under, and suffering it to roll over them, rise again beyond it, and make the best of their way ... out into the sea. As soon as they have gained by these repeated efforts, the smooth water beyond the surf, they lay themselves at length on their board, and prepare for their return. As the surf consists of a number of waves, of which every third is remarked to be always much larger than the others, their first object is to place themselves on the summit of the largest surge, by which they are driven along with amazing rapidity toward the shore ... Those who succeed in their object of reaching shore, have still the greatest danger to encounter. The coast being guarded by a chain of rocks, with, here and there, a small opening between them, they are obliged to steer their boards through one of these, or, in

ABOVE In January 1778, Captain Cook discovered a northern franchise of Polynesia which the natives called "Owhyhee". This etching by ship's artist John Webber A View of Karakakoo in Owhyhee, *shows the* Resolution *and the* Discovery *anchored in Kealakekua Bay on the Big Island. The view shows native craft meeting the two ships. The native habitations on the shore are part of what is now known as Kealakekua, and in the group of canoes paddling out to meet the ships there is one man paddling a surfboard.*

"I could not help concluding that this man felt the most supreme pleasure while he was driven on so fast and so smoothly by the sea ..."

Captain James Cook

case of failure, to quit it, before they reach the rocks, and, plunging under the wave, make the best of their way back again. This is reckoned very disgraceful, and is also attended with the loss of the board, which I have often seen, with great horror, dashed to pieces, at the very moment the islander quitted it. The boldness and address with which we saw them perform these difficult and dangerous manoeuvres, was altogether astonishing, and is scarcely to be credited."

In 1779, riding waves lying down or standing on long hardwood surfboards was an integral part of Hawaiian culture. Surfboard riding was crucial to the society, religion and myth of the islands. Kings, queens and chiefs proved their royalty by their skill in the surf and commoners made themselves famous (and infamous) by the way they took to the ocean. Place names were bestowed because of legendary surfing incidents. The *kahuna* (high priests) intoned special chants to christen new surfboards, to bring the surf up, and to give courage to the men and women who challenged the big waves. Hawaiians had no written language until the *haole* (white-skinned people) arrived, so their genealogy and history were remembered in songs and chants. There were legendary stories of love matches made and broken in the surf, lives risked and heroic ocean deeds by chiefs and commoners.

Before contact with Cook's crew, Hawaii was ruled by a code of *kapu* (taboos) which regulated almost everything: where to eat; how to grow food; how to predict weather; how to build a canoe; how to build a surfboard; how to predict when the surf would be good, or convince the gods to make it good. Hawaiian society was distinctly stratified into royal and common classes, and these taboos extended into the surf zone. There were reefs and beaches where the *ali'i* (chiefs) surfed and reefs and beaches where the commoners surfed. Commoners generally rode waves on *paipo* (prone) and *alaia* (stand up) boards as long as 12 feet, while the *ali'i* rode waves on *olo* boards that were as long as 24 feet.

SURFING DECLINE

What Cook and King described in their journals was the zenith of the sport in Old Polynesia, because in the wake of the arrival of the *Resolution* and the *Discovery*, Hawaii and Hawaiian surfing fell into a steady decline that would last 150 years.

European contact was not good for Hawaii. After the publication of Cook's and King's accounts, Hawaii became the Pacific destination of choice for sea captains, brigands, adventurers, missionaries and other opportunists. The *haole* brought new

"The boldness and address with which we saw them perform these difficult and dangerous manoeuvres, was altogether astonishing, and is scarcely to be credited."

Captain James King

BELOW Surf swimming by Sandwich Islanders, *circa 1878, an etching from* The Uncivilized Races of Man in All Countries of the World. *In the nineteenth century, a trip to Hawaii was like a trip to the Moon. While the rest of the world were buttoned up in wool when they went bathing, Hawaiian surfers went out into the surf naked.*

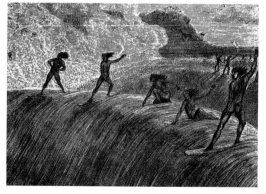

technologies and religions, along with vices and diseases that ravaged a society that had evolved for more than a millennium.

As the *kapu* system crumbled, so did surfing's ritual significance within Hawaiian culture. It brought about the demise of the Makahiki festival, the annual celebration to the god Lono in which surfing played an integral role. Set adrift from the old ways, Hawaiian culture fell into chaos. As Houston and Finney wrote: "For surfing, the abolition of the traditional religion signaled the end of surfing's sacred aspects. With surf chants, board construction rites, sports gods and other sacred elements removed, the once ornate sport of surfing was stripped of much of its cultural plumage."

Some historians attribute the Calvinist missionaries with killing off surfing but the truth is, Hawaii was changing dramatically before the missionaries arrived in 1820 thanks to contact with *haole*.

The undermining of Hawaiian culture did, however, accelerate in the 1820s with the arrival of the Calvinists. The missionaries frowned upon or forbade the wearing of loin cloths, gambling and the close intermingling of men and women on land and sea. With this enforced modesty and morality applied to surfing, Hawaiians very quickly lost interest in the sport. To put it in a modern idiom, if you couldn't bet money or get naked or meet chicks, where was the fun?

Despite the imposed morality, surfing didn't disappear altogether from Hawaii in the 1800s. Mark Twain sailed to the Hawaiian Islands and had a go, describing it in his 1866 book *Roughing It*. "I tried surf-bathing once, subsequently, but made a failure of it. I got the board placed right and at the right moment, too; but missed the connection myself. The board struck the shore in three-quarters of a second, without any cargo, and I struck the bottom about the same time, with a couple of barrels of water in me."

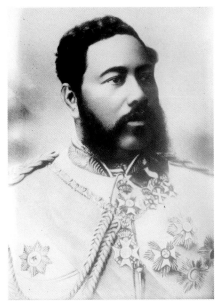

ABOVE *David Kalakaua, aka The Merrie Monarch, became Hawaii's king in 1874. He resisted the increasing* haole *influence on the Hawaiian islands, and restored traditional Hawaiian arts like* hula, *and* he'e nalu (surfing).

THE MERRIE MONARCH

David Kalakaua was an *ali'i* and a proud Hawaiian. He earned the nickname The Merrie Monarch and led a resurgence in Hawaiian pride – and that included the practice of *he'e nalu*. Kalakaua did not trust the *haole* and during his reign he rolled back restrictions on *hula* dancing and surfing and other *haole* moral codes. Surfing began to flourish again as a Hawaiian sport.

In fact surfing would outlive the monarchy. After King Kalakaua's death in 1891, Hawaii's sovereignty was threatened by American interests in the tremendous wealth generated by the island's No.1 export, sugar. Hawaii was annexed to the United States on August 12, 1898. Despite the renaissance of interest brought about by

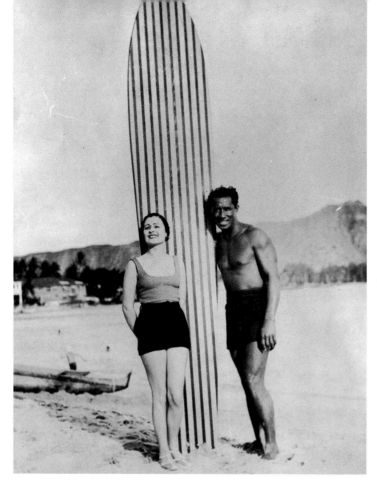

"Waves are the ultimate illusion. They come out of nowhere, instantaneously materialize and just as quickly they break and vanish. Chasing such fleeting mirages is a complete waste of time. That is what I choose to do with my life."

Miki Dora

David Kalakaua, by 1900 surfing had almost completely disappeared across the islands, except for in a few isolated spots on Kauai, Maui and Oahu.

WAIKIKI BEACH BOYS

In 1901 Captain William Matson opened the Moana Hotel on Waikiki beach and used images of surfing, canoes and tropical ocean sports to promote the hotel. Tourists who came to Hawaii were introduced to the secrets of the sea by a group of brown-skinned Hawaiian watermen who became known as the Waikiki beach boys.

Chicago newspaperman Alexander Hume Ford pitched up there and together with George Freeth, a local of Irish and Hawaiian parentage, taught novelist Jack London how to surf. Hume Ford created the Outrigger Club on Waikiki beach and both he and Freeth appeared in short stories by London. Within six months of the articles

appearing, Freeth was putting on surfing demonstrations at Venice Beach, California, and to promote Henry Huntington's new railway line to Redondo Beach. Freeth was billed as the "Hawaiian Wonder", "King of the Surf Board" and "The Man Who Walks on Water".

DUKE KAHANAMOKU

In 1908, Duke Paoa Kahanamoku and his friends formed the *Hui Nalu* under the *hau* tree at Waikiki, a surfing, swimming, paddling and canoe-racing club in answer to the *haole* Outrigger Canoe Club. Duke was a supremely talented swimmer and easily qualified for the US Olympic team in the 100-metre freestyle in Philadelphia, then broke the world record as he qualified for the 200-metre team relay in New Jersey.

At the Stockholm Olympics in 1912 he won Gold in the 100-metre freestyle, and Silver in the 200-metre relay. His fame focused worldwide attention on Hawaii, the beach boys and surfing. He was invited everywhere to give swimming exhibitions and more often than not, Duke travelled with a surfboard.

In 1914, Duke was invited to Australia by the New South Wales Swimming Association and as well as showing off his swimming prowess, built his own board and gave surfing demonstrations, including one with teenager Isabel Letham who became the first woman to surf in Australia.

Tom Blake and Duke Kahanamoku met by chance in Detroit in 1920, when Duke was returning from winning a gold medal in the 100-metre freestyle at the Olympic Games in Antwerp. Blake was a wanderer from Wisconsin who had competed in swim events. They both went to a theatre in Detroit to watch a newsreel of the Olympics. Blake pitched up in Hawaii in 1924 and his water skills and reputation threw him in with the beach boy set, which included the Kahanamoku brothers. Duke wasn't around but his

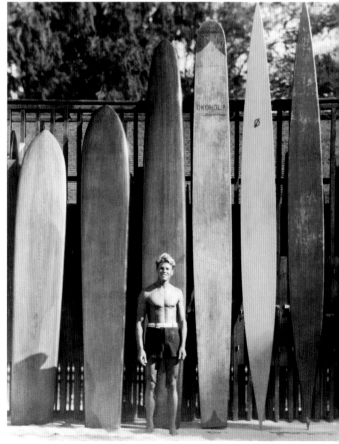

BELOW *The pioneer of the coast haole lifestyle, Tom Blake came to Hawaii in the early 1920s when Hawaiians were surfing on* alaia, *less than 10 feet long. Blake found longer* olo *boards in the Bishop Museum and crafted modern versions, first from solid wood, then chambered boards. These modern* olo *allowed Blake to beat all comers at paddleboard races and gave access to the bigger waves that broke off Waikiki.*

brother Sam showed Blake around, let him ride one of Duke's boards and took him out tandem into the surf of Waikiki. Blake got caught up with all things surfing and went to the Bishop Museum in Honolulu to study the enormous old boards preserved from the days of the ancient Hawaiians. Among these were the long, narrow giants called *olo* boards. Blake refined the *olo* by making the boards out of carved chambers, like an aeroplane wing. He called them "cigar boards" and they revolutionized both paddling and surfing.

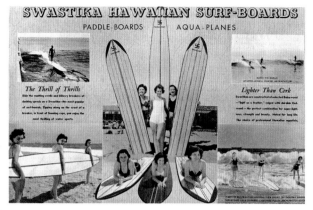

Blake's hollow boards were made of hardwoods and had no fins for stability. Around 1936 surfers began having problems with their hardwood, finless surfboards "sliding ass" in the critical part of the wave. Tom Blake was inspired by the stabilizers on airships and began experimenting with fins, while the Hawaiian surfers took axes to their boards, chopped down the tails and created "hot curl" boards which could hold a high angle on a wave without sliding ass.

Through the 1930s, Hawaiian surfers were mostly based around Waikiki, but with these new hot curl boards they began exploring new waves on the west side of Oahu and on the North Shore.

HOT DOG

Just after the War, surfers like Dale Velzy, Bob Simmons, Matt Kivlin and Joe Quigg were still riding the big, heavy, 11-foot redwood planks of their forefathers. But they began adopting and adapting wartime materials to make surfboards shorter, lighter and more accessible to anyone who wanted to take up surfing. Styrofoam had been used in aeroplanes, and fibreglass and resin in PT boats. Surfers like Joe Quigg began investigating these materials with a fervour. In 1947 Quigg made a shorter, lighter board for Darrilyn Zanuck, the daughter of movie mogul Darryl Zanuck. The guys who made the board found that they could turn the board on a wave and make it go faster; Darrilyn barely got a chance to ride the board that is considered the "Eve" of the modern surfboard.

By 1950, surfboard makers had given up on Styrofoam and turned to polyurethane foam, which was easier to work with and didn't explode when it came into contact with polyester resins. In 1949 Bob Simmons made a board as light as 11 kgs (25 pounds) and sold around 100 boards that summer, inspiring him to open a surf shop in Santa Monica. Joe Quigg, Matt Kivlin, Dale Velzy and a handful of surfers up and down the coast also went into business, working as hard as they could in the summer and then going to Hawaii for the winter.

ABOVE *Pacific System Homes marketed their boards as the Swastika Model, using the hooked cross in its original Sanskrit meaning as, "an auspicious object". Though they had success with their boards through the 1930s, they changed the name to Waikiki Models in 1937, after the Swastika became closely identified with the Nazi party.*

The Simmons Spoon in 1949 lead to the Malibu Chip in the early 1950s. The post-war period was called "The Golden Years" by Miki Dora. He was one of Malibu's best surfers and one of the Godfathers of hotdogging and surfing as a rebel lifestyle. Dora was one of the lucky few to be perfectly positioned to enjoy a time when surfboards went from clunky to refined allowing surfers to express themselves on all those empty walls at Rincon and Malibu. During the 1950s, surfers were under the social radar. When society paid them any attention at all, they were lumped in with beatniks, bikers, artists, homosexuals and writers. Then in 1959 came the movie *Gidget*. *Gidget* sparkled with many of the things that made the Golden Years golden, showcasing Los Angeles' climate and location. Surfers took wooden station wagons and turned them into Bedouin vehicles for surfin' safaris. Miki Dora doubled the surfing for Kahoona, played by Cliff Robertson, in the movie and is immortalized surfing stylishly on some clean, green, glassy waves at Malibu and Secos.

In 1959, a high school student named Brian Wilson got a C grade for a composition called *Surfin'*. In 1959, Jack O'Neill moved his small wetsuit and surfboard business from San Francisco to Santa Cruz. In 1959, Larry Gordon was a 19-year-old chemistry major who teamed up with Floyd Smith to make polyurethane blanks in Smith's garage in Pacific Beach. The surfing world was about to change.

BELOW *In 1957, a writer named Frederick Kohner listened to the adventures of his teenage daughter Kathy Kohner who was spending the summer at Malibu beach, having good clean fun (he hoped) with a bunch of surfers. Kohner turned his daughter's experiences into a coming of age story called* Gidget *– his daughter's beach nickname, a contraction of "girl" and "midget". When the novel became a movie starring Sandra Dee as Gidget, surfing went interstellar.*

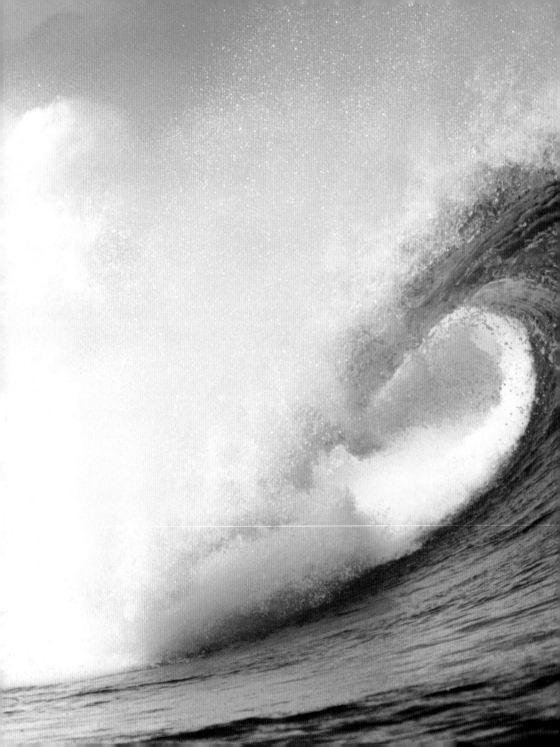

2

POETRY AND PHYSICS

WIND AND WATER

"And I have loved thee, Ocean! and my joy
Of youthful sports was on thy breast to be
Borne, like thy bubbles, onward; from a boy
I wantoned with thy breakers – they to me"

Lord Byron, Childe Harold's Pilgrimage

GEORGE GORDON BYRON, the sixth Baron Byron, didn't surf but he acted like a waterman. In May 1810, the 22-year-old rascal adventurer swam four kilometres of open water across the Strait of Hellespont (now called the Dardanelles). This was his tribute to the mythic Leander, who every night dared to swim the Hellespont from Abydos to Sestos to win his love Hero, a disciple of Aphrodite. The swim eventually killed Leander but the myth survived. Lord Byron's success gave new life to the legend, and was followed by many other dangerous, romantic, rebellious and infamous stunts.

Handsome, intelligent, daring: Byron was the very model of a modern major waterman – the forefather of all the crazy stunts now performed by surfers. But today top surfers spend their lives reading waves, surveiling weather charts and satellite photos and doing the math. They read the way swells appear on the horizon and shift toward the shore, the way they hit the point, the reef, the sandbar, the jetty. Surfers read waves to find the best takeoff spot, the best place to paddle (or tow) in, the best place to hit their first turn. Surfers read the sections of a wave – the bumps, flat spots, hollow spots, power spots. They read where to turn, where to cut back, where to pull into the tube, where to get out.

Just as Eskimos have several dozen words for snow, and the Hawaiians have dozens of terms for ocean conditions, surfers have a huge lexicon to describe the width, length, duration, parts and character of waves.

CORDUROY TO THE HORIZON

There are many different kinds of waves: shorebreaks, beachbreaks, reefs, points, reef-points, pier breaks, jetty breaks, wedges, bomboras, bommies, outer reefs. As waves move down the reef or the point or the beach, they can peel left, peel right, close out,

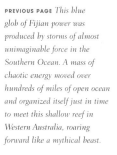

PREVIOUS PAGE This blue glob of Fijian power was produced by storms of almost unimaginable force in the Southern Ocean. A mass of chaotic energy moved over hundreds of miles of open ocean and organized itself just in time to meet this shallow reef in Western Australia, roaring forward like a mythical beast.

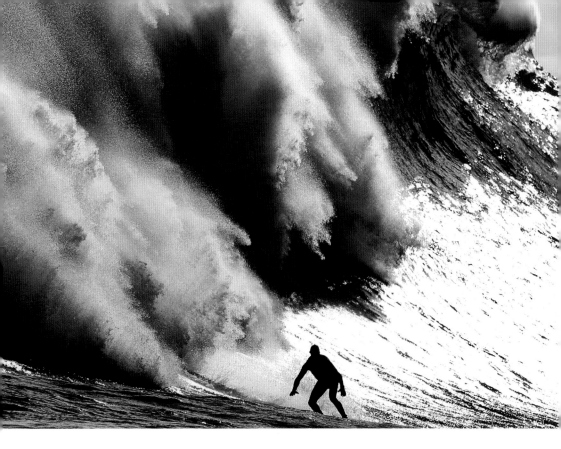

barrel, wedge, back off, bowl, section, bottom out, pitch, triple up, ledge, flatten out, double up, close out, line up, freight train, reform, backwash, a-frame, cap and spit.

 To describe the height and power of the waves, some surfers measure from the back and some from the front, so waves can be juicy, mushy, sloppy, burgery, slow, fast, ankle-slappers, waist-high, overhead, double overhead, mush-burgers, mackers. Surf conditions can be pumping, cranking, firing, flat, going off, going down, cooking, crowded, empty, consistent, inconsistent, hollow, coming up, glassing off, booming, bombing, out of control.

 When surfers wake up they want to see "corduroy to the horizon", which means lines of swell stacked out to sea. What they don't want to see is bad wind conditions at first light, also known as "morning sickness". Surfers anthropomorphize waves to describe the various parts: lip, face, back, shoulder, bottom; while there are a dozen different names for the curl and what happens in there: tube, pit, barrel, green room, Pope's Cathedral, vortex, foam ball, glurge, impact zone.

ABOVE *At the bottom of a Dungeons monster, and ready to head for higher ground. American big wave surfer Greg Long was towed by a jet ski into this wave, which breaks in shark-infested waters near Cape Town, South Africa. This wave was moving close to 30 mph when it came out of deep water and hit the reef at Dungeons.*

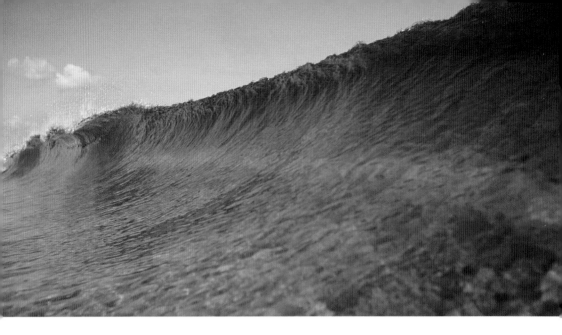

FROM RIPPLE TO SWELL

Surfers experience the last few minutes of a long, powerful journey. Generated by unimaginably powerful storms in cold, distant oceans, swells pass from infancy and group together in adolescence, maturing as they move through miles of ocean, crossing lines of latitude, pushing out of one hemisphere and into another. They are giant pulses of energy which even out over time and distance and appear on the near horizon as long, evenly spaced soldiers, ready to die as they storm the beaches and the points and the cliffs and the reefs and the headlands, in a blast of power. There are many different kinds of waves, but the technical term for the waves that surfers ride is "surface ocean waves" and they are the product of wind transferring its energy to the ocean.

When the ocean surface is rippled and the wind continues to blow, the wind has more purchase on the backs of these ripples and pushes them into something higher and with more energy, called wavelets. These wavelets now move in the direction of the wind, which continues to act on the depressions to transfer more energy.

Seas are large areas of water exposed to sustained winds; they are a mass of chaotic energy with wavelets of varying size and wavelength resonating from the direction of the wind. Under sufficient pressure, an area of ocean that the wind is blowing across becomes a fully developed sea: waves act and interact, some colliding and cancelling their energy, others combining their energy into steeper wavelets.

A swell is formed when wind of a certain speed and duration blows over a distance of water called the "fetch". The higher the wind speed, the longer the duration

ABOVE *Long-distance energy is made visible as a swell generated in the frigid waters of the Southern Ocean feels a coral bottom in the Indian Ocean, and falls forward in a lovely demise.*

"Surf conditions can be pumping, cranking, firing, flat, going off, going down, cooking, crowded, empty, consistent, inconsistent, hollow, coming up, glassing off, booming, bombing, out of control."

and the greater the fetch, the larger the swell. The storms that generate swells vanish within a couple of days, but the energy they transfer into the ocean can travel for thousands of miles and show up days and weeks later on distant shores, long after the winds that produced the swells have gone.

GET ON BOARD THE WAVE TRAIN

Ocean swells are like baby white sharks – they are on their own, released into the ocean immediately after birth. The raw seas of the fetch area are all confused and jumbled – a seething mess of short- and long-period swell energy all overrunning each other. The short-period swells are the fresh result of recent winds, while the long-period swells were produced earlier in the storm and have energy and momentum. Period is a measure of energy and is mostly manifest below the ocean's surface.

As these seas/proto-swells move out of the fetch area, the short-period elements start to fade while the more energetic ones start to race ahead. Short-period waves

LEFT *According to the Beaufort Scale – developed by Sir Francis Beaufort, an Irish admiral and hydrographer – a "calm" ocean is one that has no wind blowing across it. When the ocean is calm there is no wind and no ripples. When the wind starts to blow, the surface of the ocean begins to form ripples as the wind transfers some energy to the water's surface. Ripples are technically called "capillary waves"; they have a wavelength of less than 1.74 centimetres, and they live and die very quickly. As the wind continues to blow, the ripples don't move in the direction of the wind, but fan out at 70–80 degree angles from the direction of the wind.*

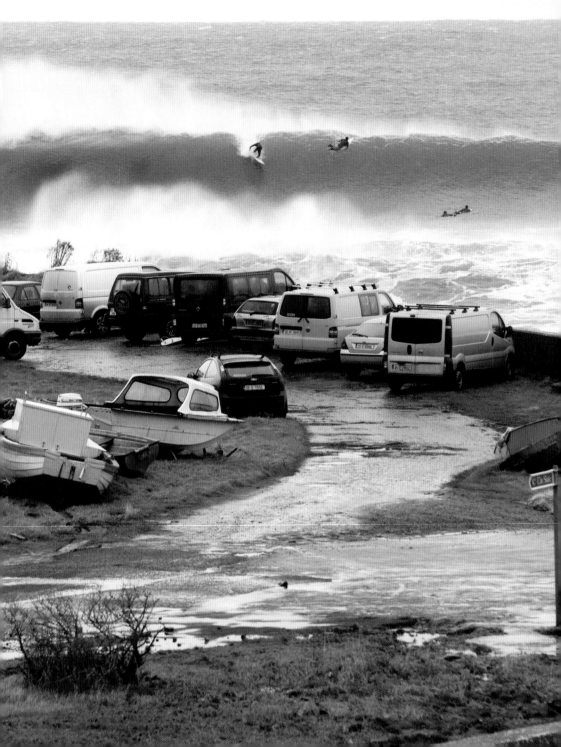

haven't as much wind energy and are moving slower. The slower waves start fading while the longer-period waves start expanding.

After a swell has travelled 800 nautical miles away from its source it loses almost two-thirds of its size and most of that is loss of short-period energy. But at the same time, the period or time between the passage of two successive wave (swell) crests is increasing.

As a swell moves away from its stormy source, the different bands of energy within it group together based on direction and wavelength. The swells with longer wavelengths move faster allowing the creation of swell groups or swell trains, which eventually show up at beaches in groups that surfers call "sets".

The speed of a swell through the open ocean is the period of the wave multiplied by 1.5, so the speed of an 18-second period swell is 28 nautical mph, or 33.6 mph (54 kph).

A 40–45 foot sea can generate a 20+ second period swell, assuming the swell has sufficient distance to "unwrap". Mark Sponsler, a transplanted Floridian who lives in California and does surf forecasts for www.wavewatch.com defines this as: "The distance that raw, untamed waves being generated under the influence of wind must travel away from that fetch before they settle down into regular well-spaced swells. It's sort of like unwrapping a Christmas present by peeling off the outer papers to expose the gem hidden inside. Unwrapping normally takes about 1200 nautical miles. In other words you don't want the swell-generating storm to get closer to your shore than that distance. Of course, if you live on the East Coast of the United States, you take what you can get. It's all a matter of perspective, geology and expectations."

BUILDING UP A STORM

In old Hawaii, the *kahuna* religious leaders would stand at the water's edge, swing flora over their heads and sing chants to the water, imploring the gods to kick up some surf. Today, such paganism has been replaced by pure science, as surfers who are good at math use the Internet to calculate when a swell will arrive, while everyone else can look to www.wavewatch.com, www.surfline.com, or a dozen other surf forecasting sites to find out when a swell will appear on the horizon, and at what angle it will approach the coast.

FAR LEFT The Irish coast twists and turns, so no matter what swell is running or what wind is blowing, there will be nooks or crannies to make sense of it. In November 2007, the perfect swell-producing storm rumbled though the North Atlantic and lit up Ireland. Maine photographer Nick LaVecchia happened to be in the right place at the right time, and caught Kilcummin making good sense of this huge swell.

WAVE BREAK

Waves begin to "shoal" or feel the ocean bottom at one-half of their wavelength. Doing the math for an 18-second swell, 18 squared is 324 and that multiplied by 2.56 is 829 feet, so a swell train with a period of 18 seconds begins to feel the bottom in about 800 feet of water. Large continents usually have a continental shelf that extends for hundreds of miles from the coast, while surf spots in the open ocean sometimes have no shelf at all, which is why waves like Teahupoo and Pipeline and Jaws break with such power.

"Shoaling" is a phenomenon that occurs when an ocean swell approaches shore and begins to feel the bottom, and the friction slows things down. As the water gets shallower, the energy stored in the base of a swell is pushed upward and the wave height increases.

Surfers who know how to do the math look for period (the interval between waves) as much as wave height when a swell approaches the coast, because a 5-foot wave with a 12-second period will not be as big as a 4-foot swell with a 20-second period.

A long-period swell will feel the bottom and "wrap" into a coast sooner than a short-period swell, and that wrapping effect brings the swell into areas of the coast that a shorter-period swell will miss.

Local conditions also influence the arrival of waves: Tides, currents, local winds and cloud conditions put the final icing on the cake of a swell, and that icing can be sweet or sour. A tide that is too high or too low will leave too much water on the reef, or not enough, and that will spoil the effect.

Some coastlines are surf friendly, some aren't. Most of the Pacific coasts of Washington and Oregon are too craggy, steep and rugged to be good for surf spots, but that is not the case with the west coast of Ireland. The Irish coast lies exposed to the North Atlantic and to low pressure systems that originate from North American storms which blow over a thousand miles of fetch, from Newfoundland, under Greenland and toward Ireland.

Some have described the Irish coast as a "cold water Indonesia" because millennia of hammering by the ocean has created an intricate tangle of nooks and crannies, a fractal coast that bends out for hundreds of miles. And so the Irish coast is a horn o' plenty for every kind of wave that surfers love: reefs, points, beachbreaks and rivermouths.

BIG EIRE

On the morning of Thursday, November 29, 2007, a low pressure system formed below Greenland and began moving east. The energy came spinning off North America from around the Horn of Newfoundland and entered the North Atlantic with over 1,000 nautical miles between Quebec and Ireland. That energy might have had its source halfway around the world, in Siberia, according to Mark Sponsler: "Those storms just follow the jet stream from west to east. Often when we get a good storm cycle going in the North Pacific, the remnant energy from those storms regroup after passing over Canada, building in the far North Atlantic and then slamming into Europe."

On that Thursday, QuikSCAT showed winds of 50 to 60 knots blowing almost straight east across the North Atlantic. That wind was still blowing by evening, producing seas of 44 feet. The winds were still blowing the morning of Friday the 30th, and still at 50 to 60 knots. By evening the winds had dropped to 40 to 50 knots, but there were seas of up to 47 feet aiming directly at the coast of Ireland at around 54 degrees north. By Saturday the energy from the storm was only 354 nautical miles from the coast of Ireland and the storm filled nearly 50 per cent of the area between North America and Europe with winds in excess of 50 knots, for 48 hours, all aimed directly at Ireland.

On Saturday December 1, "forerunners" from that area of fetch began impacting on the Irish coast. These were the swells with the longest period which outran all the other wave trains and arrived along the coast first. Duncan Scott, a transplanted surfer who calls London home, was waiting with a jet ski and some mates who were keen to have a go. Nearshore models forecast 38-foot wave heights at an 18-second period for noon on Saturday in Donegal Bay. However, by 2:00 a.m. on Saturday, the Galway M1 buoys were already showing 48-foot readings – it was destined to be a big one.

Surfers generally look for calm or offshore winds, which blow from land toward the sea and help groom incoming waves, holding back the falling lip or crumbly sections and giving a shaggy incoming swell a celebrity makeover. But offshore winds can also

BELOW *For many years, surfers have eyed Mullaghmore as a reef that had the potential to produce giant waves. That potential came true on December 1, 2007, and was met by the tow team of Gabe Davies and Richie Fitzgerald and the tow team of Alistair Mennie and Duncan Scott. Mullaghmore had world-class size and power on this day, and this wave of Gabe Davies' was arguably the largest ridden.*

blow too hard and make waves impossible to catch as surfers paddle like fury into the wind and are blown back, or are held up in the lip and go over the falls.

Early on the morning of December 1, surfers Duncan Scott, Alistair Mennie, Richie Fitzgerald and Gabe Davies, and photographers Kelly Allen, Mickey Smith and Tony Plant got the first glimpse of this historic swell. The surf off the point at Mullaghmore was absolutely giant, and the southwest wind that plagues the coast at that time of year was cut down by the headland. They made their way to Mullaghmore harbour and saddled up on jet skis with surfboards, cameras and safety equipment before motoring out to make history. As lightning thundered on the horizon, these UK surfers brought the British Isles into serious consideration as a big-wave destination, surfing and surviving some of the biggest waves the Irish coast had ever seen.

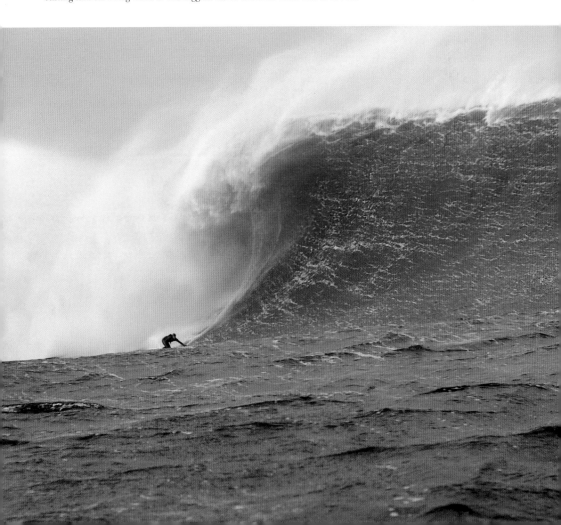

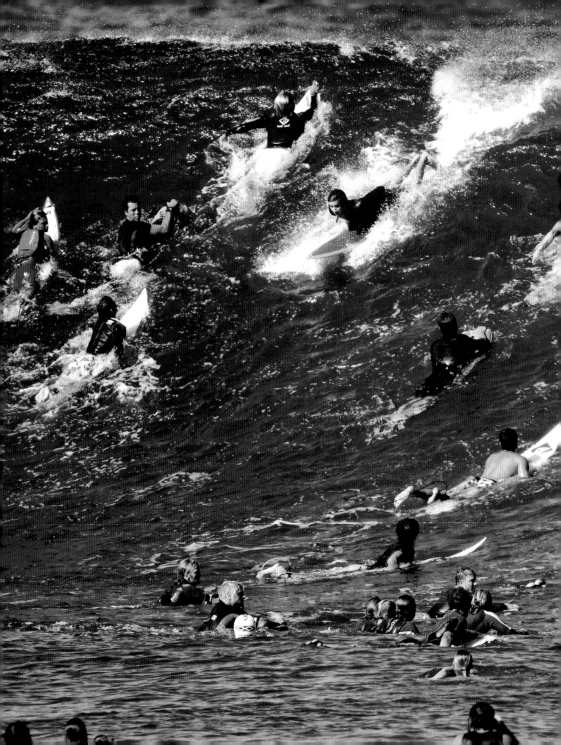

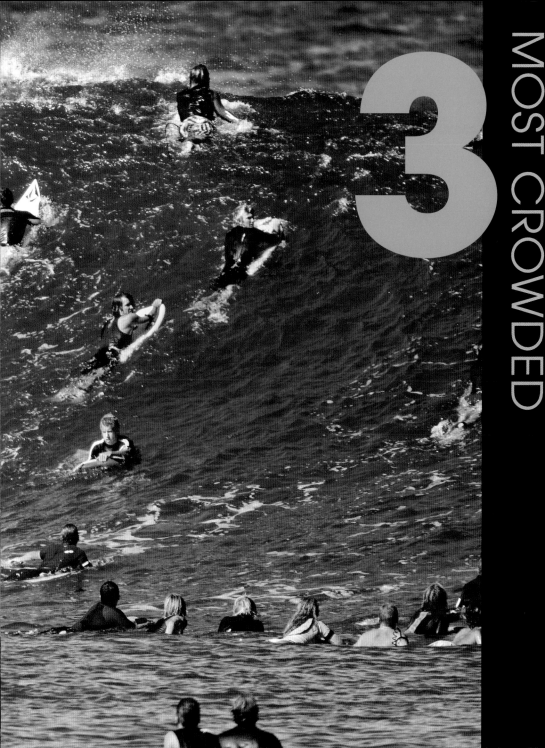

IN THIS CROWDED WORLD

> "In this crowded world, the surfer can seek and find the perfect wave, on the perfect day, and be alone with the surf and his thoughts."

John Severson, *Surfer* magazine, 1960

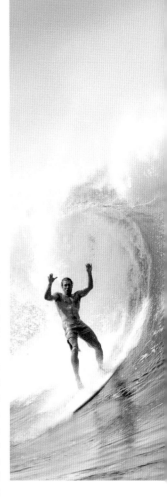

ASK ANY SURFER LIVING near a popular urban surf break, from Piha to Pipeline, Newquay to Newcastle to Newport, Supertubes to Superbank and most likely they'll complain that their home spot is the most crowded in the world. And they'll be right. Ask a dozen surfers what the most crowded line up is and you'll get a dozen different answers. The world is overcrowded. The surfing world is overcrowded. Over half the world's population lives within 200 kilometres of the coastline, and eight out of 10 of the world's biggest cities are coastal.

The movie *Gidget* came out in 1959 and lit the fuse of surf culture which then exploded by 1964 with the Beach Boys, Jan and Dean, and Frankie and Annette. But in 1960 that fuse was still burning slowly. When Severson started *Surfer* magazine in 1960 it was a quarterly with a circulation of 5,000: "The 'crowded world' was all around us but not in the surf," Severson said. "In 1960, a surfer could at times paddle out at a top spot and surf alone." By 1961, *Surfer*'s circulation was up to 12,000 and in 1962 they printed 55,000 of their first bi-monthly. The escalation that Severson saw in two years continued and now, almost 50 years later, the surf industrial complex employs tens of thousands of people and is worth billions of dollars a year in clothing, accessories and surfboard sales.

The surf industry and professional surfing have become tightly-run marketing machines flowing surf culture into every corner of the world. Hundreds of surf schools pump thousands of new surfers into the ocean every year, and the sum total of all of that is a population of surfers ever-growing at the same rate as world population.

Where *Surfer* magazine stood alone as the pioneer surfing magazine, now there are dozens of magazines and scores of websites providing instantaneous information. If there is any one factor that has made surf crowding worse, it is the Internet, and surf forecasters and webcams, which take all the guess work and mystery out of the ocean, leading crowds directly to the perfect wave on the perfect day.

PREVIOUS PAGE *Pipeline at its worst: "Back in the day, there was a REAL set of rules," says Pipeline Posse founder Braden Dias, one of the top Pipe surfers over the last fifteen years. "You wouldn't be able to go out there and break ANY of these rules without paying the consequences. Nowadays, the law is getting involved because there have been a bunch of fights at Pipe, due to the enforcement."*

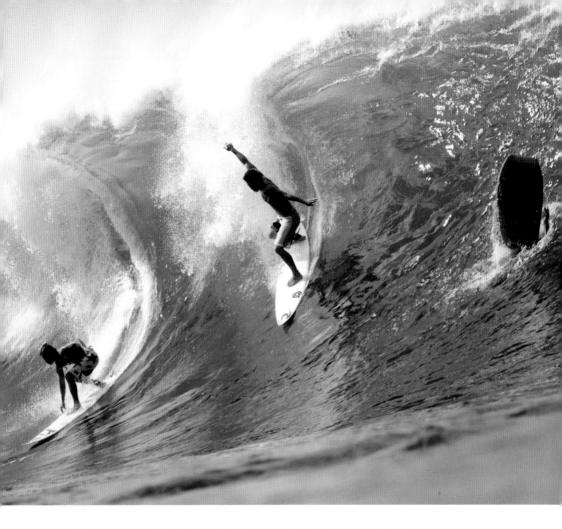

There was a time when the first day of a new swell was the "local's privilege", when surf would just show up over the horizon without any warning, inspiring everyone to start yelling "Surf's up!" as devotees dropped everything, grabbed their boards and headed for the surf. Surfers who lived near a break and had a finger on the pulse would enjoy the first day of that swell in relative peace and calm, until word went out on the Coconut Wireless and the mainstream news, and the rest of the world would come streaming in.

Most popular surf spots are now scanned by at least one, if not several surf cameras and surf forecasters can predict a swell many days, if not weeks in advance.

ABOVE *Triple trouble at the Pipeline. The wave is dangerous enough without having to deal with crosstown traffic. The bodyboarder has the good manners to pull out, but the other three are heading for a collision.*

MALIZOO

Malibu is a surf spot that is regularly deluged by four or five times too many surfers. In October 2007, Santa Ana winds kicked up firestorms that threatened large parcels of Southern California. Malibu burned on Sunday and Monday, but by Tuesday, the winds had died and the fires had gone elsewhere. The Pacific Coast Highway was closed for those three days, and the Sheriffs and Highway Patrol that manned the roadblocks were not yielding. Outsiders could not get in and for three days, Malibu was "Locals Only".

And it was nice. The firestorm and the road closures coincided with an A+, well travelled, overhead southern hemisphere swell and those Santa Ana winds. On Tuesday the surf was as good as it gets. The crowd of surfers at Malibu numbered no more than 20 throughout the day, and by afternoon, the Happy Few were sharing a joke: "We all died in the fire and went to heaven, and heaven is perfect Malibu, in the 1950s, with modern equipment and local surfers only."

Two weeks later, the fire was already a memory, the roadblocks were gone and Malibu was back to abnormal. The major surf websites showed startling photos of a

"We all died in the fire and went to heaven, and heaven is perfect Malibu, in the 1950s."

giant southern hemisphere swell that had ravaged Teahupoo in Tahiti and created some of the biggest waves ever ridden there. And with that overture, all of California knew exactly when that swell would be showing up, the swell size and wavelength period and which beaches were situated best to catch it. Around 100 surfers showed up in Malibu. Malibu cannot support 100 surfers. It cannot support half that number, and so it dissolves into a chaos which sees seven (and sometimes nine) surfers riding one wave at First Point and all the established rules of the road flying out the window. Surfers scramble for any piece of that energy they can get, dropping in on other surfers, colliding, getting in each other's way.

In terms of sheer numbers Malibu doesn't have nearly the crowds you might see at Waikiki or Shonan in Japan or Superbank in Australia, but in terms of total number of people in the water divided by number of waves available, Malibu is a real contender for Dumbest Crowd.

LEFT *It was crowds at Waimea and Pipeline that forced Laird Hamilton, Darrick Doerner and Buzzy Kerbox onto jet skis to find new happy hunting grounds for big waves such as Jaws on Maui. But such is the juggernaut that is twenty-first century surfing, Jaws, too, is now affected by huge crowds when it breaks.*

ENGLAND

The popularity of surfing these days has pushed crowds into the most obscure nooks and crannies of the world, and is a problem in Europe's most densely populated country, England, where the ratio of good surfable beaches to number of surfers is high. Duncan Norris lives in the wilds of South Devon, and grew up surfing a beautiful, lonely stretch of beach called Bantham. According to Norris, now in his 40s, that stretch of beach is not so lonely any more: "Crowds are a major problem now at Bantham," Norris said. "In the late 70s and early 80s everyone knew their place and every face had a name. Now a clean swell will see 100–150 in the lineup, about 50 or so that can surf and the others clogging up the peak, section and bowl. It's frustrating to have nice waves but to have to miss the section and go around someone just sitting clueless and in the way!"

Duncan is talking about a very rural corner of England, a place that is accessible only through miles and miles of driving by hedgerows, dodging tractors and cows, skirting mud puddles. Bantham is as underexposed to the open ocean as most surfing beaches in England and yet, when the surf is there, it's crowded.

Surf forecasts, surf schools, softboards and the sheer numbers of people are the cause. This experience is repeated in the major spots in Devon and Cornwall, which all suffer from surfing being cool. Around Malibu, fires and floods and mudslides will close the roads and bring a temporary respite from crowds. In England, it was an outbreak of

BELOW *Dora didn't approve then, and he wouldn't approve now. Miki Dora was one of Malibu's best surfers during the Golden Years of the 1950s. He stunt-doubled for Cliff Robertson in* Gidget, *and watched with shock and awe as Malibu was soon overrun with Valley cowboys, hodads, aeroplane workers, half-wits and wannabes. When* Surfer *magazine accused Dora of being ruthless on the waves, he cranked it to 11: "It's a lie. I'm vicious. We're all pushing and shoving, jockeying for position, and if I get the wave first – if I'm in the best position, then I feel I deserve it." Dora died in 2002, but his legacy remains at Malibu.*

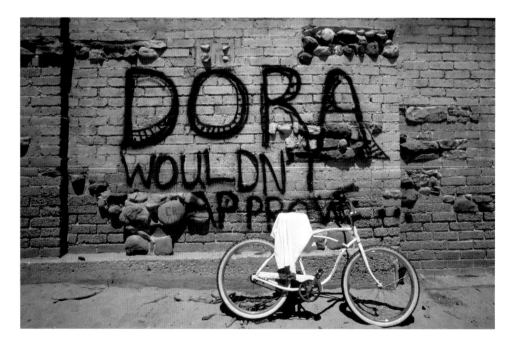

foot and mouth in 2001 that reminded surfers at Bantham of the peaceful days of the 1970s. Foot and mouth was a critically serious threat to the cattle herds of England, and to the British economy. To keep the disease from spreading, many areas were closed and that included the beach at Bantham, although it was possible to paddle across the bay from another beach. Norris got around it: "I went surfing by paddling down the River Avon and out to sea. On this particular midweek day I hadn't checked the surf, so thinking it was small took out my 1965 Harbour 10' 2" with a fin like a wedge of cheese." Norris had a blast from the past: 4- to 6-foot surf, clean and deserted, no one on the beach

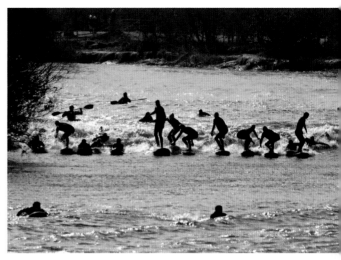

and no one in the surf, on the kind of day that webcams would have transported an instant crowd: "We often remark that our beach has changed and does not break as well as we remember," Norris said, "but I found out that it is the same, it is just the people floating about that make it seem different! There I was surfing an old log, no leash, paddling into waves when and where I wanted to . . . alone with my thoughts."

PIPELINE

In Hawaii, it was crowds at Waimea Bay in the 1980s and 1990s that drove Laird Hamilton, Buzzy Kerbox and Darrick Doerner to the outer reefs, in boats and then jet skis, to experiment catching waves using engines.

In the 1990s, the crowds at Pipeline, and the danger that comes with surfing an extremely dangerous wave, drove away the greatest Pipeline surfer of all time. Gerry Lopez surfed Pipeline from the 1960s into the 1990s, and was one of the pioneers of deep tube riding. He was to Pipeline what Babe Ruth was to Yankee Stadium and a part-owner of the "Pipeline House" which was HQ to two generations of Hawaiian surfers who competed at Pipeline. You would think that Gerry Lopez would have a free pass at Pipeline, but in the 1990s he sold the Pipeline House, packed up his wife and son and moved to Oregon, saying, "I felt out of place there".

That's a sad statement, but Lopez is neither the first nor the last surfer to be driven away by crowds. Surfers do things to other surfers at Pipeline that would get them arrested for "reckless endangerment" on land: dropping in, bailing out, wiping out in one of the most powerful waves in the world over the hardest reef in the world.

"Surf cops" have been proposed in other crowd zones, like the Superbank, but if Pipeline lifeguards wrote $25 tickets for every infraction of the rules of surfing, the proceeds would balance the state budget, and Hawaii would not have to charge taxes.

But that kind of surfzone patrolling isn't going to happen anytime soon, and around Pipeline over the years a number of private "benevolent" societies have bubbled up in order to maintain some order. During the 1970s and 1980s, the *Hui o He'e Nalu* were a presence with their black shorts, an unofficial badge which commanded respect. The *Hui* are an informal Hawaiian water police force who made sure newcomers and outsiders followed the rules of respect. The *Hui* has been joined by the Wolfpack and the Pipeline Posse, crews of concerned Hawaiian natives who had respect slapped into their heads as kids, and saw crowds overwhelm the unwritten laws which had been true at Pipeline through the twentieth century.

SHONAN, JAPAN

When asked to name the most crowded surf spot in the world, veteran surf photographer John Callahan and veteran extreme surfer (and Hawaii resident) Garrett McNamara both nominated "Shonan, Japan". Shonan is one of the closest surf spots to the huddled masses of Tokyo; millions of people all cramped together, yearning to breathe free and catch some waves in the sunny surf when the summer heat of the city becomes unbearable.

Shonan has at least two cameras pointed at the surfline. Although it is best during typhoon season from late August to October, the surf is packed with people all summer long – hundreds and thousands of surfers bobbing around in an ocean that is often dead flat: "The crowd situation at Shonan owes a lot to Japanese cultural sensibilities: On the weekend, Japanese surfers with jobs go surfing," said John Callahan, who lives in Singapore and produces photographs for surf magazines around the world. "Shonan is one of the most accessible spots for thousands of Japanese surfers with shops, food, and drink, all arranged for maximum convenience. It's quite within the cultural parameters to surf with other surfers, where a magazine or website tells you to surf, with the board the magazine or website tells you is the best board, in the wetsuit that is the best wetsuit, at the same time, at the same spot. And often on the same wave – hence the crazy crowds."

Go to Shonan on a weekday, after summer officially ends on 1 September, and there might be 20 people out and a clean 4- to 6-foot typhoon swell cracking off the

"You would think that Gerry Lopez would have a free pass at Pipeline, but in the 1990s he sold the Pipeline House, packed up his wife and son and moved to Oregon, saying, 'I felt out of place there'."

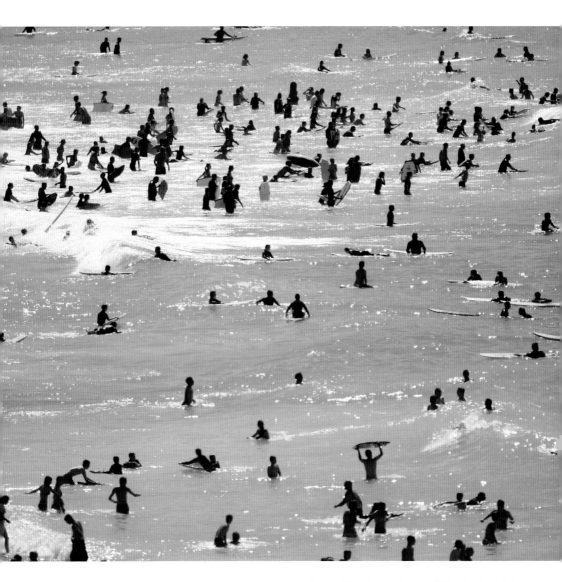

ABOVE *Newquay's Fistral beach is the centre of UK surfing. Overlooked by the Headland Hotel (the setting for the movie version of Roald Dahl's The Witches), the beach is crowded enough in August without the addition of hundreds of surfers. The Cornish town of Newquay has been using the image of surfers on Fistral to promote itself since the 1950s and with the growth of the sport has come massive crowds.*

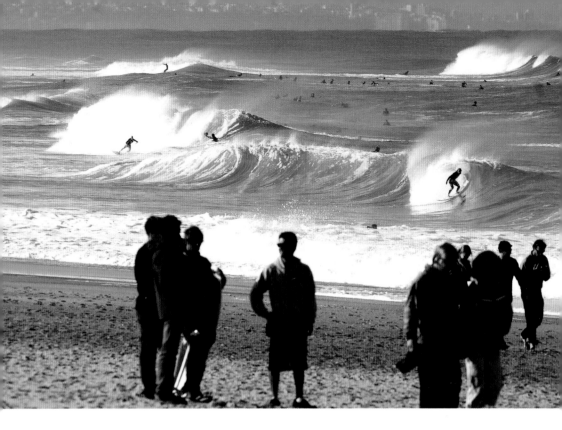

banks. Normal Japanese are at work; there will probably be a few resident foreigners out along with a few Japanese. There are more Japanese out surfing on a weekday in Shonan than there were 10 and certainly 20 years ago, but not many – it's hard for Japanese to defy crushing pressures for cultural conformity and face brutal condemnation from family, friends, and indeed the entire nation for being 'bad Japanese'."

But as more and more Japanese surfers travel to places like Bali, Queensland, Hawaii and California, they see that people there do what they want, when they want, and they take these ideas back to Japan. Some of them attempt to lead this kind of lifestyle in Japan, but it is not easy. Hence the crazy weekend crowds.

SEBASTIAN INLET

Surf forecaster Mark Sponsler lives in California now and surfs Mavericks, but for real crowds Sponsler looks back east to the place where he grew up, Sebastian Inlet.

Surf is king in Florida, with thousands of eager groms, longboarders, and wannabe rippers who will do anything to get out of the heat, humidity and mosquitoes and into marginally cooler water to ride anything that looks like a wave. And for a coast

that has little to no surf 85 per cent of any year, when there's even a hint of swell there's only one spot that catches and magnifies it for all it's worth. First Peak at the Inlet is that spot: "There is only one real peak that refracts off the jetty making for a perfect little A-frame that peels right down the beach," Sponsler says. "There's a group of about 15 guys that fight like dogs to be on it every time it shows any sign of movement, with another 30 that are waiting to ascend to their posts, and they all claim their right to surf it to the exclusion of everyone else. There's only one catch: they have to share it with redneck fishermen poised just 50 feet away who take pleasure in casting right into the lineup. That doesn't count when schools of densely packed mullet swarm just off the beach through the lineup, with sand sharks trolling through gorging for all their worth. It's not the best wave in the world, and not the most crowded in sheer numbers, but Sebastian Inlet certainly is pound for pound the highest density of people with conflicting self interest crammed into what could marginally be called a surf spot."

SUPERBANK

Kelly Slater grew up surfing First Peak at Sebastian Inlet, and there are times he won't surf Pipeline because of the crowds. He deals with crowds at Sunset and Waimea Bay, but when asked to name the most crowded spot, he says: "Superbank".

When cyclone swells sweep down from the Coral Sea, all of Australia goes on red alert and half the country flocks to the Gold Coast. The result is chaos, which Australian surf writer Andrew Kidman described like this: "When a swell is running during the summer on the Gold Coast beaches, all hell breaks loose. Thousands of beachgoers, who haven't a clue about the ocean but love to play in it, suddenly appear. Add to this the hundreds of surfers that each day ride the Superbank – some skilled, some unskilled – and basically you've got yourself a lifesaver's nightmare. As the tide drops and the banks collapse under the pressure from the swell, swimmers and surfers are swept out to sea in torrential rips. Lifesavers spend the day rescuing panic-stricken, sunscreen-covered men, women and children, and surfers unfit for the occasion, lost out at sea."

When a big swell is running through Superbank, the current is horrendous, and the surf lifesavers are too busy saving surfers and swimmers and kayakers and surf-skiers and boaters to enforce any laws. The chaos inspired the Surfrider Foundation and local government to propose a system of "surf police" to maintain order in the water.

Wayne "Rabbit" Bartholomew is a former World Champion and president of the Association of Surfing Professionals who grew up along Queensland's Gold Coast, lives there now and works from an office with an enviable view of Superbank. "Snapper is definitely the most crowded point going, especially in the two weeks around the Quiksilver Pro, when everyone makes their judgments, but believe it or not, it gets very uncrowded on the Superbank. Except on epic swells when it does appear to line up from Snapper to Kirra, Superbank is usually quite empty. Often, right in front of the ASP office, I'll see empty barrels going off for hundreds of metres."

AM I BLUE?

NEOPRENE SURFING WETSUITS are miracles of modern science. Like just about everything else, wetsuits have benefited from innovations in materials technology. They are warmer, stretchier and tougher than ever before and the liners inside them can be customized to a whole range of different temperature conditions. And that is a useful thing, because as some surfers push deeper into the tropical waters of the South Pacific and the Indian Ocean, others are going to the opposite extreme and looking for rideable waves as close to the poles as nature and human endurance allow.

In February 2000, a crew of California surfers including Steve Hawk, Chris Malloy and Dr. Mark Renneker shipped out on the 65-foot *Golden Fleece*, embarking on a perilous surf trip to Antarctica. Departing Tierra del Fuego in Argentina from the port of Ushuaia – the southernmost city in the world – they crossed the same iceberg littered waters that sank the 250-foot MS *Explorer* in November 2007. *The Golden Fleece* passed through the Beagle Channel then crossed the Drake Passage and had an adventure that was *Happy Feet* combined with *Surf's Up* – penguins by the hundreds of thousands, leopard seals, humpback whales, calving glaciers and rough seas.

The first place they surfed was Elephant Island, a fecal chunk of rock made famous by Ernest Shackleton and the crew of *The Endurance*, for this is where 21 of the crew hunkered down for four months, praying their expedition leader had somehow made it across 800 miles of ocean, in an open boat: "We didn't really get waves on Elephant Island," Steve Hawk said, "Although Chris and a guy named Edwin surfed a wave breaking off a little underwater shelf on an iceberg."

After nine days of poking around, seeing many wonders and surviving many perils, they got the best surf of the trip on Low Island, a world-class Ranch-style righthander at a glacial moraine near Cape Garry. At some point, a San Francisco native named Sedge Thompson dipped a thermometer and came back with a reading of 0.5°C (33°F), one degree above freezing.

At a latitude of 63 degrees south, Low Island is even lower than Elephant Island and in extreme terms represents the furthest south anyone has ridden a wave. Because of the way the land mass is configured in the northern hemisphere, it is possible to surf closer to the pole in the north.

TOP O' THE WORLD

Unstad is a beautiful, glacial bay on the northwest coast of the Lofoten Islands. True to form for Norway, there are only a couple of houses, several score sheep and maybe two

PREVIOUS PAGE *Iceland may be green and Greenland may be icy, but Iceland still has plenty of ice ice, baby. Surfers with good wetsuits are willing to go to the ends of the earth and search every crack and crevice to find good surf. The obsession is that strong.*

RIGHT *To most people in Iceland, going into the ocean means death. The ocean is not a place for recreation and fun. The ocean is where fishermen fall in and freeze to death. But in the last 20 years, more and more surfers have been doing the Iceland thing, exploring the coast of one of the cleanest, best-run countries on earth, and surfing beaches that are backed by glaciers, or volcanoes under glaciers, flowing steaming hot water down to a freezing ocean.*

"The water was only 32°F or so which was cold enough, but it was sunny. I have been colder in Santa Cruz."

Robert "Wingnut" Weaver

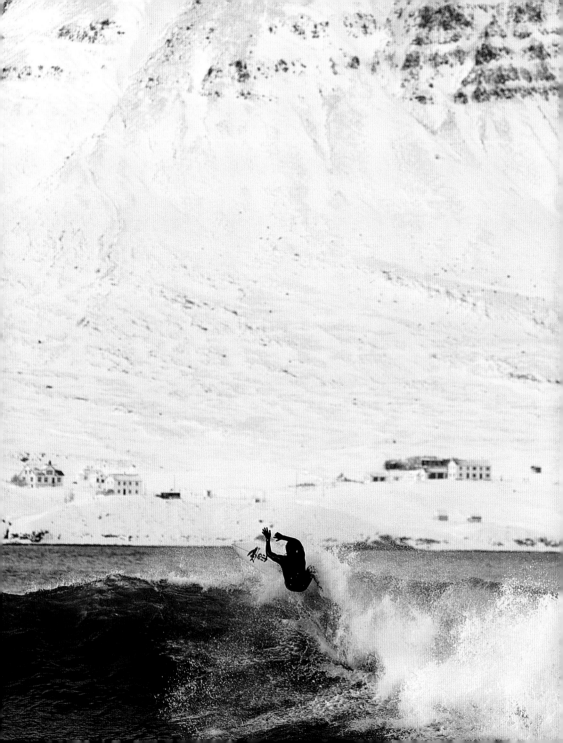

dozen people living in Unstad, but there is a multi-million dollar tunnel to get there. At a latitude of 68 degrees north, Lofoten is even closer to the North Pole than Low Island is to the South Pole. But Antarctica is a novelty; Unstad is a legitimate surf spot that is regularly visited by hardy sons of Vikings and travelling surfers lured to this far corner of the surfing world by the romance of surfing a long, perfect left under the midnight sun.

Unstad is two degrees north of the Arctic Circle, but the northerly surfing phenomenon is all down to the Gulf Stream, which flows northwest across the Atlantic Ocean and becomes the Norwegian Current after it crosses that line in the snow. The Norwegian Current carries enough heat to keep Unstad surfable well into winter, long after the sun has disappeared.

Mattias Hornquist is a Swedish surfer and a true descendant of Vikings. He has lived in the Lofoten Islands since August 2003, working as a fisherman in the cod season and surfing when he is not at sea. On February 13, 2007, Hornquist celebrated his entry into his 30s by entering into 30 degree water at Unstad. "It had been quite cold

BELOW *"Whoa dude, Iceland was so cold I took off on this wave and pulled into the barrel and it froze in midair!" Well, not that cold really. This is just a natural ice formation, doing the kind of thing that surfers love best.*

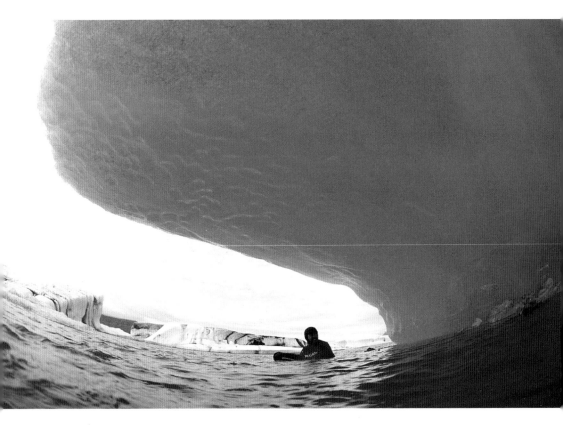

in Lofoten for a few weeks and we received lots of snow. The day before I had some great powder runs not so far from Unstad, but this day the forecast looked pretty good for some waves and I was very keen on the idea of spending my 30th birthday surfing. It was -5°C (23°F) in the air, blue skies and a light but freezing offshore wind. The waves were small but clean and to get out in the water we had to 'walk' through powder snow up to our waists. Unfortunately the waves looked better from land than they really were so we had to sit and wait around quite a bit in water that was 4–5°C (39–41°F). Waiting for my last wave, a big sea eagle came cruising over my head, so low that I could see one of his eyes."

Hornquist didn't like the look of that eagle, so he went in, endured a 200-metre walk through the snow and made it back to the car where he changed out of his stiffening wetsuit and hoped he would stay alive long enough to take a hot shower: "It might sound like a terrible surf and a terrible way to celebrate your 30th but I've got a sweet smile on my face when looking back at that day," Hornquist said. "Felt alive for sure, even though I'd reached the dirty thirty haha…"

Surfers have gone even further north. Doc Renneker was one of the members of the Antarctic expedition, and he went to the other extreme and took a surf trip with his girlfriend to the Svalbard Islands of Norway, which at 78 degrees north are just a short paddle away from the North Pole. Iceland is not a regular surf destination either, but it does have surf. In 1997, Robert "Wingnut" Weaver, Donovan Frankenreiter, Dan Duane and Doc Renneker travelled to the land of ice and fire: "The people there thought we were nuts, because to the Icelanders, to fall in the water means death," Wingnut said. "And we were surfing in it, playing in it, from a sand point at the end of a glacial river mouth with icebergs floating down the river out to sea. The water was only 32°F or so which was cold enough, but it was sunny. I have been colder in Santa Cruz."

In August 2005, Malibu resident Jefferson "Zuma Jay" Wagner travelled to Iceland to work as an armorer and Sherman tank driver on the set of Clint Eastwood's film *Flags of Our Fathers*. Jay did not bring a surfboard with him but he did bring a full wetsuit, booties, gloves and a hood, and as it turned out, the beach where they shot the invasion scenes was the main surfing beach in Iceland: "Sandvik was set up exactly like the invasion beach at Iwo Jima," Zuma Jay said. "The cliffs were in the right place at the right angle. It was perfect. At one end of the beach there was a right point and at another a left point and in the middle there were beachbreaks. There was a lot of swell."

ABOVE *Scottish surfers these days go surfing in 10°C, kitted out in thoroughly modern wetsuits. This is Aussie/British pro surfer Micah Lester, who was headed up to the top of Scotland to compete in a six-star World Qualifying Series event at Thurso: "It was early in the year as we drove through the highlands and there was still some snow on the mountains," Lester said. "We didn't have any snowboards with us so we used our surfboards to go down the mountains instead. We got a few odd looks and still had time to go surfing that same afternoon on the other side of the pass. It was damn cold but it's something I will never forget!"*

Too much swell for some of the invasion scenes, which had to roll anyway because the production was paying $250,000 a day for Scandinavian naval vessels to double for the American Pacific Fleet. The production had meteorologists and a Water Captain to keep an eye on conditions and Jay said the daily water temperature prediction was always 4°C (40°F). "It was cold, but I had a 4/3 with sealed seams and could surf for a couple of hours a day. I got some pretty good waves there and had an interesting five and a half weeks in Iceland. The black, volcanic mountain that doubled for Iwo Jima was in a different part of the island from the invasion beach, so I got to see a lot of the island. A beautiful place. Volcanic and desert in some areas, where only lichen grows, lush and green in other places."

LAND O' LAKES

Latitude isn't everything when it comes to surfing cold conditions. The weather that originates in the northern latitudes sweeps down on the Great Lakes in the winter. Those storms blowing over the long fetches in Lake Superior and Lake Michigan create beautiful reef and point breaks that entice hardy American and Canadian surfers into truly brutal conditions. According to the documentary *Unsalted*, produced by Vince Deur, surfing on the Great Lakes began on Lake Erie in Buffalo, New York, in the 1960s. But now you'll catch 'em surfing on Huron, Superior and Michigan, on both sides of the border. Canooks do it too.

Great Lakes surfers rely on local storms to kick up waves. Autumn is prime time, because it's on the cusp of lingering summer weather, and the start of the winter winds. Great Lakes surfers live for those months when the days grow short, but they don't stop when they reach December. Some of the best waves blow in in the middle of winter.

Unsalted shows guys fully suited, booted, gloved and hooded, huffing over snow and falling through the ice to get to the surf. The surf of the Great Lakes is remarkable for the quality of the waves produced in a short fetch in fresh water, and also for the apparent brutality of the winter conditions. The water is 0.5°C (33°F) and the ambient air temperature can be around -10°C (13°F) and the windchill can be -23°C (-10 F).

ALASKA, SIBERIA . . . AND MAINE

Surfers on the east coast of America are proud of the waves they get in the winter, and believe the conditions they endure are comparable to Alaska. Jamie Meiselman is an East Coast surfer who has been combing the coast from New Jersey to Maine for the last 20 years. He has surfed Yakutat, Alaska, and on Lake Champlain in Vermont. He works for a company building the Ron Jon's Surf Park in Orlando, Florida: "I have surfed the Northeast year-round and while we probably have the coldest 'coastal' conditions in the U.S. (air/windchill frequently below zero from northwest winds coming out of Canada), the ocean temperature never gets colder than the low-mid 30s for any stretch.

BELOW *Eggum, along with Unnstad, in Norway's Lofoten Islands, are the most northerly surf spots in the world. They are also perfect places to view the midnight sun, given their location within the Arctic Circle in the 67th and 68th parallel. The sun rises on May 26 and doesn't set until July 17. Warm water from the Gulf Stream keeps the water free from ice throughout the stormy winter months, with a fetch that stretches all the way across the Atlantic, from Nova Scotia.*

"Yakutat in April has pretty mild air and water compared to a typical northeast winter day. I would bet that the Great Lakes has comparable air and wind chill temps to what we experience in the Northeast, but because the Lakes actually freeze, they are probably surfing in water temps that hover right around 0°C (32°F) or even a bit colder as the water has trouble freezing under wave action."

When you think "cold" the word Siberia comes to mind and there are surfers who have made the trek to Kamchatka, a peninsula in eastern Siberia that used to be top secret and off-limits and the home of various Soviet submarine and air bases. Opened to the world in 1990 when the Wall came down, a few surfers have ventured out of Anchorage in Alaska, flying to Petropavlovsk then touring the coast in Hind helicopters. Kamchatka is on the eastern edge of a giant land mass, so the jet stream that sweeps over it is coming from Russia, with love, but not a lot of heat.

With Russians enjoying a burgeoning economy and far more leisure time, it remains to be seen if the nation that drills holes in frozen lakes in the middle of Moscow to go swimming will produce a hardy brigade of cold-water surfers that takes the sport into yet more desolate spots.

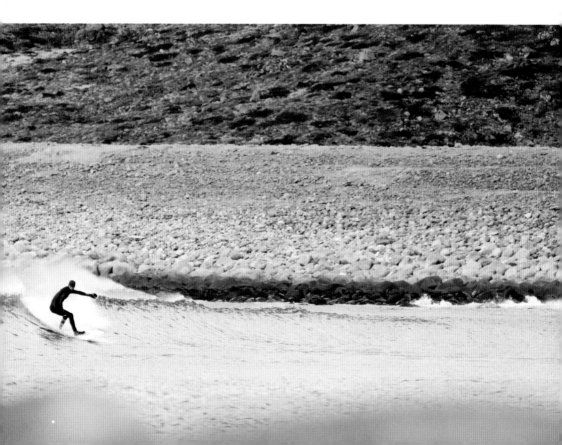

AND SOME LIKE IT HOT!

AL GORE CAN TELL YOU ALL about melting glaciers and drowning polar bears and how much warmer the planet earth has become since the start of the Industrial Age. And while Global Warming Deniers are spouting off, surfers are some of the first to feel the effects of a planet with an inner atmosphere that is getting closer and closer to a microwave oven.

Anyone who has been to Mexico in July or Fiji in January will swear they're the hottest places on earth. Sean Murphy is the owner of WaterWays Travel and spends a good part of the year travelling along the equator. He says Fiji is positively arctic compared to other places: "I have been to Fiji about fifteen times, and the Andaman Islands made Fiji seem like a cool spring getaway," Murphy said. "I was there in March just before the monsoon season. The Andaman Islands were so unbelievably humid, any non-surf activity in the sun or on land would kill you without water."

Antony "Yep" Colas believes that the Indian sub-continent is also in contention for hottest: "One serious challenger would be India, in May 2003, when we surfed Andhra Pradesh. Heatwaves killed 600 people with 47°C (116°F) peaks somewhere inland. It was hot as hell, but Oman and Pakistan are playing in the same league of oppressive heat." Photographer John Callahan agrees about Oman. He was there as a photographer and worried about the effect of that brain-bubbling desert heat on his equipment: "We surfed a couple of days when it was 45°C (113°F) and the offshore interior desert winds were so arid your hair would dry in the lineup between sets!"

MAKRAN COAST

There are different kinds of hot surf, but a group of desert-loving Englishmen found all three on a trip to Pakistan in 2001. This was a few months before 9/11 but the place was still dangerous in the political sense. Writer Stuart Butler, photographer Antony Colas, Cornwall bodyboarder Ben Clift and *Surfer's Path* art director Dan Haylock were lured to this part of the world by an aerial photo in a book about Alexander the Great. The photo showed a dead riverbed snaking down to the coast, where a perfect right point was wrapping in whitewater lines.

The Makran coast has always been a barrier between the Arabian Sea and the interiors of Pakistan and Iran. According to Stuart Butler, who wrote about the expedition in *The Surfer's Path*, the desert ended the lives and campaigns of Cyrus the Great and Semiramis – the Queen of Assyria. And the Makran nearly destroyed the army of Alexander the Great when they were returning from a campaign in India.

RIGHT Some like it hot in Oman. Four surfers on John Callahan's trip to the desert kingdom traverse the sand, putting their tropical wax to the test.

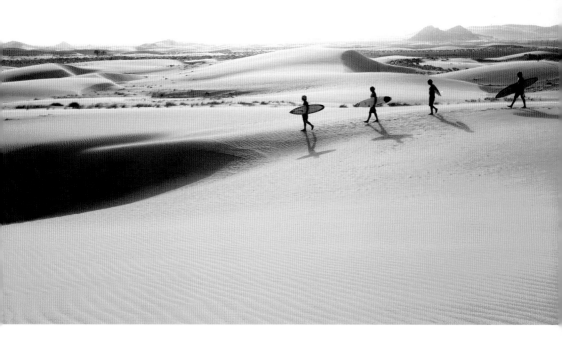

The modern obstacles began with the Pakistani government, but persistence got them through to Karachi and the Makran Coast. They poked around near Gwadar, in an area popular with gun and heroin smugglers and pirates who prey on boats in the Strait of Hormuz. The surfers had armed guards with them at all times, as they surveyed coastal areas that most of their guards had never seen. Cars with surfboards attracted attention wherever they went – which is not such a great idea in a place full of kidnappers. Looking for a setup like the photo of the river mouth they had seen, they found a right point firing along a muddy-sand point. The surfers endured the kind of heat that kills soldiers, and stops armies in their tracks: "On some days," Stuart Butler wrote, "the heat reached such a pitch that it was almost impossible for us to find the strength to lift our heads from the ground where we slept."

After poking along the coast for days, these desert-loving surfers weren't so in love with the desert. And then they found a spot they called Mirages, because what looked to be perfect 6-foot surf from a distance, turned out to be about half that size. But still surfable. The surf was firing around the point, and they surfed it for two days before bumping into two armed men, who turned out to be part of a ten-man platoon of Pakistani coastal guards who were engaged in a running gun battle with 200 smugglers trying to rendezvous with small boats offshore. The gun battle lasted the whole night, but in the heat of the day, it was too hot to shoot and kill. The good guys and the bad guys called a ceasefire, and the surfers went surfing to cool down.

"On some days, the heat reached such a pitch that it was almost impossible for us to find the strength to lift our heads from the ground where we slept."

Stuart Butler

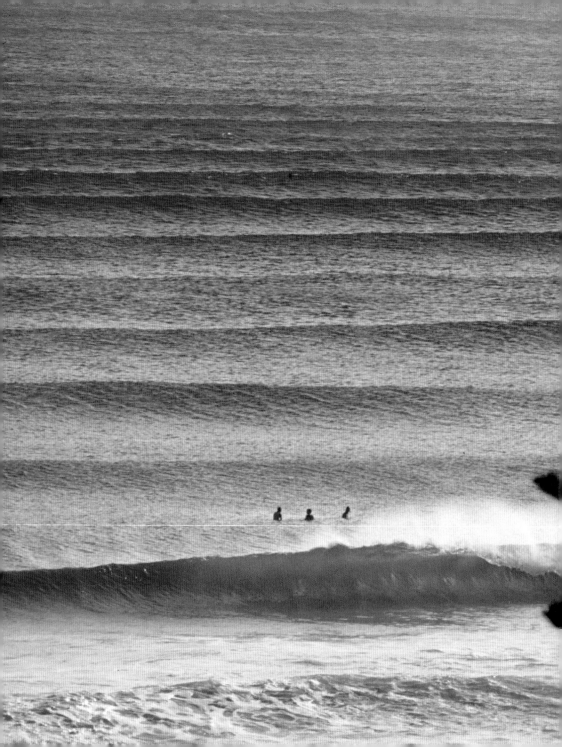

POINT BREAK

REEF BREAKS, JETTY BREAKS, pier breaks, river mouths, inlets, beach breaks, outer reefs, inner reefs, bomboras, bommies, shoreys, barrier reefs, reef passes, artificial reefs. Waves break over different surfaces above and below sea level. Some waves are long, most waves are short. The longest waves are usually waves that break around points or headlands. Of all these different kinds of breaks, point breaks are prized among all other surf breaks, because they are long.

The length of point breaks is determined by the physical law of refraction. An open ocean swell is an efficient carrier of energy. As the swell energy moves through the ocean, water particles move in an ellipse, but end up where they started and don't move forward. When a swell begins to feel shallow water, the water molecules at the bottom of the ellipse are slowed by friction. When the ratio of swell height to water depth is three to four, the friction causes the wave to topple over and break.

PREVIOUS PAGE *Superbank in Australia isn't entirely a natural creation. There were waves from Snapper Rocks to Kirra before, but the Tweed River Sand Diversion scheme dropped many tons of fairy dust from the top of the point, creating one of the semi-natural surfing wonders of the world.*

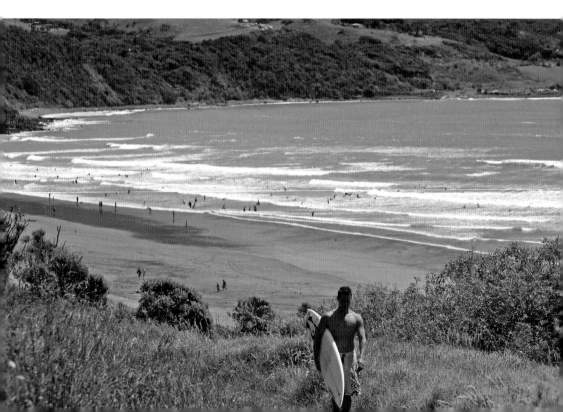

"There's some place in Mexico. I've never been there but I read about it in the *Guinness Book of Records*. The longest wave I have ever surfed is …"

When a swell approaches a point of land, the part of the swell in shallow water is slowed down, while the swell in deeper water moves forward. This is what marine scientists call "refraction", and surfers call wrapping, peeling, tubing, winding, grinding or lining up. Those rare point breaks that go for a mile or more are the best of the best.

DOWN MEXICO WAY

Ask 100 surfers to name the longest natural wave, and you will get the same answer, then many subsequent answers: "There's some place in Mexico. I've never been there but I read about it in the *Guinness Book of Records*. The longest wave I have ever surfed is …"

That blank could be filled in by Cape St. Francis in South Africa, Scorpion Bay in Mexico, Rincon in California, Raglan in New Zealand, Chicama in Peru, or Pavones in Costa Rica. All of these spots are contenders for longest wave on their day, but "that

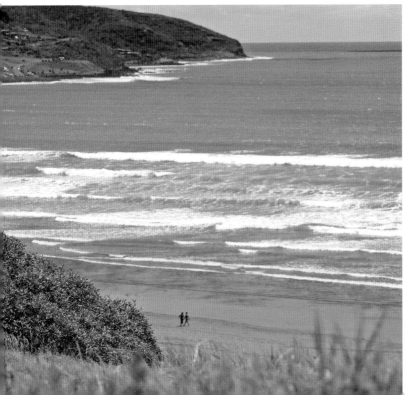

LEFT *Raglan is a long, lovely left point on the west coast of New Zealand. This is one of the first stops for swells generated in the Southern Ocean, and those swells wrap around the point in seemingly endless lines. Mike Hynson and Robert August surfed Raglan in* The Endless Summer, *and Bruce Brown introduced the wave to the world by saying it was so long, the surfers could "ride one wave before lunch, and one after".*

place in Mexico" has imbedded itself in the psyche of surfers around the world, even if 99.99 per cent of surfers have never been to Matanchen Bay, or couldn't find it on a map. And the claim's not even true.

Air travel was rare during the early years of surf exploration in the 1950s and 1960s, so San Blas was one of the ends of Terra Cognita, a place surfers could get to in a couple of days of driving, hitch-hiking, taking buses or sailing. Matanchen Bay is to the south of San Blas, in the state of Nayarit, Mexico at about 21 degrees south latitude.

Ron Stoner was one of the best surf photographers of the 1960s, and one of his adventures deep into Mexico resulted in a spot being named in his honor. Stoner's Point is at the top of the headland, and on a big southern hemisphere swell the even, long-lined, long-period swells can connect from Stoner's Point through to Las Islitas and then into Matanchen Bay to create that legendary, mile-long wave that featured in the *Guinness Book of World Records* for so many years.

On the right day, Matanchen Bay is a great wave, but that "right day" comes maybe once a year, and only on giant southwest swells that come from deep in the southern ocean and approach the coast of Mexico with the proper angle to light up the points around San Blas.

THE PERFECT WAVE

In 1963, Mike Hynson and Robert August were the stars of *The Endless Summer*, an influential documentary about surfing produced by Bruce Brown. All three were surfers who had been involved in surfing from the 1950s and were appalled by the surf culture explosion only four years after the movie *Gidget*.

The Endless Summer visited South Africa, a place that had a fairly active surf scene, but way more surf than surfers. A local surfer named John Whitmore showed them around, and took them to a spot called Cape St. Francis, where Mike and Robert found the perfect wave, and gave the outside world its first look at Roaring Forties power and length. Cape Saint Francis was the star of *The Endless Summer* which Brown toured as a surf movie with live narration on the east and west coasts in 1964. In 1965, Brown took the movie as far inland as he could, to Wichita, Kansas, to see how it would play to non-surfers. It was a huge hit, so he took his 16mm print, laid down a narration that had been hammered smooth by live performances and blew it up to 35mm. Columbia Pictures had done well with *Gidget* and *Ride the Wild Surf*, so they distributed *The Endless Summer* and it established Cape Saint Francis as the world's most perfect wave.

J-BAY

Surfer magazine thought they knew better than Bruce Brown – they labelled Cape St. Francis unreliable, and introduced the surf world to the dependable and consistent waves at Jeffreys Bay. Soon, visiting surfers began to camp out along the undeveloped beachfront and dine in the nearby Afrikaaner fishing township, also called Jeffreys Bay.

"By 1963 surfers were being portrayed as bums and surf Nazis."

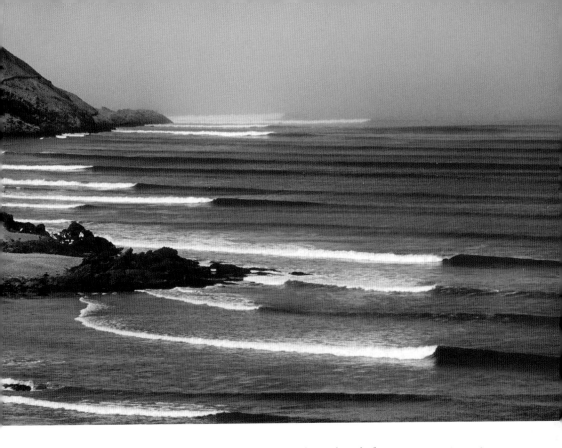

Jeffreys Bay is a long sand and reef point located at 34 degrees latitude, fronting a town which was a fishing village, then a hippie hangout, then a surf mecca. It's now a holiday and retirement town with a regular population of 20,000 which swells in summer to as many as 120,000 surfers, sailboarders and people who just love the ocean.

The wave was first noticed by John Whitmore when he was selling Volkswagens in Cape Town. The vehicles were assembled in Port Elizabeth, so Whitmore made countless drives on the 750-mile N2 Highway between Port Elizabeth and Cape Town, and took detours to beaches that were wild and empty.

The Endless Summer lit the fuse of surf culture which exploded in South Africa in 1964. John Whitmore began importing Clark Foam and when he brought the Bruce Brown movie *Waterlogged* to Cape Town, he sold out nine shows a day for nine days.

As surfing exploded, South African surfers began to explore their seemingly endless coast, particularly Jeffreys Bay. Jeffreys Bay is now divided into six sections, from top to bottom: Boneyards, Supertubes, Impossibles, Tubes, the Point, and Albatross. Supertubes is the mental poster that lines the walls of every surfer's brain. When

ABOVE *Looking up the point at Chicama, on a smaller day. There's over two kilometres of nooks and crannies from the inner beach to the top of the point. When the swell is up, it all connects.*

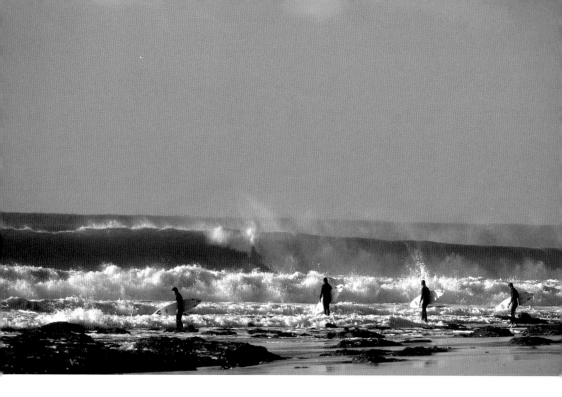

Supertubes is working, it's a perfect, grinding, winding wall that can be anywhere from waist high to almost triple overhead. The wave has length, speed and a perfect combination of hollow tube sections and bending walls for going Mach One and doing everything in the repertoire. According to the *Encyclopedia of Surfing*: "A good Supertubes wave will last for about 250 yards. On the rarest of days a surfer can take off at Boneyards and carry on through Supertubes into an express section known as Impossibles, which shoots the rider into Tubes and through to the Point – a high-speed, 1,200-yard-long ride lasting nearly two minutes."

Hook into one of those screamers and you will swear that Jeffreys Bay is not only the longest wave in the world, but also the fastest wave in the world. If someone ever did connect the wave from top to bottom, it would be the world's longest wave. But Kelly Slater says it ain't so: "I'll bet my house," Slater said during a contest at Lower Trestles in California in 2007, "that no one has ever connected from Boneyards to Albatross."

DEEPEST PERU

Peru has a long surfing history going back as far as 3000 B.C. when Peruvian fishermen rode waves on bundles of reeds called "caballitos". A wealthy Peruvian sugarcane heir named Carlos Dogny visited Hawaii in the 1940s and on his return founded the Club

Waikiki in Lima in 1942. By 1965, Peru had enough of a surf scene to host the World Surfing Championships, which was won by Peruvian Felipe Pomar.

In 1966, a Hawaiian surfer named Chuck Shipman was in a passenger jet flying along the Pacific Coast of Peru when he saw something far below that looked to be a very, very long wave breaking along a desert point. When Shipman got to Hawaii he called back to Peru to have some of the local rogues check it out. In September 1966, a group of Peruvians including Carlos Barreda, Oscar Malpartida and Ivo Hanza went on a surf safari to check out at sea level what Shipman had seen from the air.

What they found just over 400 miles north of Lima was the small, dusty fishing village of Puerto Malabrigo, with a fleet of fishing boats anchored off the tip of a long pier. The fishing village was there because it was protected from the open ocean by a 2-mile, bone-dry, sand-bottomed point which pointed west, directly out to sea. What they also found was lots of ground swell flowing out of the deep, refracting around the top of the point and along its north flank into a left point that could be ridden for minutes at a time.

This wave was long, maybe even longer than that place in Mexico they'd heard about. Maybe longer than Cape St. Francis. The wave was long and the water was cold, shockingly cold considering Chicama was only seven degrees south of the equator. The land around Chicama is dry and lifeless, but the ocean is jumping. The winds that create the currents that bring up all the nutrients for the anchovies, sardines and jack mackerel to thrive on, also blow from the Roaring Forties up toward the equator, over hundreds and thousands of miles of open fetch. Northern Peru is like a catcher's mitt for all that groundswell rumbling up from Antarctica, and by the time it reaches northern Peru, it has covered more than 30 degrees of latitude and is fully unwrapped, lined up and ready to rumble.

In October 2007, forty years after Chuck Shipman's sky-high curiosity led to the discovery of one of the Seven Natural Wonders of the Surfing World, California TV producer and surf writer Joel T. Smith took a "surf and research" trip to Peru: "looking into non-Polynesian evidence of wave riding". He also got to try out the best that Peru had to offer.

Smith got lucky, arriving as a swell was hitting on a Friday afternoon. It lived up to the hype: "I tell ya, the first vision of Chicama in all its splendor," Smith said, "sun glistening, wind off-shore, lines stretching to infinity with perfect periods ..."

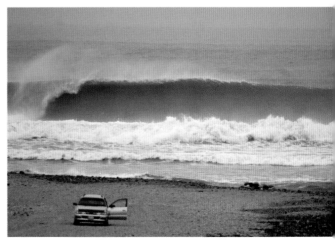

BELOW *Pacasmayo, Peru's other incredibly long left point. Some say Pacasmayo is a longer wave than Chicama, that it breaks bigger and more often and with more power. Apparently it's the kind of wave that makes a surfer forget to close the car door in the frenzy to get a piece of it.*

"Great surf but an absolutely horrid place to hang out. Ah Mexico: The land of untreated sewerage."

Joel T. Smith

Chicama is not perfect all the time, and it's not always the longest wave. The entire point is four kilometres long and divided into three sections: The very outside point is called Malpaso, which breaks for about 150 metres. The next point toward town is called the Cape, which breaks for another 600 metres before hitting deep water. The main point is called . . . Main Point, and this is to Chicama what Supertubes is to J-Bay. This is the money wave that surfers fantasize about.

The entire point never connects, no matter how big the swell, but when it is over six feet, the Main Point links up with sections called The Point and El Hombre and breaks all the way to the pier in town – a ride of 2.5 kilometres that lasts four minutes.

Some say Main Point is slow, some say it's fast, but all surfers who have been to Chicama say legs are more important than arms. Most surfers have never ridden a wave for a minute, so four minutes might as well be an hour. Paddling back out is not an option: too far, too much current. Most surfers walk, and it takes a good 30 minutes walking to cover a distance that took a couple minutes on a surfboard. There is a transport business of motorcycle cabs that will drive surfers back to the point for a small fee, and lately there have been boats and even jet skis showing up in the lineup to get surfers back.

In this crowded world, Chicama has managed to avoid the commercialization that has taken over other surf meccas like Uluwatu, Jeffreys Bay and Puerto Escondido, in Mexico. There are no Chicama Pointe Condos along the point, which still looks like the surface of the moon, and is also a hideout and hunting ground for local banditos. There are a couple of inexpensive hotels in town, where surfers pay $15 to $25 a night to recover from all that surfing and walking, or wait hopefully for the next swell.

For a wave that is so good, Chicama has also managed somehow to dodge the crowds. When Joel T. Smith arrived there on a Friday afternoon in October, the Main Point was pumping from the top to town and . . . "I was the only one out," Smith said. "It was magical. Surf was shoulder high and glistening. The swell was just starting to happen." He was one of just a dozen people in the water that Saturday in October. The surfers were spread out over more than a kilometre, and a conversation in the lineup would be interrupted by a surfer catching a wave, and disappearing for an hour. Smith compared Chicama to a very long Malibu, or Pakalas on Kauai. Some people think Chicama is slow, Smith thought not: "No time for cutbacks. Just pump down the line and tuck under the sections."

ABOVE *Surf guide Carlo Rigoletto counts the crowd from the cliffs overlooking the take-off spot at Chicama. What? There is no crowd . . .*

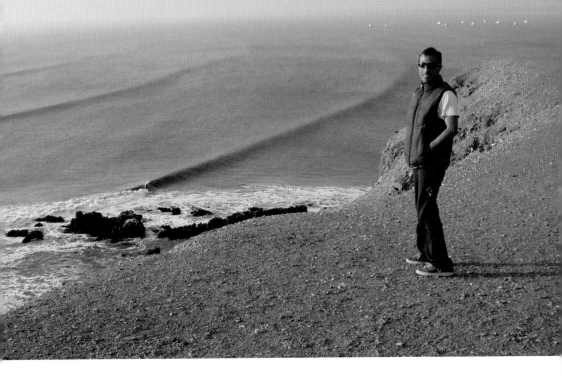

PACASMAYO

Joel T. caught countless waves from the top of Main Point to the pier, but the longest wave he caught on that trip was at another left point, further north up the coast. Pacasamayo is a long, desert point that leads down to a fishing village with a pier, just like Chicama. It makes it to number one on many lists of Longest Waves and the Peruvian surf guide book lists it as longer than Chicama's rideable section on a big day, even though Chicama's headland is longer.

Joel T. Smith has surfed three of the waves that are considered the longest in the world: Pacasmayo, Chicama and Matanchen Bay. Smith's experience was that Chicama was a cleaner, crisper wave. The downside is that it needs just the right direction and size to show its best.

Comparing both of those Peruvian waves to that place in Mexico, Smith argues that Matanchen Bay breaks rarely, and the clouds of mosquitoes, biting midges and other flying critters make waiting an agony. Smith went to Stoner's Point in 1996 arriving in a van with no air conditioning to fend off the 100 degree air and 100 per cent humidity: "The mosquitoes attacked the van. The windshield was almost black with them. We slathered ourselves with insect repellent and ran into the water. Getting back into the van was hell. Bites everywhere. Great surf but an absolutely horrid place to hang out. Ah Mexico: The land of untreated sewerage."

MESSING WITH MOTHER NATURE

IN JULY 2002, Californian Bill Sharp was the right guy in the right place at the right time with the right cameras to record an Australian making history on the world's most perfect, man-made right: Damon Harvey doing what they said could not be done, connecting the Superbank from the top at Snapper Rocks, all the way to Kirra.

Surfing pioneer Bill Sharp is no stranger to artificial waves created by the hand of man. He grew up in Newport Beach, California, riding the summer waves at the Newport Wedge, which are made by big southern swells refracting off the north jetty of Corona del Mar. It was the Australian winter of 2002, the first great season of the Superbank, when the many metric tons of sand transplanted from the Tweed River Scheme filled in and settled in. That sand might as well have been fairy dust, as it created a mind-boggling mother of a perfect point sandbar from Snapper Rocks to Kirra. This miracle of man bungling with nature was scarcely to be credited and from his view at The Outrigger hotel, Sharp had the best seats in the house.

"I was just surfed out after a really good day," Sharp said. "It was crowded, but you get five waves to yourself and you are done. I was kicking it on the balcony about an hour before sunset. There had been a few waves suggesting a link all the way, but I saw a bomb break way outside the rocks at Snapper with a guy charging backside in the slot."

From the top of a high rise in Coolangatta, Sharp had a panoramic view of the entire two kilometre miracle: from the takeoff at Snapper Rocks, through Rainbow Beach, the old Greenmount Headland, Coolangatta Beach, and Kirra. Ever the media professional, Sharp had both a still camera and a video camera at hand. Sensing history being made, he shot a sequence of still photos with a 200mm lens. When the surfer made it past the meat of the Snapper section, Sharp from his high perch could see an endless wall lining up all the way through. He put the still camera down, raced into the bedroom, pulled out a video camera and raced back to the balcony as the camera was powering up. What Sharp

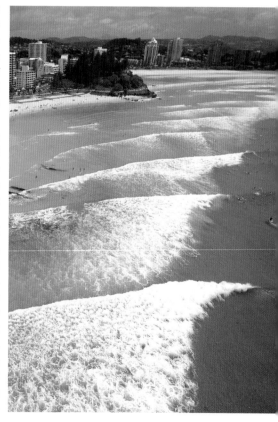

BELOW *Superbank, as seen from Snapper Rocks, looking down past Greenmount Point to Kirra. Superbank is the artificial wave that all surfers hope the engineers can make one day, but for now the best artificial waves are still accidents of geometry.*

captured was a historic video that was a combination of the Zapruder film of the Kennedy assassination and all those shaky videos of the Sumatran tsunami. If the video is shaky, it's because Sharp stood and panned slowly as the backside surfer went the distance, working over a slow but relentless wall, the entire length of the Superbank, more than two kilometres from Snapper Rock until Harvey kicked out, three and a half minutes on video, at Kirra: "Just one of those things where you see something about to happen that means nothing to other people, but having a bag full of loaded cameras makes the difference between a world record first and just another dude claiming hard at the pub."

SUPERBANK

Coolangatta point is the southernmost tip of Australia's Gold Coast. Coolangatta is Waikiki, Ipanema, Miami Beach and Atlantic City rolled into one – it serves surfers, gamblers, sun worshippers and yachtsmen, so it is in the interest of local businesses to keep the coves and beaches from Snapper Rocks down to Kirra brimming with sand. In 1965, the extension of the Tweed River training walls 380 metres to sea created a navigable waterway in the Tweed River, but it blocked sand that flowed naturally around Danger Point from south to north and kept the beaches loaded with sand. From 1995 to 1996, 800,000 cubic metres were dredged from the south side of the Tweed River and deposited at the top of Danger Point. This raised an eyebrow among local surfers, afraid their beloved surf spots at Snapper, Little Marley Point, Rainbow Bay, Greenmount Point and Kirra would be buried for the betterment of New South Wales boaters, and Queensland tourism. Surfer eyebrows were raised even higher, as Queensland and New South Wales worked on an agreement for a permanent sand diversion dredging program. The idea was outrageous to surfers and beach lovers who shrunk at the thought of mega-tons of ooky river-bottom silt being firehosed at their prized Gold Coast surf spots – especially Kirra.

The Tweed River Sand Bypass Project accomplished many things, but the most amazing thing is that it benefited and pleased just about everyone. The real estate and commercial value of the Superbank on the local economy is through the roof, and the wave is there to stay, as long as the sand keeps pumping.

OPTIMISM IN THE CHANNEL

Artificial reefs are dependent on swell. They can't create magic without materials, so you have to wonder about the wisdom of putting an artificial reef halfway up the English Channel.

In December 2007, England's Marine and Fisheries Agency granted a special environmental license to Bournemouth Council to begin construction of an artificial reef between Bournemouth and Boscombe piers. Bournemouth is on the south coast of England, about halfway between Land's End and Dover. The limited swell window in the middle of the English Channel is even smaller for Bournemouth, which is tucked away within Poole Bay and the Isle of Wight.

Stuart Matthews has been surfing England his whole life, and he says there is more surf in that area than the location would suggest: "Bournemouth reef does get swell and just 25 miles away to the west, a reef break at Kimmeridge Bay is one of the best waves in the UK – when it breaks."

Recreational studies of the area have tallied anywhere from 77 to 100 surfable days in the Bournemouth/Boscombe area, and the local hopes are that the reef will make sense of what ocean energy is available in the area and turn it into a year-round surf spot.

The reef was designed by Dr. Kerry Black of ASR Marine Systems who predicts the wave will produce a righthander that rates a 5 on a scale of 10 – with Pipeline an 8–9 on that scale. Like Narrowneck Reef (in Australia) the reef will be made of 30 metre-long geotextile bags filled with sand. The bags will be laid 225 metres out to sea, to the east of Bournemouth Pier, creating a reef the size of a football pitch – which can be as big as 90 metres by 120 metres.

However, if a vibrant new surfing community can help Bournemouth shrug off its reputation as the retirement capital of England, then the cost of construction will have been a small price to pay.

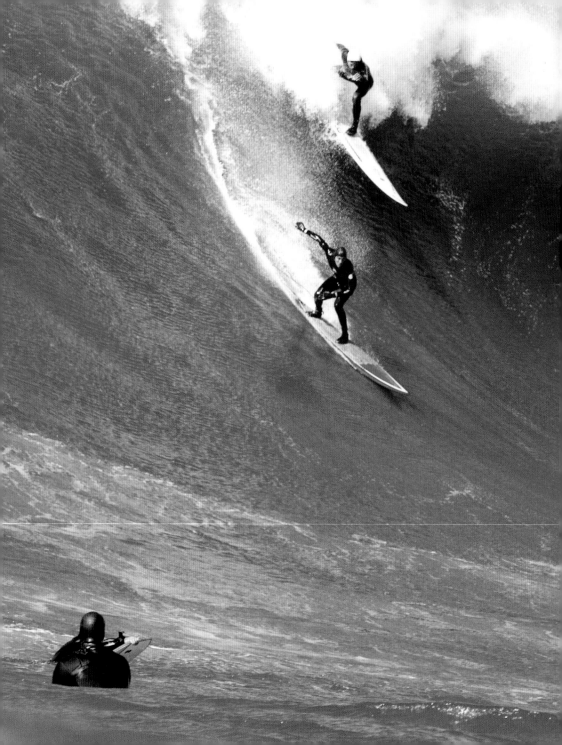

6

KILLER WAVES

PIPELINE IS LIKE AN OLD GUNSLINGER now – a quick, powerful, potentially lethal wave with a deadly reputation, challenged by upstarts with fancy names. Pipeline was first surfed in 1961, which makes the wave almost 50 years old, and for most of the last four decades it was regarded as the most dangerous, challenging surf spot in the world – the Hawaiian wave that all others were judged by in terms of power, speed and danger. In the last ten years, with the rise of spots like Teahupoo, Mavericks, Shipstern's Bluff and Cyclops, Pipeline is no longer the most challenging, but in terms of numbers, it remains the most dangerous, and deadliest.

Banzai Pipeline is the full and proper name for the spot, while the wave breaking to the right is called Backdoor. In December 1961, Bruce Brown was checking the North Shore with California surfers Phil Edwards and Mike Diffenderfer when they stopped at Banzai Beach in front of a surf spot without a name. Phil Edwards went out and rode a wave, while Brown filmed. There was a pipeline construction project nearby and Mike Diffenderfer suggested they name the break "Pipeline". Brown called the spot "Banzai Pipeline" in his movie *Surfing Hollow Days*.

Mark Cunningham worked for 29 years as lifeguard for the City and County of Honolulu and 18 of those were at Pipeline. He believes the 'birth' of Pipeline is one of the earliest hypes on record: "You really believe that a bunch of unknown Hawaiian wave sliders didn't give it a go, pre-Cook?" Cunningham said. "Come on now. You don't think some Waikiki beach boy had a session out there goofing off with his buddies or whilst trying to impress some tourist girl during a Circle Island Tour? How 'bout some crazy ass Navy SEAL from Pearl proving to his pals it was really no big a deal? The possibilities are endless."

Pipeline is a wave in the middle of the North Shore of Oahu, where open ocean swells come out of deep water and hit a reef of hardest limestone lined with coral caves. Dr. Ricky Grigg has been surfing Hawaii for 50 years and is one of the world's leading experts on coral reefs; he says the limestone base at Pipeline makes it one of the

"Half that pack went in, and about a dozen guys came running down with swim fins searching for his body. When we found him, he was up by Pupukea."

Greg Long

PREVIOUS PAGE *Gmac (right) goes big, and sometimes Gmac goes down. This is Garrett McNamara in a bad spot at Mavericks in January 2008. The next 30 seconds of his life will go like this: Fall through the air, hit water like concrete, skip like a stone, get sucked over the falls, plunge 30 feet under water into cold blackness, get tossed around like a ragdoll and make it to the surface, just in time for the next wave to do the same thing.*

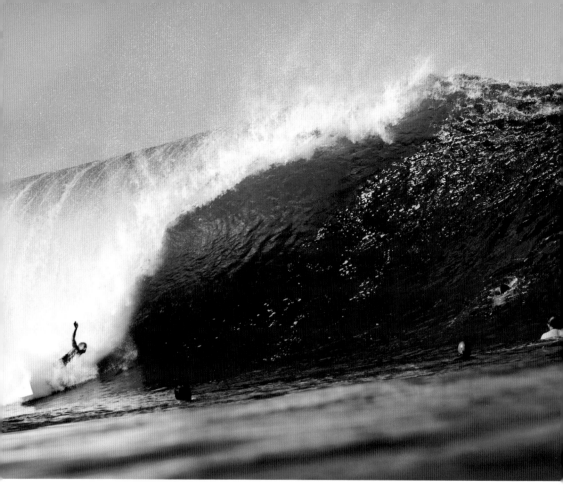

hardest reefs in the world. On top of the limestone are coral and lava formations that look like tank traps, and this is what surfers see just below the surface as they are dropping into waves that move as fast as a gunfighter drawing and firing. It is also what they try to avoid when they wipe out on a wave and fall from 10 to 15 feet above sea level and get tossed around over a reef that is only a few feet below sea level.

TRAGEDY AT THE PIPE

During the winter of 2006–2007, Shaun Tomson broke his nose on the reef at Backdoor during a Legends heat. In 1975, Tomson had been the second surfer to win the Pipe Masters riding with his back to the wave, and he was the surfer who led the aggressive attack on Backdoor – going right and getting deeper in the tube over a reef that is even shallower than Pipeline. During the Legends heat, Tomson took off on a Backdoor wave,

ABOVE *Last ride for Malik Joyeux. What looked like a standard wipeout to the dozens of surfers, photographers and spectators turned out to be fatal for the respected Tahitian charger. Joyeux hit the bottom, or hit his board, and Pipeline had claimed another life.*

pulled into a barrel, broke his board out from underneath him and broke his nose – the first time he had suffered that injury while surfing. He watched the famous final between Kelly Slater and Andy Irons from the Media area, with a bandage on his nose, smiling quietly to himself, because the Pipeline had finally got him after all those years.

While the bigger days at Pipeline look dangerous, it's the smaller days that break on the inner reef that have the most potential to kill or maim. On December 2, 2005, 25-year-old Tahitian surfer Malik Joyeux was surfing Pipeline with about 60 others on a 6- to 8-foot day. Joyeux was a respected Tahitian surfer who had won the 2004 Billabong XXL Monster Tube Award by driving through a giant tube at Teahupoo.

At around 10:30, Joyeux dropped in on the first wave of a three-wave set, and went down on what appeared to be a standard wipeout on a Pipeline wave. He dropped into a thick peak, lost his balance, fell backwards at the bottom and took the full impact of the lip. This happens all day long at Pipeline and many wonder how more people aren't hurt.

This time tragedy struck. Joyeux' board popped up, but the surfer didn't. While Pipeline is perhaps the most competitive wave on earth, surfers do keep an eye on each other and when a board came up but no surfer, people on the beach and on both sides of the wave whistled and shouted that something was wrong.

Twenty surfers risked their own necks, paddling into the impact zone to look for Joyeux, who could have been floating unconscious, or stuck in a cave: "There were about twenty of us that paddled in right away and tried to find him," Greg Long told *Surfer* magazine. "But we couldn't. Eventually half that pack went in and about a dozen guys came running down with swim fins searching for his body. When we found him he was up by Pupukea (approximately 250 metres north of the Pipeline peak). We put him on a longboard and were just scratching and kicking to get him in. But by that time it had been about 15 minutes. The lifeguards tried to do some compressions, but it wasn't working. Then they put him in an ambulance and that was the last I saw him."

Pipeline's neighbour Backdoor has also claimed its share of casualties. Where Pipeline breaks into a sandy channel, Backdoor breaks over an increasingly shallow rock reef that sometimes exposes itself dry to surfers as they flash past.

JACK JOHNSON

Jack Johnson was on the road to every Hawaiian kid's dream – the travelling life of a professional surfer – but a collision with the reef at Pipeline rearranged Jack's face, some of his teeth, and also his career path.

Jack was born in 1975 and grew up on the beach at Pipeline. Just outside his backdoor there was a T. Rex that Johnson was eventually going to have to deal with, and he first surfed Pipeline at 10 years old. He was 17 years old when he made the local trials of the Pipeline Masters – a major accomplishment for a Hawaiian kid. Johnson was in the four-man final with Pipeline greats Liam McNamara (brother of Garrett), Johnny Boy Gomes and Michael Ho, but he did not advance to the main event.

Two weeks later, Johnson wiped out at Pipeline, hit the reef and came up missing teeth and needing 150 stitches in his head. During his two-month recovery, Johnson worked on his music, taking the time to hone guitar chops he had been working on since he was 14. At UCSB Johnson played rhythm guitar for a party band called Soil, and got to know California waves. While Johnson's friend Kelly Slater and his peers dominated pro surfing, Johnson graduated from UCSB with a film degree in 1997. In 1998 he produced the surf movie *Thicker Than Water* with the Malloys – surfing brothers from Ventura who had also taken their lumps at Pipeline. In 2002, Johnson and Kelly Slater produced the surf movie *September Sessions* and that same year Johnson recorded *Brushfire Fairytales*. The album went platinum, and that was followed by *On and On* in 2003, which sold over a million copies. It's possible that none of it would have happened if Johnson hadn't nearly wiped his face on the reef at Pipeline in 1992.

That danger came true on February 9, 2005 when 33-year-old North Shore photographer Jon Mozo disappeared while taking photographs from the water at Backdoor. A friend alerted lifeguards that Mozo had disappeared, and Mozo was found on the bottom with massive head injuries. He was pronounced dead at Kahuku Hospital, leaving behind a wife and four kids.

The crowd on both Pipeline and Backdoor magnifies the danger. With several webcams pointed at Pipeline 24/7 and hundreds of camera lenses, the extra attention puts a double or triple layer of surfers and bodyboarders on the peak, on top of the local surfers who are just there to get barrelled. The crowd forces less experienced surfers to take waves that no one should go anywhere near, and to have that many surfers in a dangerous area inevitably leads to collisions and injuries. The list of injuries goes back to the 1960s – some of the casualties, like Gerry Lopez and Greg Noll, are well known, most however are anonymous guys who left the beach missing chunks of skin or teeth.

In November 2005, Pipeline local Tamayo Perry was badly injured by the discarded board of another surfer while surfing a big day at Pipeline: "I got scalped, brah," Perry said to Chris Cote. "It was from someone else's stupidity, too. His rail just split my melon wide open, it's the gnarliest gash ever. I knew something hit me but I didn't know how bad it was. Then Kalani Robb paddled up to me and I could tell by the look on his face that I was in trouble. I was that close to getting medi-vac'd by helicopter outta there and having metal plates in my head."

Perry made it to the beach, and to the hospital, but he was left with a permanent scar, which he now covers with a helmet when he surfs Pipeline.

In January 2007, Japanese surfer Moto Watanabe became a victim when crowd pressure forced him to take a wave that then killed him. According to Scott Basham, who wrote an account for www.surfermag.com, Watanabe stayed out in the water at Pipeline as a good 8- to 12-foot swell from the day before deteriorated with a northerly change in direction and a treacherous bump appeared on the wave faces.

Watanabe was an outsider on the fringe of the Pipeline pecking order, so he boldly/foolishly paddled into waves where angels fear to tread. East Coast ripper and self-described Pipe "scrapper" Jesse Hines, had been chatting with Watanabe just seconds before the fateful 8-footer loomed: "The wave looked good at first, but just transformed into a monster," Hines said. "Even a boogie-boarder couldn't have made that drop." Watanabe grabbed his rail and tried to power his way backside into the left, but the wave hurled itself outward, the lip seemingly thicker than the wave was tall. He was wiped out in the lip by a bump and was driven head-first into his board in only three feet of water. Ironically, it was the first season he had chosen not to wear a helmet.

Watanabe was brought to shore alive, then passed into a coma on the ambulance ride to the hospital. After 11 days on life support, Watanabe's parents, who had flown from Japan, made the decision to remove the life support.

MAVERICKS CLAIMS A LEGEND

In 1994, Mavericks became world famous when it drowned one of the most experienced big-wave surfers in the world, the Hawaiian surfer Mark Foo. Foo had flown to California the night before with Ken Bradshaw and Brock Little to check out this *haole* wave, that was making so much noise and challenging Hawaiian supremacy. This was a big but not huge day, and Foo rode well until he took what looked like a standard wipeout on a big but not giant wave. He went down and disappeared, but Mavericks is such a huge area that is so far from shore, no one noticed he was missing.

As the beautiful day grew windy and stormy, a photo boat full of surfers heading back into Pillar Point Harbor passed a piece of Foo's surfboard floating on the water. Surfers then saw Foo's body floating just under the surface. It is thought that Foo's surf leash snagged on the rocky reef after he wiped out and Foo was unable to free himself.

The death of Mark Foo began to establish Mavericks as one of the deadliest waves in the world. One year after his death, almost to the hour, a group of Hawaiian surfers paddled out at Waimea Bay for an informal tribute and goodbye to their friend Mark Foo. Around that time, California surfer Donnie Solomon was riding a big but not huge day at Waimea Bay. Solomon knew what he was doing, but he got caught inside, paddling out in a bad spot when Hawaiian surfer Kawika Stant was dropping in. Solomon didn't want to bail his board in front of the Hawaiian surfer, so he tried to duckdive the wave – pushing through a huge mass of water to get to the other side. Solomon went backward over the falls, and disappeared. There were dozens of eyes watching, but Solomon wasn't noticed missing until his board was seen floating in the middle of the bay. Photographers on jet skis and lifeguards from shore rushed out to rescue, but it was too late, and the second experienced surfer drowned in two years.

Todd Chesser was one of Hawaii's most experienced big wave surfers in the 1980s and 1990s. He was coming up as surfers began experimenting with jet skis to tow in to waves, but Chesser was one of the holdouts against this new innovation. Waimea was too crowded so he started surfing Oahu's outer reefs, but when the outer reefs were invaded by floating buzzsaws, Chesser felt the squeeze.

In February 1997, Chesser was on Maui, waiting in the wings to perform a dangerous stunt for the finale of the waxploitation movie *In God's Hands*, which used the conflict between traditional surfers and motorized tow surfers as the dramatic theme. Chesser was supposed to go over the falls on purpose for the cameras, and he had the skills to make it look good and come out with his skin. But the stunt involved towing in behind a jet ski, and that didn't sit well with Chesser. It could have been the reason he decided to bail out on the stunt – and the money – and fly back to Oahu.

On the morning of February 13th, Oahu Civil Service workers were warning residents of the North Shore about a rising swell. Chesser was warned but he grabbed friends Cody Graham and Aaron Lambert and paddled way outside to an outer reef called Outside Alligators. There were no jet skis on this day at Outside Alligators and

BELOW *Santa Cruz surfer Darryl "Flea" Virostko is one of the best big-wave surfers in the world, a little big man known for taking off on whatever the ocean throws at him. Flea has survived truly horrendous wipeouts at Mavericks and many of the world's biggest surf spots. This is Flea in the middle of his now-famous "Flea Flicker" wipeout at Waimea, during the Quiksilver in Memory of Eddie Aikau Big Wave Event at Waimea Bay.*

that became an irony, because if there had been, Chesser probably wouldn't have drowned. The fast-rising swell that meteorologists had warned about was coming up as the surfers were getting out there, and before they could get their bearings and their lineups, a giant set came through and caught all three surfers inside. The last thing Cody Graham saw was Chesser standing up on his board and diving off in the face of a mountain of whitewater. Graham and Lambert were driven so deep they nearly drowned, and when they came to the surface, they found Chesser floating unconscious on the surface.

Had there been a jet ski in the lineup, Chesser would have been to shore in minutes. Instead, his friends struggled for 45 minutes to paddle the unconscious surfer to shore. At some point they lost their grip on Chesser, and lifeguards who had been alerted, found Chesser and his board washing around in the rocks. Attempts to revive him failed and he became the third experienced surfer to die in four years.

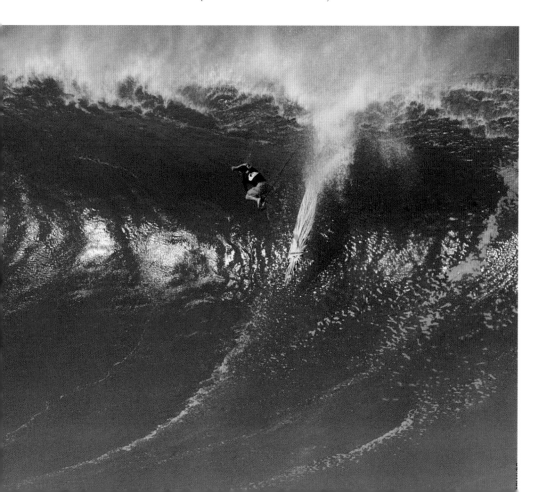

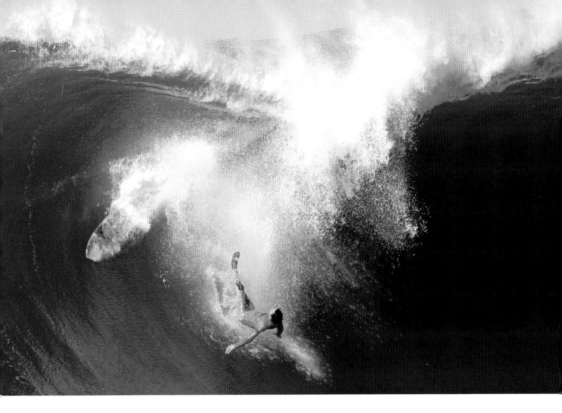

TEAHUPOO

Look at surf magazines or watch surf videos or YouTube and you will see surfers and bodyboarders in horrendous positions around the world: Going over the falls onto the reef at Teahupoo or Cyclops, getting held down by two waves at Mavericks and Dungeons, getting hit by the lip 100 miles out to sea at Cortes Bank. All around the world, surfers are getting lip-launched, pounded, beat down, held down, clocked, worked and otherwise pummelled by waves that make Pipeline look innocuous.

Teahupoo would appear to be a challenger for the most dangerous and deadly wave, whether it's a jet ski going over the falls and nearly taking off the head of Raimana van Bastolear in 2005, or the horrendous wipeouts taken by Garrett McNamara and others as they tow into what is generally considered the heaviest wave on earth. In 2000, a local surfer named Briece Taerea was killed when he tried to duck-dive through the back of a giant wave, got sucked over onto the reef and was knocked into a coma.

GHOST TREES

In December 2007, one of the biggest west swells in 20 years swept the entire Pacific from northern California to Hawaii. Mavericks, Waimea Bay, Jaws, Todos Santos and

ABOVE Not the best way to experience Mavericks. In fact, it's one of the worst. Falling backward out of the lip on a big day at Mavericks is about as much fun as chucking yourself backward out of a moving car. Water feels like concrete when it's all drawn up tight in a big wave. This surfer is going to smack his head, crack his neck, wrench his back, not penetrate under water, go over the falls and be held down for a good 20–30 seconds. And hopefully there isn't a second wave to do it all again.

Ghost Trees all had some of the biggest waves ever seen. Along 17 Mile Drive, crews of tow surfers were boldly whipping into 30-foot-plus waves at Ghost Trees, a giant wave that breaks frighteningly close to the rocks and allows almost no room for mistakes.

While most surfers were tow surfing, Santa Cruz surfer Anthony Tashnick and 45-year-old Carmel surfer Peter Davi tried to paddle in. With all the water moving and the offshore winds blowing, catching a wave with human power was almost impossible.

At some point, Davi broke his leash and started swimming to shore. A tow team offered Davi a ride to shore but he refused, and he also refused an offer of a Personal Flotation Device. Swimming in cold water, in what was probably a 4mm-thick wetsuit, through giant surf, will tire even the youngest and strongest.

Davi disappeared from the lineup as the tow surfers continued to challenge a giant day: "We are always watching each other's back," said Don Curry, a Carmel surfer who had known Davi for years and had who had been quietly checking the limits of this wave closer to home. "We are extremely aware of everyone in the game. But when you paddle in, you are not really in the same game, because you are way inside."

Some time later, Santa Cruz surfers Anthony Ruffo and Osh Bartlett saw a body floating in a kelp patch. They swam to the body and discovered it was their friend, but he was beyond hope.

Dickie Cross drowned at Waimea Bay in 1943, and then for the next 50 years, not one experienced, well-known surfer died in big surf. Since 1994, surfing has lost Mark Foo, Donnie Solomon, Todd Chesser, Malik Joyeux and Peter Davi. These were all experienced guys, who knew what they were doing and the ocean still claimed them.

Mark Cunningham no longer works at Pipeline, but he still has a finger on the pulse of the spot. According to Cunningham, the City and County of Honolulu Ocean Safety division has daily log sheets for every lifeguard tower on the island for the last 30 years. There are also Incident Reports for every first aid, rescue and/or drowning, but in these lawsuit-happy times, the City and County are reluctant to share this information.

Speaking to Tim Ryan in the *Honolulu Star Bulletin*, Cunningham estimated that he'd saved hundred of lives while "losing about six . . . There are a lot of lifeguards who have made a lot of rescues. Doesn't make any difference how many you save, you never forget the ones you don't."

> "Doesn't make any difference how many you save, you never forget the ones you don't."

Mark Cunningham

BELOW *Longtime Pipeline lifeguard Mark Cunningham keeps his eye on the waterline.*

JUST WHEN YOU THOUGHT IT WAS SAFE ...

ON AUGUST 28, 2007 Todd Endriss was in the perfect time, place and position to get jumped by a white shark. The 24-year-old Monterey County resident was paddling out at Marina, a surf spot deep within Monterey Bay, and well within the Red Triangle of northern California. Endriss was one of about half a dozen surfers in small surf, breaking in less than 10 feet of water. There were a lot of dolphins in the water, swimming close, acting strange. Endriss had just caught a wave and was most likely setting off a lot of vibration as he paddled back out when a white shark, estimated to be 12 to 14 feet long, struck with tremendous force. Before Endriss knew what had hit him, the shark bit him twice, shook him, thrashed around and then disappeared, leaving Endriss bleeding profusely from his upper torso, and the other surfers in the water wondering whether to rescue Endriss, or move to Montana.

Endriss had the presence of mind to get on his surfboard and paddle in, trailing blood to the beach where some surfers made makeshift tourniquets while others kept him warm and elevated, and others called for help. Paramedics arrived none too soon and within an hour, Endriss was taking the helicopter ride to the Burns Unit of the Santa Clara Valley Medical Center. The shark had just missed his spine and his femoral artery and left his pleural sac exposed. Endriss lost half his blood, but he survived.

If you go by the book *Shark Attacks of the 20th Century From the Pacific Coast of North America*, then Todd Endriss's attack was by the book. He was attacked between August and November, in less than 10 feet of water, in water temperature between 10 and 15°C (50–60°F). Endriss was the guy who moved, so he got attacked.

At the end of the twentieth century, Ralph S. Collier compiled all the recorded shark attacks from Mexico to Canada, detailed each attack and then did a statistical analysis, looking at the attacks in about two dozen variables: time of day, activity, water depth, water clarity, sex of victim, etc. Out of 108 reported attacks from 1926 to 1999,

"I thought the shark was either going to eat me right there or I was going to fall in, lose my board and have to swim a mile to shore."

Vic Calandra

Collier came up with these statistics: 46 per cent of the attacks were on divers, and 38 per cent were on surfers. Collier also found that attacks on people occurred in every month of the year, with a peak during August, September and October. There were 16 reported in October, 17 in August, and 21 in September. Surprisingly, considering how big white sharks are, Collier found that of the 30 reported attacks against surfers, 77 per cent occurred where the water depth was 6 to 18 feet.

Of those 108 attacks from 1926 to 1999, only eight were fatal. Already in the twenty-first century, Collier has 37 authenticated unprovoked shark attacks on humans listed on his website, including two fatalities. Of those 37 attacks, 30 were on surfers and one was on a paddleboarder. The two fatalities were a female swimmer at Avila Beach in August 2003, and a free diver near Fort Bragg in August 2004. Those 37 attacks in the last seven years represented 65 per cent of the total number of attacks reported during the last 100 years.

BELOW *Don't let the smile fool you. Mr. White is the stuff of nightmares, the monster under your bed, the ghost in the closet. A ton of trouble. A mini-submarine with teeth. You have a better chance of being hit by lightning but still, the spectre of shark attack is on the minds of every surfer who enters salt water.*

HIT AND RUN, BUMP AND BITE, SNEAK ATTACK

What sounds like the names for potent cocktails are actually the three kinds of shark attacks, as categorized by George Burgess of the Florida Museum of Natural History. Burgess categorizes shark attacks into "hit and run", "bump and bite" and "sneak attack" and points to three sharks as responsible for the majority of the attacks on humans: the white shark (*Carcharodon carcharias*), tiger shark (*Galeocerdo cuvier*) and bull shark (*Carcharhinus leucas*).

The most common shark attacks are "hit and runs". These usually occur close to shore, in turbid water, where sharks hunting for prey often meet in swift collision with swimmers and surfers. Sharks will attack by sight, vibration and smell, but in the surf zone, smell and vibration are cut down by background noise and so sharks respond to

BELOW *This table shows statistics of confirmed unprovoked shark attacks, as compiled for the Global Shark Attack File http://www.sharkattackfile.net/*

THE FIN FILES

WORLD 1580–2007			
Total attacks	2,198	Fatal attacks	471

UNITED STATES 1670–2007			
Total attacks	993	Fatal attacks	54

CALIFORNIA 1926–2007			
Total attacks	95	Fatal attacks	7

FLORIDA 1882–2007			
Total attacks	577	Fatal attacks	13

HAWAII 1828–2007			
Total attacks	113	Fatal attacks	15
Maui	36		3
Oahu	34		6
Kauai	19		2
Hawaii	12		4
Molokai	5		0
Unspecified	7		0

NORTH CAROLINA 1935–2006			
Total attacks	31	Fatal attacks	4

SOUTH CAROLINA 1837–2006			
Total attacks	56	Fatal attacks	2

TEXAS 1911–2007			
Total attacks	33	Fatal attacks	3

BRAZIL 1931–2007			
Total attacks	89	Fatal attacks	21

BAHAMAS 1749–2007			
Total attacks	26	Fatal attacks	1

ANTILLES 1749–2007			
Total attacks	39	Fatal attacks	18

MEXICO 1880–2007			
Total attacks	37	Fatal attacks	20

SOUTH AFRICA 1905–2007			
Total attacks	214	Fatal attacks	41
Natal	91		27
Eastern Cape	83		6
Western Cape	39		8
Unspecified	1		0

AUSTRALIA 1700–2007			
Total attacks	343	Fatal attacks	136

NEW ZEALAND 1852–2007			
Total attacks	47	Fatal attacks	9

ASIA 1580–2007			
Total attacks	117	Fatal attacks	55

OCEANIA AND PACIFIC ISLANDS 1925–2007			
Total attacks	125	Fatal attacks	51

EUROPE 1847–2007			
Total attacks	39	Fatal attacks	19
Italy	13		4
Greece	9		8
Croatia	5		4
France	4		1
Spain	4		0
United Kingdom	2		0
Malta	2		2

bright flashes and colour contrasts. Bathers wearing jewellry, or contrasting swimsuits, or bathers who have skin tone contrasts from their tan lines can easily be mistaken for prey. Sharks attack quickly, realize their mistake and then swim off. The victims are left with lacerations to their feet and legs, with no idea of what hit them.

MAN FIGHTS SHARK

In August 2007, a 47-year-old paddleboarder experienced the second kind of shark attack, the "bump and bite" and it was the stuff that nightmares are made of. Vic Calandra was competing in a paddleboard race from Zuma Beach to Surfrider Beach, California. He was standing up on an 18-foot paddleboard and propelling himself forward with an oar. Coming around Point Dume, Calandra headed straight for Surfrider which put him about a mile off Corral Beach. Calandra heard something behind him and saw a fin. This happens often around Malibu, but it's always a dolphin. This time it wasn't, and Calandra steered away as the 14-inch shark fin followed him.

ABOVE *British tourist Chris Sullivan is wheeled through a Cape Town hospital in March 2005. Sullivan suffered lacerations after he was attacked by what is believed to have been a Great White shark while he was surfing off the city's Noordhoek beach.*

Calandra's first thought was "Oh F***!" He steered away from the shark, which tracked him and then closed the distance. Standing up, Calandra got a very good look at a white shark nearly as long as his 18-foot paddleboard. He was at least a mile out to sea as the shark did several passes around and under his board, showed its stomach as it passed by and then came back and began bumping the paddleboard: "I thought the shark was either going to eat me right there," Calandra said, "or I was going to fall in, lose my board and have to swim a mile to shore with an oar in my hand and a shark in the water." Calandra alternated between kneeling on the board to keep from falling in, and standing to see where the shark was, and slapping at it with this oar. This went on for several long minutes until other paddlers heard Calandra's cries for help.

Joey Everett is an LA County Lifeguard who was competing on an 18-foot prone paddleboard. He steered toward the distress call. As he approached Calandra, he saw the paddler hitting the water with his paddle, and the fin and back and head of a large white shark: "Vic said the shark was about 15 feet long and I told him not to fall in," Everett said. "We were too far outside to run for it, so I went by the book."

The book dictates that when a shark is acting aggressively and you can't get away, act aggressively back. White sharks zero in on vibration with sensors in their snouts and jaws: "Ampullae are electro receptors that function only when the shark is within one metre of the source," Ralph Collier said. "Vibrations are picked up by the lateral line." Only sharks know how sensitive these places are, but Everett took a chance and rammed the shark with his paddleboard, then began beating on that big snout with his fists: "It was like a barfight," Everett said. "I was whaling on it with my fists, and Vic was whacking it with his oar, and the thing still wouldn't go away."

After several minutes of tussling, the shark seemed to be scared off by Calandra slapping the water with his paddle, leaving the two adrenalized surfers a mile out to sea. They paddled for shore, watching each other's backs in fear of the third kind of attack,

the sneak attack: "We thought of all those Discovery Channel Shark Week shows where the white shark comes rocketing out of the water like a Polaris missile," Everett said. "So we hopscotched each other and made it to a small fishing boat that had a radio. I got on it and called Baywatch and that was the end of my race."

They sent the Baywatch boat and some jet skis to warn the other paddlers there was a white shark with a bloody nose in the water. Vic kept going and finished the race. He still isn't sure why he stayed in the water after all that.

Other shark researchers don't see shark attacks divided up in quite the same way. Sean van Sommeran of the Pelagic Shark Research Foundation thinks that: "So called 'bump and bite' is often an investigation of an item or object the shark is unsure or curious about. Often time it is a bump and circle event without any bite actions. It's good news if the shark shows itself. When they mean business, they close from a distance at speed, and they can do this at any angle. Sometimes they 'tap' on items with their teeth like someone tapping fingernails on a beer bottle."

Shark bites are typically cautious as the sharks don't like to break their teeth for no good reason, hence the bump and close inspection which involves sight, smell and 'electro-magnetic scanning' of a target. "Contrary to popular belief, white sharks have hard heads capable of taking hits, cuts, etc," van Sommeran said. "The shark's nose is sensitive but not easily damaged and I've seen large seals bite sharks right on the face/nose and the sharks press on like a machine, seemingly unconcerned with the seal's efforts to injure it or fend it off. Even adult elephant seals well over a thousand pounds."

MR. WHITE TAKES A HOLIDAY

White sharks in the Hawaiian Islands are a curiosity, but tiger sharks are the real threat from Niihau to Kauai. Where the majority of white shark attack victims survive because of the attack pattern of those sharks, tiger shark attacks often end in dismemberment and death. Sea turtles are a great delicacy to tiger sharks – like a big green bon bon, soft on the inside, crunchy on the outside. Sea turtles have been protected since the passing of the Endangered Species Act of 1973 and they are everywhere in the Hawaiian Islands, passing through the surfline from Haleiwa on Oahu to Honolua Bay on Maui to Hanalei Bay on Kauai – and making surfers nervous.

Perhaps the most famous shark attack of the last 20 years involved a tiger shark on the north shore of Kauai. On October 31,

BELOW Do you trust technology enough to put it between you and Mr. White? The Shark Shield SURF is Aussie technology, an electrical package that attaches to the tail of any surfboard and trails electrodes in the water. According to a company press release: "The unit generates an electrical field that is detected by the ampullae of Lorenzini, found on the snouts of sharks. Once detected by the shark's sensors, the field causes muscular spasms that result in the shark being deterred from the area." Cost for peace of mind? About $700. But will the electrodes throw better spray on turns?

2003, 13-year-old Bethany Hamilton was surfing at Tunnels Beach with friends Alana, Byron and Holt Blanchard. At 7:00 in the morning, Hamilton was lying on her board with her left arm in the water when she was the victim of a sneak attack by a 14-foot tiger shark. The shark took off Hamilton's left arm in a flash, and was gone. Hamilton was helped back to shore by her friends, who made a tourniquet for her arm with a surf leash and took her to the hospital.

This was the sneak attack broadcast around the world, and the story continued, as Hamilton showed immense grit and was back surfing only 10 weeks after the attack. To see Bethany Hamilton surfing with only one arm is to be deeply impressed by her tenacity, and to wonder how good she would be if she hadn't been the victim of a hit and run at 13. Hamilton survived her shark attack in the Hawaiian Islands, but others have not been so lucky.

Surfers who go into the waters along the shores of Hawaii are well aware of the shark danger, but surfers had dodged any attacks until 29-year-old Bryan Adona disappeared while bodyboarding west of Waimea Bay in February 1992. His body was never recovered, but the next day his bodyboard was discovered with a 16-inch bite mark that was identified as a large tiger shark.

In November 1992, an 18-year-old bodyboarder named Aaron Romento was attacked by a tiger shark and killed while surfing at Ke'eau Beach Park on the west side of Oahu, near Makaha. Daniel McMoyler disappeared in December 1993, while surfing along Oahu's southwest shore. His remains washed ashore near Waipio a month later. Thirteen years later in March 2006, 28-year-old Canadian surfer Elizabeth Dunn was bitten by a shark while surfing at Leftovers on the North Shore of Oahu and that same month, a seven-foot shark swam through the lineup at Pipeline and cancelled the final bodyboarding heat of the T and C Surf Women's Pipeline Pro.

"The shark took off Hamilton's left arm in a flash and was gone."

SOUTH AFRICA:

In July 2000, a young South African surfer named Shannon Ainslie was jumped by not one but two adolescent white sharks while surfing at Nahoon Reef, near East London in the Indian Ocean, on the Eastern Cape of South Africa. White sharks ganging up like velociraptors was unusual, but what was even more unusual about this attack is that someone caught it on video. The surfing and the civilian world saw the repeated image of a young surfer being stalked by two white sharks coming up through a breaking wave to get him. Shannon Ainslie survived that attack with no more than a cut hand. A while after, Ainslie was in the water at Jeffreys Bay during the Billabong Junior surf contest when another young surfer was bumped by a shark and he stayed in the water to come to that surfer's aid.

Ainslie's experience highlights what all surfers know about South Africa, but a lot of South African surfers believe is an overstated myth about their country – the place has lots and lots of sharks. It's rare to find a South African surfer – or a visitor to South

Africa – who hasn't had a personal close encounter, or a friend who's been in contact with a shark. Hawaiian surfer Brock Little has a very vivid memory of surfing out at Jeffreys Bay in the 1990s and watching a local surfer sitting upright on his board and praying with both hands as he was circled by a large shark.

South Africa has the Indian Ocean running along its east flank and the Atlantic on its west, and the range of water temperature makes it home to tropical and temperate sharks. According to Steve Pike, the author of *Surfing South Africa*, these include a number of species that have been known to attack people. The bulk of attacks come from the ragged tooth, tiger, Zambezi (bull), hammerhead and great white sharks.

The Zambezi shark is the South African name for a bull shark. They are so named because they sometimes travel up rivers such as the Zambezi to look for food. Zambezi sharks prefer the warmer waters of the KwaZulu Natal region and Transkei and are a particular threat around river mouths. South Africa's tiger sharks also prefer the warmer waters of KwaZulu Natal which is the most northerly province on the eastern cape, in the Indian Ocean. Durban is at a latitude of 29 degrees south and Cape Town is at 33 degrees south, but Cape Town borders the colder Atlantic and Durban the Indian Ocean, so the shark threat in these two places is very different.

Ralph Ellison of California's Shark Research Committee knows California's white sharks well and has performed research in South Africa that has led him to believe that South Africa's white sharks are sleeker, leaner and faster than their California cousins. White sharks in South Africa still share a preference for water temperatures between 10 and 15°C (50–60°F), which make them a threat in the southern provinces, close to the tip, around the Western Cape and Cape Town – which is on a similar latitude to Los Angeles, but with colder water.

Both Steve Pike and Greg Bertish, the owner of True Blue Surf and Adventure Travel in Cape Town downplay the shark threat in South Africa: "There are so many sharks here and so few attacks, really," Bertish said. "During the season, from September to February, the shark spotters see great whites almost every day. They patrol the back line, but very rarely are they interested in the many surfers close by in the water every day."

Author Steve Pike grew up in the Transkei region, which is on the Eastern Cape and begins just north of East London. The Transkei has many rivers running to the sea, which have always been danger areas for shark attacks, because sharks hang around the river mouths to feed, and murky water often leads to mistaken identity, and attacks. Timing is important if you need to minimize the risks of a shark encounter when surfing the east coast of the country. The best times of the year are autumn, winter and early spring, between March and October.

When South African surfers are asked to point to the sharkiest spots, they often name Breezy Point in the Transkei, which is also called Ntlonyana. Surfer Alex Macun

ABOVE *Bethany Hamilton ripping Haleiwa on the North Shore of Oahu. Haleiwa is a hard enough wave with two arms. To see Bethany surfing the place on a big day is to be amazed at her talent and tenacity. It makes you wonder how good she would be with two arms, and how far she will go with one.*

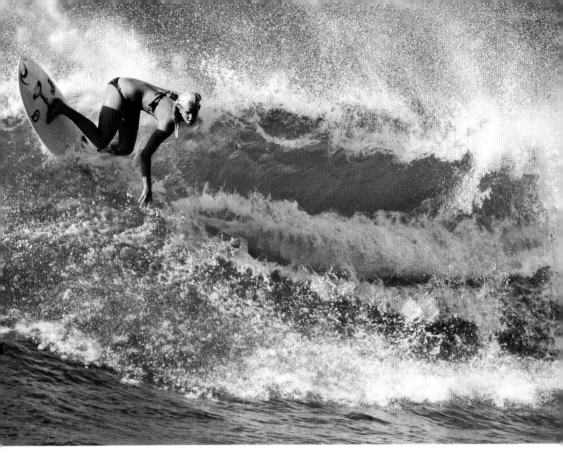

was killed by a shark there in the winter of 1982, and in May the year before Simon Hammerton had to have his left leg surgically amputated after an attack.

South Africa has a number of outer reef spots where giant waves break way out to sea in cold, deep water, near seal rookeries where sharks hang out looking for a snack. All surfers who have ridden Dungeons comment on the presence of sharks, but Greg Bertish insists that up until the time of writing there has been no recorded attack. Within False Bay there are a number of outer reef breaks with almost mythic reputations in South Africa, both for the size and danger of the wave, and the sheer number of white sharks in the water. The population of white sharks in South Africa has been estimated at 2,100, and that number has been growing steadily since the white shark was designated a protected species in 1991. Sharks are a constant presence in all South African waters yet South African surfers still take the risk, like playing baseball in a field ringed by lions.

WATCH OUT FOR THE NOAH

When Bruce Brown went to Australia for *The Endless Summer*, he found great waves, pretty girls in skimpy bikinis, "blokes with funny accents" and a lot of sharks. "They call sharks the men in the gray suits here in Australia," Brown narrated as the surfers watched the silhouettes of several sharks in a place they wanted to surf. Australians also call sharks "The Landlord" and "Noah's," which is short for "Noah's Ark," rhyming slang for shark. What was true in 1964 is truer now. The table below shows statistics of confirmed unprovoked attacks, as complied for the Global Shark Attack File:

State	Total	Fatal	Last fatal attack
New South Wales	140	61	1993 Byron Bay
Queensland	103	38	2006 N. Stradbroke Island
Victoria	24	7	1977 Mornington Peninsular
South Australia	29	14	2005 Glenelg Beach
West Australia	37	10	2005 Houtman Abrolhos Island
Northern Territory	2	2	1938 Bathurst Island
Tasmania	8	4	1993 Tenth Island
Overall Total	**343**	**136**	

Shark attacks can happen anywhere in Australia, but if you ask Australian surfers to name shark-sketchy places, 90 per cent of them will name either South Stradbroke Island in Queensland, or Cactus in South Australia. Cactus is a surf spot in the back of beyond, well off the beaten track (which in this case is the Eyre Highway). To get to Cactus, it's 791 kilometres from Adelaide to Ceduna, then go off the track for 71 kilometres to Penong, and then follow lonely dirt tracks for another 20 kilometres to Cactus. The main surf spot there is Caves, which breaks into a deep channel that is known as a popular hangout spot for very large white sharks.

Cactus is infamous for sharks throughout Australia but when Australians talk about shark attacks at Cactus, the one they all seem to remember is, "The Honeymoon Guy". The Honeymoon Guy was a 25-year-old New Zealand surfer named Cameron Bayes, who went out early on Sunday September 24, 2000 to catch the surf while he had the beach to himself. Just after 7:15 a.m. he was hit by a 16–18-foot shark that launched itself out of the water at him. It dragged him and his board down, shook him and hauled him 400 metres out to sea where it thrashed his board away.

Tina Bayes witnessed the attack, and went to hospital suffering from severe trauma. Mr. Bayes's body was never found. The whole incident was reported in detail by an Australian coroner as there was no body to confirm death, but several people witnessed the gruesome event.

The Honeymoon Guy was neither the first nor the last fatal attack at Cactus, and that spot is now infamous in the surfing world for being one of the sharkiest surf spots.

The day after Cameron Bayes was attacked, 17-year-old Jevan White was killed by a shark at Black Point, near Elliston, South Australia, to the west of Cactus.

One of the pieces of advice Ralph S. Collier gives in *Shark Attacks* is to avoid spots where multiple attacks have occurred. For South Africa that would be Breezy Point, Jeffreys Bay and Nahoon Reef. For Australia, it's Cactus and South Stradbroke Island. For Hawaii, the west side of Oahu around Makaha is a good place to avoid, as is Olowalo (Thousand Steps) on Maui and perhaps all of the North Shore of Oahu.

For California, there are several spots within the Red Triangle that have been the scene of multiple attacks. Bolinas Lagoon, Stinson Beach, Salmon Creek and Mavericks are all contenders, but if you really want to have a close encounter, Dillon Beach at the mouth of Tomales Bay is the place. Tomales Bay is a long, protected fjord in Marin County, known to be a breeding ground for adult white sharks. Great Whites get hungry after sex and at the mouth of Tomales Bay is a long sandbar left called Shark Pit. It has been the scene of nine shark attacks.

In October 1996, 21-year-old surfer Mark Quirt survived a severe mauling by a white shark at the mouth of Tomales Bay. This one was by the book, as well. It happened in October, Quirt was in 10 feet or less of water, he was a surfer and he survived. The difference about this attack was related by local surfer Dale Webster: "Mark told me the jowls of jaws made a roar while it was attacking. He can still hear it."

BELOW *Australian surfers have to contend with sharks not found in South Africa, Hawaii or California. Wobbegong is an aboriginal Australian word for a carpet shark. These sharks are bottom dwellers that can grow as big as 10 feet, but are generally not aggressive. Most attacks occur when humans step on them. The sharks are very flexible and can bend back and bite a hand that has them by the tail. The bronze whaler is also known as the copper shark or the narrowtooth shark. They are aggressive predators that come close to shore to chase schooling fish like salmon and that puts them in close proximity to surfers.*

SURF AND TURF

SURFING LOCALISM TAKES MANY forms, from verbal threats to punchouts to torched cars, but the general definition of localism was laid down by Matt Warshaw in the *Encyclopedia of Surfing*: "Territorial practice whereby resident surfers in a given area try to exclude nonresident surfers through threat, intimidation and occasionally violence; a predictable, if rarely defensible, surf world response to overcrowding."

RIGHT *What Would Jesus Do? If he grew up surfing a spot with his friends, and then all of a sudden found it overrun by outsiders, taking his waves? This is how the surfers of Pleasure Point think Jesus would have handled it.*

That is the definition for a dirty business which includes theft, vandalism, gangs, terroristic threats and physical violence. Everything from graffiti to murder, and which has spread across the surfing world from Angourie to Zihuatenejo. It's possible surfers in old Polynesian Owyhee protected their spots from other villages and islands, and maybe that old Hawaiian territorial imperative was behind the greeting that the first waves of "coast *haole*" got when they made their way to the Hawaiian Islands in the 1930s, 1940s and into the 1950s. The aloha spirit was not always there, and surfers like Tom Blake, Gene "Tarzan" Smith, Tommy Zahn and Greg Noll were harassed and even beaten up by Hawaiian surfers in the late 1940s: "You know, when a *malahini* (foreigner) finds himself in the Islands," Zahn was quoted in the *Surfer's Journal*, "first it's the big handshake and the Good Time Charlie . . . once they find out you're going to hang around then you go through a whole new phase."

In California, surfers for the most part were just getting along. From the 1940s into the 1950s they were such a rare breed that when one car full of surfboards passed another car loaded with surfers, both cars would stop and talk, compare notes, maybe go driving off in the same direction together.

In 1947, Joe Quigg's custom Malibu Board was 2 feet shorter and 30 pounds lighter than typical boards of the day. From then on surfboards got shorter and lighter, creating problems with locals. Because now a surfer could turn while riding at an angle across the wave and surfers needed to ride alone. Whereas surfers in previous decades often rode in congenial groups of five or more, "one surfer/one wave" became the norm. In the movie *Gidget* our heroine is initiated into the group and introduced to the mysteries of the sea, but there is no hint of Kahoona, Moondoggie, Lord Byron, Stinky and Lover Boy trying to keep surfers off "their" waves. As a matter of fact, although these surfers are hotdogging the waves at Malibu and Secos, they are still taking off all for one and one for all – six or seven guys on a wave, cruising along, without a care in the world.

The cultural jump from 1959 to 1969 was profound. In 1965, New York writer Tom Wolfe wandered down to the beach around Windansea and wrote *The Pump House Gang*, which was published in 1966. The 7,000-word short story was perhaps the most

astute opinion on surf culture by an outsider since Captain Cook, but the Windansea guys didn't like it much, and they graffitied "Tom Wolfe is a Dork" on the pump house.

In 1966, Nat Young defeated David Nuuhiwa at the World Contest at Ocean Beach, San Diego, and that started divisions within the surfing brotherhood which splintered into other divisions: longboard vs. shortboard, foot on the nose vs. foot on the tail, America vs. Australia, "soul" surfers vs. competitive surfers.

If things had been bad until 1970, they were about to take a turn for the worse. Pat O'Neill – son of Jack O'Neill, the founder of O'Neill wetsuits – began experimenting with the first surf leash. He used a piece of rubber tubing that was attached to the nose of his board with a suction cup, while the other end was attached to his wrist. O'Neill developed the leash to keep from destroying his boards against the cliffs.

"First it's the big handshake and the Good Time Charlie … once they find out you're going to hang around, then you go through a whole new phase."

Tom Zahn, *The Surfer's Journal*

Pat O'Neill was a good surfer who just didn't want to destroy his surfboards, but the leash caught on quickly up and down the California coast, then around the world and that innovation fanned the flames of territorial behaviour. Previously, surfers and surf spots had been stratified by ability: good surfers could ride the dangerous spots because they were good surfers and wouldn't lose their boards. Bad surfers would spend all their time swimming for their boards, or destroying them in the rocks, and so kept away from the good surfers.

As crowds grew through the 1980s and 1990s, localism became an institution at places like Sunset Cliffs in San Diego, Palos Verdes in Los Angeles County and Silver Strand in Ventura County. If a surf spot was remote or defensible, surfers would try to keep it remote from the hoard of surfers that numbered millions by the 1990s.

PALOS VERDES

The Palos Verdes Peninsula is one of the most exclusive places to live in Southern California, and it has an institutionalized history of localism going as far back as the 1950s. The Palos Verdes Peninsula is to the local surfers what Tintagel Castle was to King Arthur: high, surrounded by water and easily defensible.

Palos Verdes guys feel a sense of entitlement to "their" spots and don't want to see them turn into Malibu, so they have a long tradition of verbal and physical intimidation and vandalism, even going back to the 1940s, when Bob Simmons had stones thrown at him while going down the trail. He got his revenge by driving an axe into paddleboards owned by the local surfers: "I have been surfing PV on a regular basis for over 25 years," Joel T. Smith said. "The localism is a real thing. I've had rocks thrown at me while walking down the cliff to Lunada, and been cursed and even physically threatened at Indicator – by people who have surfed there far less than I have."

John Philbin is a surfer/actor/stuntman who is best known to movie goers as the pidgin-talking Turtle from *North Shore*, and as the bank robber in the Jimmie Carter mask from *Point Break*. Philbin grew up under the mantle of Palos Verdes localism, and he now spends half of his year on the North Shore of Oahu. As both a perpetrator of localism and a victim of it, Philbin is ambivalent about the practice: "As a little grom growing up in Palos Verdes, I did what the older, cool surfers, my heroes, did or told me to do, in order to gain their respect or trust or admiration and ultimately to get good waves when the swells came," Philbin said, "and I think at bottom that is exactly what localism is all about."

Localism is also about maintaining order in the lineup, and to see out of control places like Malibu and Trestles and Pipeline and other spots where chaos rules, it is not hard to make an argument for having some kind of informal police force to make sure surfers stay in line and play by the rules.

There are arguments on both sides of localism, but few places have inspired more argument than Palos Verdes. The cliffs down to the surf at Palos Verdes are steep, and

RIGHT *Anyone can drive up to Palos Verdes, and parking is free and plentiful. But the trail access from the top of the cliffs down to spots like Lunada Bay is watched and guarded by several generations of Palos Verdes surfers. In the aftermath of troubles at Lunada Bay and Haggerty's, the Palos Verdes Police Department established video cameras to scan the surfline, but those cameras didn't last long. At the time of writing there are no surf forecasting cameras pointed at Lunada Bay, although there is one that sweeps from Torrance up to Haggerty's. And those cameras, as much as anything have brought on the decline of localism.*

the waves are all reef breaks in front of urchin-covered rocks. Philbin grew up during a time when good surfers refused to wear leashes, and that discipline was handed down to Philbin's generation by older surfers: "If you grew up surfing without a leash, like we did, you better learn how to rescue yourself and your board in treacherous conditions," Philbin said. "This kind of behaviour and training formed the ascetic of my generation of PV surfers. We saw our friends pay their serious dues, over and over again. That was a bond all PV surfers shared, so if we saw some guys with leashes and a strange shop board or a coloured wetsuit approaching the steep trail with only one way down and up the cliff, they had better be Simon Anderson or Peter Townend, or forget it. I have personally thrown rocks, stolen boards off unknown cars, waxed windows and let air out of the tires of countless unlucky strangers, all before I was 16 years old."

THE BOYS FROM BRAZIL

In Rio de Janeiro, Brazil, the locals at Quebra Mar have a reputation as bad as or worse than the Palos Verdes surfers. Quebra Mar is a left off a jetty, close to a high peninsula that looks like Palos Verdes. Localism thrives in lawless places, or places where the police are cooperative, and according to Cariocas who have been surfing Rio for decades, the institutionalized localism at Quebra Mar is as bad as anywhere in the world.

BELOW *Surfers from the Guardaria Surf School going to the beach of Sao Conrado. In Rio de Janeiro, gun-related incidents are the primary cause of death for young people. In the Rocinha, the biggest favela in South America, sports are used to provide alternatives to armed violence and drug trafficking. Tom Carroll and Jack Johnson have both visited Rocinha and Johnson donated money through the Surfrider Foundation Brasil.*

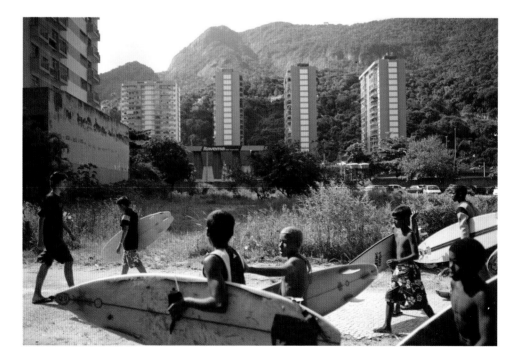

Quebra Mar was once the location for the Waimea 5000, one of the first international pro surfing contests in Brazil. Now, the break is completely off-limits to all but a clique of about 30 local surfers: "In Quebra Mar you cannot stop your car," said Brazilian surfer Fred d'Orey. "It is the worst place on earth. I have been everywhere and I know. Even at Pipe you can paddle out. These people are thugs and take pride in its reputation. They are also backed by the police, which explains why it has been going on for so long, since the late 80s. Put together a corrupt Third World country plus sleazy nobodies that can't surf and you get Quebra Mar."

Rosaldo Cavalcanti used to live within sight of Quebra Mar, and he agrees with d'Orey: "Ask Vetea David. I used to live in front of this surf spot, and once Vetea came to stay with me. First day he's there I told him to avoid surfing there because the locals would love to kick his ass just because he's famous. They do that to anyone."

Cavalcanti came home that night to find the Tahitian surfer wide eyed and white. David had paddled out at Quebra Mar, figuring he had seen it all and the place couldn't be that bad. A local surfer told him to get the f*** out of there, but the Tahitian ignored him until he was forced out of the water and chased by a local firing a gun: "Vetea said that he never saw anything like that anywhere in the world," Cavalcanti said. "Nowadays they are even worse because most of them got their ju-jit-su black belts. One thing that bothers me about giving these guys some exposure is that that's what they are looking for. They will love to be acclaimed as the worst locals in the world."

> "Put together a corrupt Third World country plus sleazy nobodies that can't surf and you get Quebra Mar."
> **Fred d'Orey**

AUSTRALIA

Australia has a lot of space for a relatively small population. But because 85 per cent of Australians live within 50 kilometres of the coast, some Australian surf spots are as crowded and localized as California or Hawaii or anywhere in the world.

In March 2000, four-time surfing World Champion Nat Young was savagely beaten by the father of a surfer Young had slapped while surfing at his home beach of Angourie, on the northern New South Wales coast. Young suffered two broken eye sockets, cracked cheekbones and damage to his sinuses. While recovering from the beating, Young was inspired to write and compile *Surf Rage: A Surfer's Guide to Turning Negatives into Positives*, a 70,000-word compilation of stories by 11 writers dealing with localism and surfer violence around the world, from Maroubra to Mauritius to Makaha.

And on the Superbank in Queensland, crowding and violence – especially an incident at Snapper Rocks that ended in a court case after a former rugby league forward attacked a surfer who had jammed a malibu board into his son's face – inspired some of the elders of the Australian National Surfrider Chapter to ask whether the same kind of traffic policing that happens on land could be applied to the water.

Currumbin State Representative Jann Stuckey outlined the Surf Cop idea in the Australian newspaper the *Sunday Mail*. Surf Cops would be different from lifesavers, in

that they would be like stadium security guards – empowered to give warnings and possibly write tickets if an incident seemed to be escalating toward violence.

The idea met with a giant Aussie raspberry from the likes of Wayne "Rabbit" Bartholomew, a Coolangatta surfer and former World Champion: "The very concept of surf police is ridiculous," Bartholomew told *Surfer* magazine. "You have to ask yourself how it could be implemented for starters. I mean, even when you go surfing with a buddy you don't see each other until you're back in the car park. The distances involved are so vast. I mean, the logistics would be enormous. A huge force would be required to implement it, leaving the rest of the community to deal with robberies, break-ins, home invasions and other major crime. Real crime. And even then, surfers would come up with ingenious disguises, like two-sided coloured rashies, nondescript boardies, hooded sun protectors. And then what if the authorities brought in water-borne police on jet skis? People would be killed. The machines would be buzzing the lineup, jetting in to nab a drop-in artist or a suspected leash-puller, and just mow people down left, right and center. You'd have fleeing surfers and police pursuits, hundreds of them, requiring a fully mobilized land and sea force, like a coordinated military operation. They would have to divert troops from Iraq to Coolangatta to continually sweep the area for those pesky surfers who consistently paddle inside."

ABOVE *To protect and to surf. As Mick Campbell oms out on the beach, syncing his mind and body before paddling out and tearing it up, two Queensland police officers scan the lineup and the beach, keeping the peace. Queensland has considered kitting out the police in shorts and rashguards, and putting them into the lineup as "Surf Cops".*

"When I go back to PV, The Hill, I get hassled, sometimes by guys who I taught to surf."

John Philbin

HUI O HE'E NALU

Localism thrives in places where laws are not enforced and while it's true that the surfline is a lawless zone around the world, in Hawaii that lawlessness is more pronounced. Hawaii is a macho place where differences are still settled with fists, and the beaten often don't report the beatings to the police – in part because Hawaiian police are sometimes slow to respond.

At Pipeline there are at least three benevolent societies – the *Hui o He'e Nalu*, the Wolfpack and the Pipeline Posse – who work as informal sheriffs to regulate behaviour on the water. On the outer islands of Hawaii, at surf spots on the North Shore of Kauai and in the nooks and crannies of the Big Island and Maui, cameras of any kind are strictly *kapu*. For many years, surf photographers were afraid to have any photos of the North Shore of Kauai published for fear of reprisals from local surfers who wanted the world to forget they existed.

All over Hawaii there is a threat of physical violence for anyone getting out of line, and in a strange way, that threat is a good thing that keeps people in line. You won't see seven surfers on a wave at Haleiwa or Hookipa or Pakalas, because that invisible threat hangs over surfer behaviour.

In Hawaii, the *Hui O He'e Nalu* have long been identified by the black shorts they wear, and now they have some imitators around the world – local surfers who identify themselves to let people know who the regulators are. In the Mascarene Islands of Mauritius and Reunion there are local surfers called the White Shorts. Tamarin Bay on Mauritius is a long left reef made famous by the 1970s surf movie *The Forgotten Island of Santosha*, and it has attracted travelling surfers ever since. These locals are mostly ex-patriate Frenchmen and not actual native residents of Mauritius. They are a joke or a threat, depending on whom you talk to, but the sharks found around the surf spots of these islands are more of a danger.

Localism has roots in Hawaii, flourished in California and now thrives in pockets around the world. John Philbin moved away from Palos Verdes to attend USC and make a name for himself in Hollywood. He now lives in Pacific Palisades and finds it ironic that when he goes to Palos Verdes to visit friends and family and go surfing, he is subjected to the same kind of behaviour he perpetrated as a teenager: "Yes, now when I go back to PV, The Hill, I get hassled, sometimes by guys who I taught how to surf," Philbin said. "Can you imagine my ironic delight? So now I get it worse than I gave, in my own hometown, and lord forbid I should bring a guest down, physical violence would ensue."

DON'T GO NEAR THE WATER

CALIFORNIA SURFBOARD SHAPER Al Merrick was crossing Ventura's Santa Clara River in the 1990s to get to a sandbar that was creating a nice peak at the rivermouth. Merrick's pants got wet on the crossing, and he laid them out in the sun to dry while he went surfing. When he returned, the pants were dry, but as Merrick was putting them on, the fabric that had come into contact with the water crumbled.

Whether or not Al Merrick's story is apocryphal, other stories are equally scary, and verified: In May, 1992, a 20-year-old surfer became nauseous after surfing at Surfrider Beach in Malibu. Getting sick after surfing Malibu is something modern surfers have learned to live with – locals call it "Maliflu" – as Malibu Creek is polluted by runoff from the San Fernando Valley, wastewater from the Tapia Water Treatment plant and leaking septic tanks and runoff from parking lots in the middle of Malibu.

The surfline water quality at Malibu regularly gets F grades from the Surfrider Foundation and Heal the Bay, but what most surfers have learned to live with killed one otherwise healthy 20-year-old. The surfer's symptoms grew progressively worse, and doctors identified he had coxsackie B virus. The surfer subsequently died from damage to his heart caused by a virus usually associated with diabetes. It was impossible to prove the surfer contracted the virus from polluted water in the surfline at Malibu, but doctors could not find any other source.

DOWN DOHENY WAY

Doheny Creek empties at the surf spot called Doheny – mentioned by the Beach Boys in *Surfin' USA* – but the ocean waters there are triple tainted. From 2001 to 2004, Doheny was the three-time loser of Heal the Bay's damning award for Most Polluted California Beach, beating out Surfrider Beach in Malibu, Avalon Beach on Santa Catalina and Kiddies Beach in Channel Islands Harbor in Oxnard. "They're the worst of the worst in the state," Heal the Bay's executive director Mark Gold told the *LA Times*. "Every single one has poor water circulation and a storm drain or creek discharging as a pollution source."

RIGHT *Disappearing under a tide of plastic bottles, this scene from a beach near Naples in Italy is repeated on surf beaches the world over. While ocean-going surfers rarely have to avoid floating objects (apart from the occasional unleashed board), surfers of tidal bores have to dodge fridges and dead farm animals.*

"It takes two weeks for the symptoms to hit you – like a baseball bat."

Jeff Divine

Doheny won that dubious honour because of its triple whammy location at the mouth of a storm drain and outside of a large yacht harbour. When you factored bird droppings into that, it's a wonder that beach was ever open at all.

OLD BLACK WATER

One hundred and fifteen miles of the Tijuana River runs through Mexico and then the river sneaks across the border with the USA for the last 5 miles. The California terminus of the Tijuana River is "protected" within the Tijuana River National Estuarine Research Reserve. In theory, on an ideal planet, wetlands are nature's natural filter, sifting large and small pollutants out of the river before they can get to the sea. But not even 5 miles of wetlands can undo the damage that 115 miles of Mexico does to the Tijuana River.

Seth Mydans wrote about the Tijuana River for the *New York Times* in 1990: "When the Tijuana River ripples down the hillside from Mexico into the United States, it brings each day millions of gallons of raw sewage, a thick black stream that meanders, bubbling and stinking, past stables and farmland to empty into the ocean off San Diego."

The Tijuana Sloughs might just be the only still-existing California surf spot that was more popular in the 1930s and 1940s than it is now. There are also other popular surf spots from that era, like Killer Dana in Dana Point and Flood Control in Long Beach, that have been engineered out of existence. But in the mid-twentieth century, Dempsey Holder was a local San Diego legend who surfed out there with Miki Dora, Pat Curren, Buzzy Trent and Bob Simmons. Tijuana Sloughs were one of the proving grounds for the North Shore back in the 1940s and 1950s, when the waters were mostly untainted by a Tijuana that had a population of 22,000 in 1940 and 65,000 in 1950. The population has exploded to 1,125,00 in 2000. That population growth has not been met by improved infrastructure on the Mexico side of the border. In November 2000 President Bill Clinton authorized a joint American/Mexican "secondary treatment" sewage plant in Mexico to detox 34 million gallons of sewage, but seven years and hundreds of millions of dollars later, the "Bajagua" plant is nowhere to be seen, everyone is suing and surfers on the ragged edge of California have to deal with the pollution.

ABOVE *The sandbar at the mouth of the Santa Clara River is one of the most prized waves in southern California, but that prize has a price. The Santa Clara River drains 100 miles of septic tanks, agriculture and stormwater runoff straight down to the sea. After rain, you must refrain.*

MOROCCO AND EL SALVADOR

The Moroccan coast may benefit from big Atlantic swells, but it also produces some big Atlantic smells. Anza is a nice-looking right point to the north of Agadir, Morocco. According to people who have surfed there, the smell from the sewage outlet pipe is like no other, which is not the greatest recommendation.

North of Agadir and south of Rabat there is another Moroccan surf spot at Safi, a world class right point that unfortunately is in front of Morocco's industrial jewel, a big and smoky phosphate plant. According to Kristen Pelou: "The name of the place is *Billet de 10000* as it once appeared on the 100 dirhams banknote. Today, some call it 'Money Wave' or 'Cacheton,' a French slang name for medical pills. In fact, people don't know exactly what comes out of the giant pipes that throw the thick brown water at the end of the wave, it just seems that not much grows there ..."

East is east and west is west but pollution problems know no boundaries. Punta Rocas is a perfect little right point in La Libertad, which is in El Salvador, the most densely populated country in Central America. La Libertad is a town of only 17,000 people, and home to the Latin American Malibu, a perfect right point which breaks

BELOW *An excrement cannon, pointed directly at the poor, innocent surf. There are several organizations in California dedicated to preventing this kind of treatment, but they don't always overcome.*

down to a beach and a pier. And very much like Malibu, La Libertad has a lagoon at the top of the point which is essentially a sewer running from town to the sea.

Jose Borrero has a PhD in Coastal Engineering and travels constantly, for recreation and work: "La Libertad after a rainstorm is a minefield of gurgling sewers," Borrero said. "And that situation is maybe more acute than Tijuana in terms of direct exposure to people. Not too many people surf the Sloughs, plus the Sloughs are more spread out compared to 30 guys on the peak at La Libertad."

Surf photographer Jeff Divine wasn't surprised when he got sick, very sick, after shooting Punta Rocas in 2004: "I was taking water shots, and as a slight onshore started to ripple the water I noticed a scum line. As I looked closer into the water, I realized there were mini pieces of toilet paper floating. I freaked out, went in, ignored the bro-brah conversation and went immediately to take a shower. It takes two weeks for the symptoms to hit you like a baseball bat. Two weeks later a fever hit which peaked at 104 but was spiking up and down for four weeks. And then I turned yellow. The Orange County health department interviewed me twice about the situation. I lost about 15 pounds. More than a divorce diet loss. Hepatitis A is the one you recover from. Hep B and C stay with you for life and the symptoms recur. It taxes your liver. Basically as you get old you die from it."

For all the people who say Punta Rocas is a sewer, there are others who say it's a den of thieves where gangs and snaggle-toothed crackheads hide out in the cemetery near the break, robbing surfers of their surfing equipment, cameras and whatever else they can get. And surfers who go around the cemetery and walk along the beach risk rabies from dogs who are even meaner than the crackheads.

CRUMBLING PANTS

In Southern California, when it rains everyone puts their plans on hold. There are few beaches from Point Conception to Baja Malibu that aren't affected by stormwater runoff: Streets, storm drains and rivers rinse six months worth of animal droppings, agricultural waste, vehicle fluids, rotten food and drinks and every other imaginable and unimaginable waste product into the ocean.

Steve Hawk, brother of skateboard legend Tony Hawk and a former editor of *Surfer* magazine, witnessed the Santa Clara River melt Al Merrick's pants, and turned the story from apocryphal to apocalyptic: "I was there the day Merrick's pants disintegrated after crossing the Santa Clara Rivermouth," Hawk said. "I believe (Kelly) Slater and (Rob) Gilley were there also. You can check with either one of them, or Al, to confirm. It's something we all still talk about."

Hawk confirmed that this happened around 1993. They walked in from the north parking lot, near Ventura Harbor, and waded the river to get to the rivermouth, which had great waves. There was a distinct line in the water, blue on one side, murky gray on the other. If you wanted good waves, you had to get in the gray.

BELOW *First of all, relax. Those are tootsie rolls that Terry Gillard is using to dramatize the realities of surfing the Tijuana River. Despite all the signs, surfers still risk it, paddling out into a stretch of coast that is sometimes flooded by 30 million gallons of untreated sewage a day.*

"Merrick wasn't surfing this day. He was shooting video or photos from the south side of the river, near McGrath State Beach. When we were done, he waded back across the river and we all hiked north back to the lot. We decided to eat fish tacos at a little Mexican place adjacent to the lot where we'd parked. While we were eating, Al scratched the lower part of his leg, which had gotten wet in the river, and the pants ripped like paper. Up higher, they were fine – you couldn't rip them with your bare hands. He held up his leg, and we all tried. It was unbelievable. Apparently, something in the water had rendered the cotton as fragile as brittle parchment. We all freaked out. I don't know about the other guys, but I took a long hot shower when I got home."

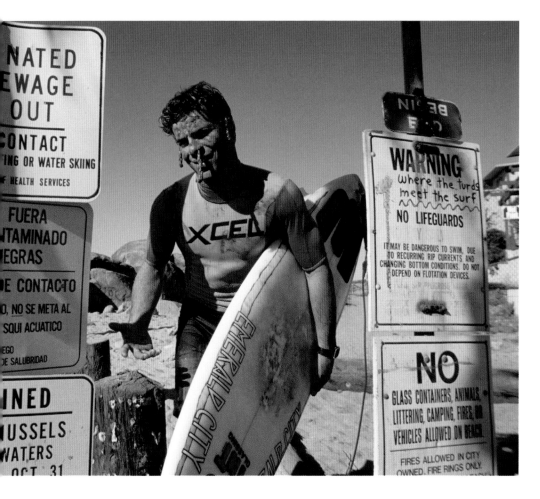

CHARLIE DON'T SURF

MAGNUS WOLFE-MURRAY IS A Scotsman who has been doing aid work around the world since 1992. As a relief worker with Medical Emergency Relief International (MERLIN), a London-based international medical relief organization, Wolfe-Murray has found himself heading into situations most people are fleeing – places like Bosnia, Kosovo, Guatemala, Somalia, Sudan and Congo.

Wolfe-Murray landed in Liberia in May 2003 when Monrovia was one of only two world capitals without electricity. Monrovia had no water, power or sewage. Cholera was epidemic and the biggest waves were the waves of refugees flooding from the deadly countryside into the city.

The election of Charles Taylor in 1997 sparked a second civil war that began in 1999, and by 2003 conflict came knocking on the outskirts of Monrovia. The UN and almost all the aid agencies were getting out while the situation deteriorated. Wolfe-Murray

"You either surf or fight."

Colonel William Kilgore 1st Air Cavalry, *Apocalypse Now*

LEFT Apocalypse Now *introduced the idea of surfing during battle. In one of the most famous scenes in American cinema, the Air Cavalry attacks a village held by the Viet Cong, providing their own soundtrack, Wagner's* Ride of the Valkyries. *The attack is nasty, brutish and short, and as it is continuing – with bullets whizzing, rockets red glaring and mortars exploding – Col. William Kilgore orders his men to go surfing in the middle of battle: "You either surf, or fight!" Malibu surfer John Milius wrote the screenplay and handed it over to Francis Ford Coppola, who rewrote it but kept the battle scene: "Everyone loved the idea," Milius said. "The surf was okay in* Apocalypse Now, *although I thought the mortar explosions in the surfline were a little silly."*

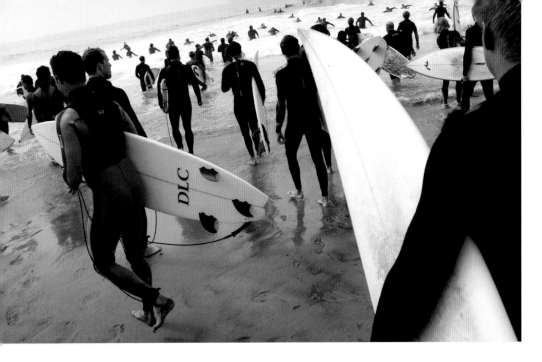

ABOVE *Surfers paddle out for a memorial to Steven "Webby" Webster at his favourite surf spot, Newport Beach, California, in October 2002. Webster was killed in the bomb blasts that killed many surfers at Club Sari on the island of Bali.*

stayed to help, but to ease the stress he went surfing when he could. The best wave in Liberia is Robertsport, a left point about two and a half hours south of town, toward Sierra Leone. But travel outside of Monrovia was extremely dangerous, so Wolfe-Murray surfed Mamba Point, a perfect-looking left in the middle of town and close to the MERLIN offices: "On bigger days Mamba turns on like Supertubes in Portugal: hollow, fast, powerful," Wolfe-Murray said. "Gnarly break. Paddling out here as the only surfer in the lineup is one thing. As the only surfer in the country it's something else, utterly outrageous.

"I remember going down to our local town beach, and shells were landing in the f***ing lineup. A lady ran out of her shack with her bleeding baby: A stray bullet had hit it in the face. Somehow it survived. I didn't surf that day."

With Taylor now gone and on trial for war crimes, life has changed for the better in Liberia. Peacekeepers are there and a stable, U.S.-backed government: "So now anyone can access Robertsport, one of the best lefts in West Africa," Wolfe-Murray believes. "Indeed, I want to build a kinda eco-surf camp there, which doubles as a renewable energy training center."

TROUBLE ARCHIPELAGO

Trouble spots are changing from day to day, in this modern world, and sometimes surfers will find themselves right in the middle of it all, sometimes without warning. The island

of Bali is an island of Hinduism in the middle of Indonesia, which is the most populous Muslim nation in the world.

The threat of anti-Western violence in Bali by Muslim extremists was only a vague thought until October 2002, when a suicide bomber set off a backpack bomb inside of Paddy's Pub in the Kuta area of Bali. The first bomb killed some but drove a huge crowd of panicked people outside and directly into the explosion of a much larger car bomb parked in front of the Sari Club.

The explosions killed 202 people, including 88 Australians, 38 Indonesians, 24 British and 7 American tourists. Another 209 people were injured – some losing eyes, arms and legs in the bombings, which were claimed by a radical Islam group called Jemaah Islamiyah. The bombing had an immediate impact on Kuta and much of Bali, clearing all but the most ardent holidaygoers, and that included surfers.

Three years later, again in October, just when tourists thought it was safe to go back in the water in Bali, three suicide bombers set off explosives in Kuta and Jimbaran Beach, areas popular with foreign tourists, including surfers. Twenty-nine people were killed and another 129 people were seriously injured. Officials later found more bombs that did not explode thanks to Balinese officials shutting down the mobile telephone service as a precaution.

There is way too much surf in the Indonesian archipelago to keep surfers away for very long and if the Bali bombings did anything, it drove surfers deeper into parts of Indonesia, away from cities hoping trouble wouldn't follow.

TAMIL TIGERS

Growing up in Northern Ireland, surfer Alistair Mennie is no stranger to civil war and strife, but he still got his eyes opened in Sri Lanka. At the tip of India, the official title of the Democratic Socialist Republic of Sri Lanka seems to be a contradiction in terms, and there is a lot of contradictory feeling on this island. Sri Lanka is a melting pot of Buddhists, Hindus, Christians and Muslims. And that melting pot seems to always be on the boil. Since 1983 there has been an ongoing civil war between the government and the Liberation Tigers of Tamil Eelam – the Tamil Tigers. Like the Basques and the Kurds and the Kashmiris, the Tamils are involved in an ongoing fight to create an independent state in the north and east of the island.

In 2001, Mennie travelled to Sri Lanka to compete at the British Professional Surfing Association Champion of Champions Surf Contest, held in Aragum Bay on the east coast. Competition is tense enough without having your hotel and the sand dunes and the beach lined with armed soldiers: "Wasn't very discreet," Mennie said. "There were fully armed soldiers on the beach and in the dunes with automatic weapons!"

Mennie went back to Sri Lanka after the tsunami and found that natural disaster had calmed things down enough not to require a military presence. But the contest has

"Incredibly in front of me were absolutely perfect three to four empty sets with offshore winds."

Bob Campi

Antony "Yep" Colas has made a habit of seeking out the places other people don't surf – travels which have taken him to China, Pakistan and South America.

Despite needing armed guards in Pakistan he rates Venezuela as one of the toughest places to surf.

"I could have guessed Venezuela was not gonna be the safest place but it really felt like a ghetto. Since the coastline had been wrecked by intense mudslides in 1999 and since the main bridge between Caracas and the coast was out of order for almost two years (it's been fixed now), the coast had turned from a flourishing tourist area into a ghost town: Lots of unemployed people who had lost jobs and an intense feel of thievery in some areas. Juan Cortado, our guide from Surf Report Venezuela, would keep saying: "No, we won't park here, too many *ladrones* (thieves)."

Yep has even crossed the Darien Gap on foot with a surfboard. "I was on an 18-month trip through Latin America on $5 a day. I had to go somehow from Central to South America. I wish I had the money to do the usual flight hop to San Andres Island and then to Colombia. I chose to go overland: wrong idea. Crossing the Darien Gap with a surfboard was maybe the craziest thing ever. It's 10 days of riding canoes in the thickest jungle and lots of bush walking. And you are mostly travelling with smugglers and deported people. The day "trek" is 48 kilometres in one day from one village to another. You wake up at 4 in the morning, walk all day in a very hilly jungle, cross dozens of rivers barefooted and get to the next stage right after dark. At the end is a 10-hour banana boat ride to Turbo, some weird harbor town in Colombia."

not returned to Sri Lanka because of the threat of violence which again escalated at the beginning of 2008 following the government's withdrawal from a 2002 ceasefire.

SURFING THE WAR ZONE

In 2002, freelance photojournalist, Bob Campi found himself covering the Intifada in Gaza, a place where life is cheap and Western journalists can be used as negotiating chips. After pulling an all-nighter in Gaza City listening to storms rattle the building, he went back to his hotel to hear the sounds of pounding surf around the back of the hotel.

"I bolted out of the car and ran around a side alley to the beach. Incredibly in front of me were absolutely perfect three to four empty sets with offshore winds. The surf was going off with no signs of dying, and the lack of sleep combined with surf stoke drove me to surf the Gaza Strip. I arranged for my driver with the armored car (a Jeep Cherokee with racks on it), and we were off.

"The plan went like clockwork getting to Tel Aviv. I had the Palestinian driver staged on one side of the Gaza boundary, waiting as an Israeli driver on the other side arrived to get me 40 minutes up the road. I coordinated all of this through a weak signal on my cell phone, but the run into town and the roundtrip back to the border went without a hitch. I got the only board I knew would be available from my friend's

local surf shop. It was an unlabelled, partially delaminated 9-foot long board tri-fin. Not the best choice, but it floated.

"Once again, I had to confront the tightly controlled passport security, only this time armed with a surfboard. Not your typical sight for a very professionally secured DMZ, and needless to say I was a little nervous this time around. Holding the board tightly under my arm, I was tracked from the towers by Israeli soldiers with binoculars, many who surf themselves, who watched me speed walking through the "Safe Zone". From their initial reactions they probably thought surfing Gaza was crazy, but some of the guards gave me the 'thumbs up' and I got through without incident.

"The drive through downtown Gaza was effortless at that hour although there was some street-side interest. The sight of that board strapped on top of the armored car must have been something to see for the Arab locals and a moment I will always treasure.

"On the beach, I conducted a quick visual check for any armed Palestinian soldiers patrolling the nearby harbour and

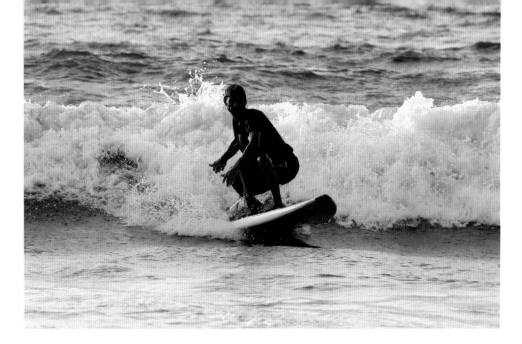

went into turbo mode to get the wetsuit on and get out. I rattled off a few quick pictures with my still camera and stashed it under a trash pile – after all I needed evidence, as who the hell would believe this was happening!

"I started to paddle out as the calls from the Mosques and gunfire shattered the morning silence. I paddled through a surreal scene and punched through the first series of waves. They were perfectly shaped and some of the best waves I had ever surfed anywhere in Israel. Without hesitation I turned and launched down the line on a crisp, head high right.

"I was in it now and as wave after wave came through, I tried to catch as many as I could, always mindful that many eyes were on me, and unwanted types could be lurking in the area. Nothing bad happened and as I sat between the sets, I thought about the war, how tense this region was and how fortunate I was to have surfing as the catalyst, neutralizing all the negatives. I just couldn't get over the fact that I was actually pulling it off and was stoked to the max."

John Milius didn't like the mortars going off in the surfline during the "Charlie Don't Surf!" scene of *Apocalypse Now*. These days, trouble spots are exploding around the world like mortar rounds. Most surfers stay home and stay away from trouble, while others actively seek it, rewriting the words of John Severson: "In this troubled world, the surfer can sneak past sentries and risk landmines to seek and find the perfect wave on the perfect day, and be alone with the surf and his thoughts – of snipers in the sand dunes."

ABOVE *One of Doc Paskowitz's boards in action in the Gaza surf. Apart from getting the boards sponsored, the Hawaiian resident managed to persuade the Israeli army to open up the Erez border crossing. The crossing had been almost permanently sealed by the Israelis since Hamas had taken control of Gaza by force from its political rival, Fatah, in June 2007.*

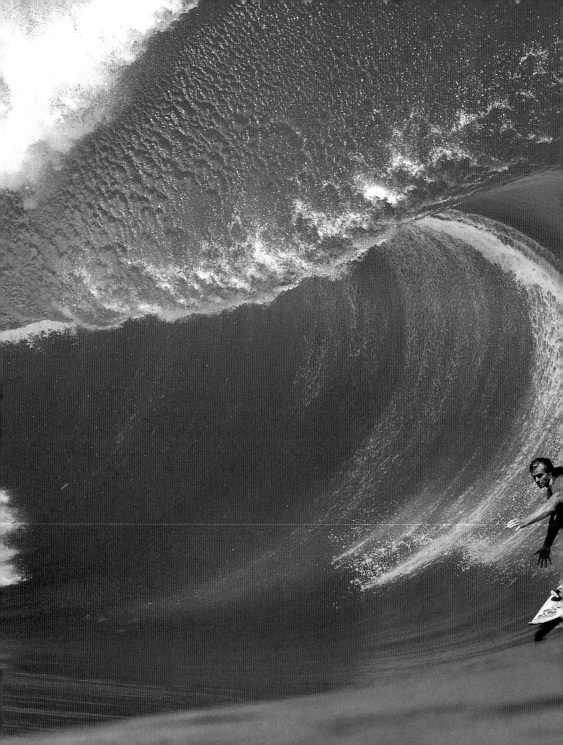

FASTEST WAVE

THE NEED FOR SPEED

IN 1996, *PEOPLE* MAGAZINE ORDAINED Laird Hamilton as one of the 50 Most Beautiful People. At the time, Laird was dating professional volleyball player Gabrielle Reece who thought of him as "beautiful when he's in motion". It's hard to imagine any surfer going faster on a surfboard than Laird Hamilton at Jaws.

What surfers call Jaws the Hawaiians call Peahi. The wave breaks on an almost perfectly shaped reef, which is actually an undersea cliff that juts a quarter mile out to sea and makes a shallow, triangle-shaped platform that drops off vertically. Jaws takes in groundswells from storms close to Japan and in the Gulf of Alaska. Exposed to more than a thousand miles of fetch, swells have "unwrapped", by the time they reach the Hawaiian Islands, and they hit the reef with enough energy to make Jaws one of the biggest waves in the world – if not the biggest. Because Maui is the visible top of a volcanic mountain, the sea floor ascends from 15,000 feet at Maui Deep to 120 feet in less than 50 miles; the sea floor then rises abruptly from 120 feet to 30 feet. The triangle shape of the reef forces the swells to rise in a perfect peak at the tip of the triangle, and then as the triangle broadens, it refracts that energy into a tubing, grinding wall that is a perfect canvas for high performance big wave surfing. Jaws is where the act of tow surfing flourished in the 1990s and into the twenty-first century.

It would be hard to design a better wave. When Jaws is at full roar, open ocean swells which are moving between 20 and 30 mph unload in 30 feet of water, and are usually met by offshore winds blowing at 30 to 40 mph. There is too much water moving too fast, and too much wind blowing into the wave faces for surfers to catch this wave with their bare hands. So surfers like Laird use jet skis to hunt the swells down as they are roaring and shifting and moving through the deep water. Tow surfing derived from sailboarding, as sailboarders have the speed to catch waves while they are still swells. The pioneer tow surfers like Laird, Dave Kalama and Rush Randle are all surfers turned sailboarders who wanted that early, fast access into waves without holding onto a rig. So they used boats, then jet skis, and now they can easily do what was once the hardest thing to do: catch a 30-foot wave. What you have at Jaws is 30-foot waves moving at 30 mph breaking in 30 feet of water, with Laird at the end of a 30-foot rope

PREVIOUS PAGE *Objects in mirror are closer than they appear. Laird Hamilton, feeling the need for speed as Teahupoo tries to gobble him. Laird rode this heavy metal thunder at the turn of the century, in August 2000, and what has been called "The Millennium Wave" raised the bar on how fast is fast. Seconds after this photo was taken the foamball spat through. No one wants to think about what would have happened to Laird if he hadn't made it.*

"There's just different kinds of fast."

Laird Hamilton

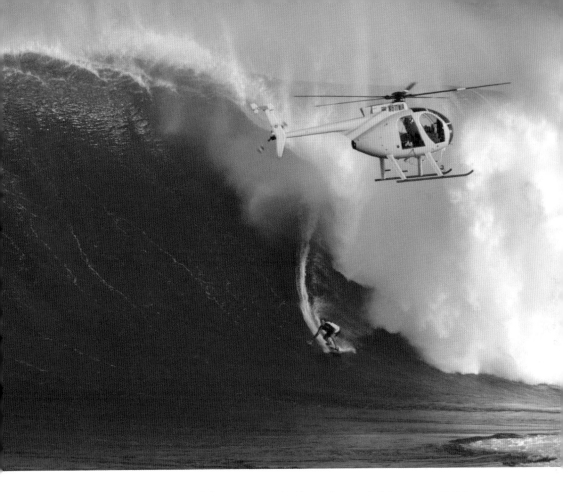

moving at 30 mph into offshore winds blowing at 30 mph. All very dynamic. And then Laird lets go of the rope, picks his entry and it really gets interesting.

 If you can't make it to Maui in the winter, and through the pineapple fields to the cliffs of Peahi overlooking Jaws to check out the greatest show on earth combined with one of the seven natural wonders of the world, check out Laird and his band of merry men surfing Jaws in *Riding Giants*, or the biosurfpic *Laird*.

 Once he lets go of the rope he is on his own, essentially surfing in front of an avalanche on water where he really can't fall. The danger is very real, but Laird doesn't play it safe. He bunny hops over chops, fades into the peak where angels would run, stalls at the top to coax even more power out of the wave, drives for the bottom soaking up all the power into his oversized frame, and when he hits his first turn, he uncoils all 6' 3" and 220 pounds of him into the greatest show on surf. As seen close up from a

ABOVE *The helicopter is hovering. The surfer is not. The surfer is Laird Hamilton at Jaws, and no one has ever bothered to measure exactly how fast he is going.*

hovering helicopter, the speed is scarcely to be credited. These guys are going so fast it looks like special effects, like the camera was slowed down a few clicks to make the surfing seem faster. Does that mean Jaws is the fastest wave in the world? Not necessarily. If you were to corner Laird in the parking lot of Ralph's grocery store in Malibu you would get a thoughtful answer: "There are different kinds of fast. Yes I go fast at Jaws but is it the fastest wave in the world? I don't know. Teahupoo demands speed to make it but I wouldn't call it the fastest. Ma'alaea, I don't think so, because of the wind. There is a place on Kauai when it's doing its thing that is one of the fastest waves I have ever surfed. And there are some spots in the Mentawais – some places I can't name – that demand a whole lot of speed when they get over 10 feet. There's just different kinds of fast."

A PHD IN SPEED

In the autumn of 2007, Dr. A. Garrett Lisi made headlines like this: "Surfer dude with no fixed address may be this century's Einstein." Dr. Lisi had come up with what he called *An Exceptionally Simple Theory of Everything* that was touted as a stepping stone toward the elusive Grand Unified Theory, which would mathematically relate the four fundamental forces of nature: gravity, electromagnetism and the strong and weak nuclear forces.

A discovery of that magnitude would put Lisi on a par with Einstein. However, Einstein didn't surf. While the jury is still out on Lisi's "Eureka!" moment, he is still uniquely qualified to comment on fast waves. He earned a double BS in Math and Physics from U.C.L.A in 1991 and a PhD in Physics from U.C. San Diego in 1999. His research involves the application of differential geometry in theoretical physics. As a surfer, Lisi has earned his doctorate in perfect waves surfing Teahupoo in Tahiti and Maui's Honolua Bay at their biggest and baddest. In September 2005, Lisi was one of the lucky few to surf Ma'alaea on Maui on one of the best days there in the last 40 years and his answer to what is the fastest wave – as you'd expect – involves a few calculations on the blackboard.

SURFIN' TSUNAMI

Dr. Jose Borrero is a Southern California surfer with a PhD in Coastal Engineering from USC. As a surfer and scientist he is fascinated by waves, and he has travelled around the world and back to surf and research waves. Dr. Borrero knows more about the mechanics of waves than most surfers, so he got a little testy when word went around that a Hawaiian surfer named Bobby Owens had surfed a tsunami in the middle of November 2006: "Would you guys please stop spreading this 'surfed a tsunami' BS!" Borrero chastised. "It's physically impossible. Period. No one has ever surfed a tsunami. They have surfed normal swell waves superimposed on a tsunami wave. Talking about people surfing tsunamis is false and irresponsible because it gives people the wrong idea about what they should do in case they are in the water at the same time a tsunami is happening. You simply cannot surf a 12 minute period wave."

On November 15, 2006, the Pacific Basin went on tsunami alert after a major earthquake rocked the ocean floor in the North Pacific and was measured at 8.3 on the Richter scale. The Pacific Ocean from Russia to Japan to La Jolla went on tsunami alert.

Surfers in Hawaii had heard such alerts before and were sensitive to sudden changes in the ocean, which showed no signs of going *lolo*, and so by 9:00 a.m., veteran Hawaiian surfer Bobby Owens was in the water at Turtle Bay – on the northern tip of the North Shore – where he gives surf lessons twice a week. "I've been a little sheepish about making a big deal about this, because I know I did not ride a tsunami," Owens said. "I know enough about tsunamis to know that basically what usually happens in six hours is condensed down to three or four minutes. It was a series of fluctuations with the ocean receding and then the ocean rushing back in."

To cut a long story short, Owens was in the water well past the time the alert had been cancelled. He was sitting out at the end of the point when the ocean began to surge out. Owens knew what was going on, and there was a co-worker on the point watching. As the surge came back in, Owens caught a wave. When he kicked out, the surge kept going and took him with it: "It was very powerful but not that scary. I just thought, 'Unbelievable!' and then I went in. I didn't ride what a lot of people would think a tsunami is. The few people I talked to I said I happened to ride a wave when the whole surge was coming back in."

"The question of what is the fastest wave is complicated to answer. A lot depends on exactly what you are asking. Waves in the open ocean travel at a speed proportional to the square root of their wavelength and directly proportional to their period. But when they hit shallow water the speed is proportional to the square root of their depth."

By that equation, the fastest waves in the ocean are tsunamis, which have wavelengths of miles and can travel at hundreds of miles per hour through the ocean. But surfing a tsunami is impossible (see box). Swell speed and energy is one factor in determining the speed of a wave, but the depth and angle of a reef or a sandbar are just as important, as are the variable conditions: tide, wind speed, wind direction, etc: "For waves you can paddle into, I have to agree that Hanalei Bay and Ma'alaea are top contenders," Lisi said. "Until September of 2005 the fastest waves I had paddled into and ridden were at Hanalei Bay." Located on the North Shore of Kauai, Hanalei is situated so the trade winds blow sideshore, giving a speed boost to waves that already have a lot of speed. Hanalei gets the same winter swells as Jaws and gets the most consistent and biggest surf in the winter of anywhere on the planet.

BELOW *Tom Curren is one of the sultans of speed. Where some use height or weight or other factors to go fast, Curren's speed is based on economy of motion plus wave knowledge plus positioning plus very good surfboards. An incredibly smooth surfer, every fibre and cell in Curren's body is dedicated to sucking every ounce of energy out of the wave and translating it into blurring speed. This is Tom Curren at Backdoor Pipeline, turning and burning all that raw Hawaiian energy.*

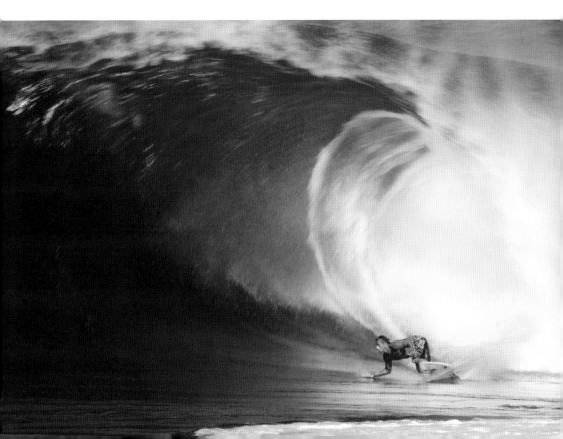

Ma'alaea is on the south-facing shore of Maui, and at the other end of the consistent scale. In September 2005, one of the best southern hemisphere swells in the last 50 years made it through the 8-mile gap between Kahoolawe and Maui, and let the new generation fight it out with the older generation for a taste of the phenomenon: "That one day in September 2005 everything came together and the place was insane," Dr. Lisi said. "Really big south swell with a perfect direction, light offshore winds. There was a mind-blowing amount of power in those waves – definitely the fastest I've ever seen."

Continental shelf is something Maui surfers don't worry about, but the gradual shallowing of the ocean around large continents is something that affects incoming swells, so it affects waves and surfers in the United States, Australia, the UK and Europe. As a swell drags across shallower water it slows down, which in turn increases its size, eventually making the wave unstable and it breaks. The longer the period, the faster the wave. And the longer it stays in deep water, the faster the swell will be.

The next part of the equation is finding a deep water break that is as close to the edge of the continental shelf as possible to minimize drag on the bottom till the last possible moment. In California, the Cortes Bank is a seamount 100 miles out to sea that rises straight up from the ocean floor a half mile down and comes to within two fathoms of the surface, as the U.S. Navy has found out.

The same winter swells that rumble the reef at Jaws also rumble the reef at Cortes Bank. Surfers familiar with Mavericks, Dungeons, Jaws and Cortes Bank say that the open swells approaching Cortes move through the ocean with startling speed, and they are as hard to chase down on a jet ski as any big wave on earth.

There are different kinds of speed on a wave, just as there are different kinds of speed behind the wheel of a car. Nasty, brutish and short waves, like Shipstern's, Pipeline, Cyclops and Teahupoo are closer to drag-racing: intensely short bursts of power that require a perfect start and demand absolute focus, and can go deadly wrong, very very fast. The speed of a great pointbreak like Jeffreys Bay in South Africa is more like a classic, luxury car – a Jaguar or Aston Martin – a more elegant, refined power that is fast in a straight line and smooth through the turns.

RIGHT *Australian pro surfer Mick Fanning finds a need for speed, surfing Bali in March 2007.*

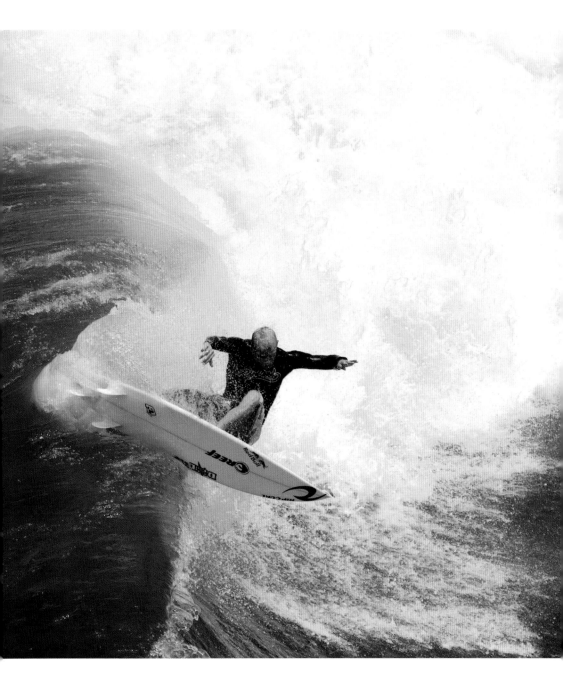

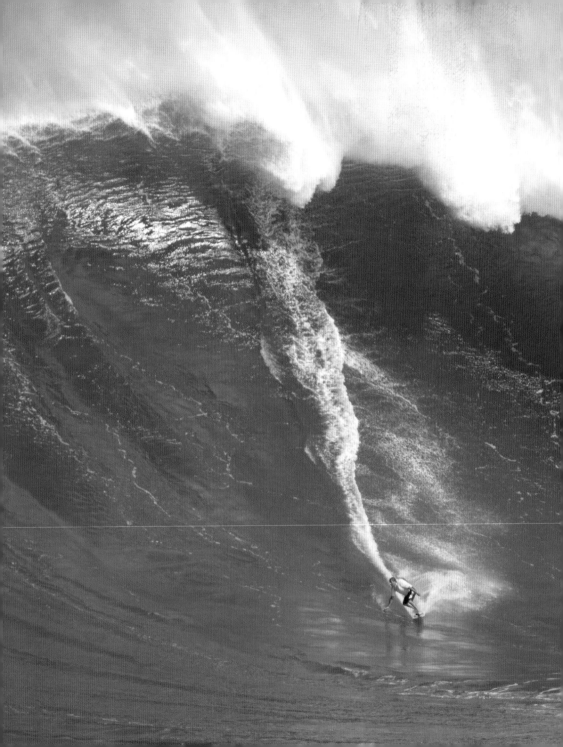

In the 1970s, surfers began poking around the Indonesian archipelago and finding a wonderland of perfect waves. Uluwatu on the island of Bali was the original perfect wave that lured surfers to that part of the world. Uluwatu is a left reef/point with several sections. The inside section is called Racetrack, because at low tide the wave bottoms out through there, demanding surfers put it in overdrive. Uluwatu was the first of many racetracks that surfers have found in Indonesia, from Timor in the east to the Mentawai islands in the west. Depending on who you ask, and their experience, they will swear that Grajagan, Rifle's, Lance's Right, Nokandui's, Apocalypse or three dozen other spots are the fastest wave in the world.

The waves of Indonesia are all coral reef breaks located within 10 degrees of the equator that lie open to swell coming from deep in the Roaring Forties of the southern ocean. By the time these swells have reached the Indonesian archipelago, they are fully unwrapped and as polished as a prince, every warble or gurgle removed by a thousand miles of swell training and travel through the Indian Ocean.

The waves of Indonesia are tight, high-pitched and torquey and run at high RPM, like driving a Ferrari along the Pacific Coast Highway. They demand perfect judgment on takeoff, a perfect first turn and then raw speed and tight turns to race a fast, tight curl line. Nick Carroll is an Australian journalist, the brother of World Champion Tom Carroll, and a surfer who has experienced the best waves the world has to offer: "I'm kinda with Laird in that there are different kinds of speed, like Sunset is actually a very fast wave if you're running the drop off the west peak down into the pit in the early part of a swell. You definitely go faster doing that than you'd ever go at Jeffreys Bay. If it's down the line speed then J-Bay would be up there; also a place in the Mentawais called Rifles, on a big day that place is faster for sure. There is another Mentawai spot called the Anti-Christ which is similar in down the line speed."

Fastest Wave is as debatable as Biggest Wave, because there are different kinds of surfers and different kinds of fast. Brock Little is a Hollywood stuntman who earns a nice dollar jumping from high buildings. As a travelling surfer, he has surfed Jeffreys Bay many times, was one of the first outside surfers to challenge Teahupoo (when it was known as End of the Road) and has surfed all over Indonesia. But when it comes to fastest wave, Brock thinks there's no place like home: "Ma'alaea, no doubt about it. I have surfed it three times, which is a lot, and I have been to J-Bay and the Mentawai islands and Ma'alaea is still by far the fastest wave in the world. When you take off there you go down all those chops, babababababa, and you pull into the barrel and you go screaming along with all that wind and those chops and you just hope you come out of the end. When you do, it's unbelievable. It would be killer to surf Ma'alaea glassy or with less than howling offshores. That would be insane, but it never breaks anyway, like maybe once every 10 years. I'm lucky to have surfed it three times. A lot has come along since then in Indo or whatever, but Ma'alaea still wins."

LEFT *God's holy trousers that is a big wave. It took some time for Laird Hamilton and Dave Kalama and Darrick Doerner and all the merry men to get used to this kind of power – to figure out that smaller boards were the way to go. More than a decade after they first began tempting Jaws, the Hawaiians are at a place where they can turn the power of the wave back on itself, and hotdog it in ways that are scarcely to be credited – though here Jorge Martinez takes the direct route.*

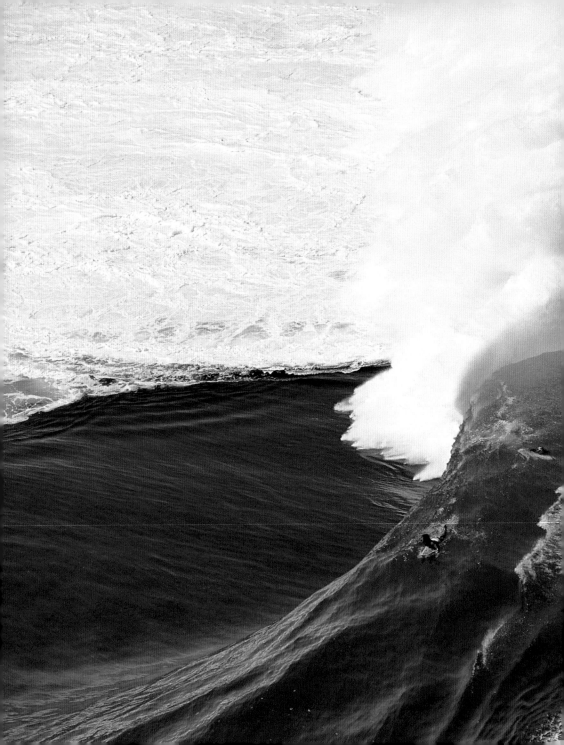

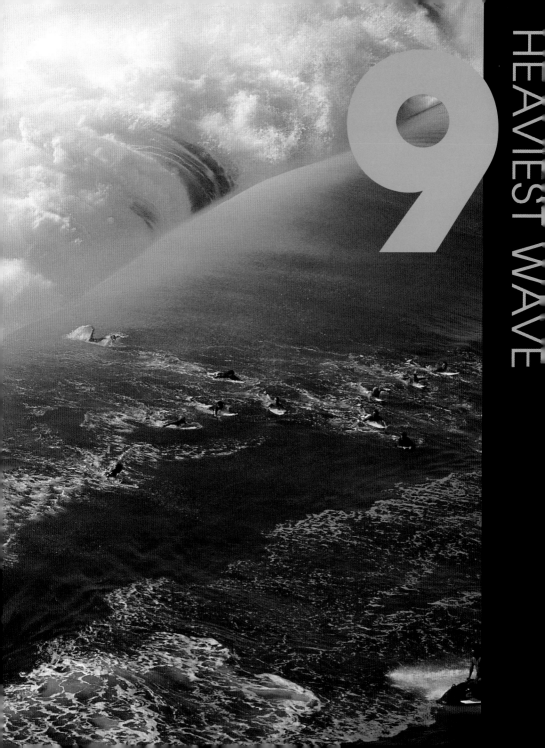

THE WORLD'S GNARLIEST

"HEAVY" IS A SURFING TERM that is a little hard to define. To paraphrase the corporate slogan of Billabong: "Only a surfer knows the meaning". While a monstrous wave at Dungeons can be heavy, size isn't the absolute determining factor. The heaviness of a wave has more to do with the volume of water pouring over in the lip of the curl, as opposed to the shallowness of the reef the wave is pouring over, and the diameter of the hollow tube between the shallow bottom and the lip.

The synonyms for "heavy" are "gnarly", "rad", and "thick". Danger is also a factor in determining the heaviness of a wave. There are a lot of heavy surf spots around the world, and they all have cool names: Dungeons in South Africa, Cyclops in West Australia, Jaws on Maui, Mavericks in Northern California, Phantoms, Himalayas and Avalanche on the North Shore of Oahu.

Wiping out in the bowl at Mavericks on a 20-foot-plus day is heavy – holding your breath for 40 seconds, 30 feet under water with tons of water pummelling you is the stuff of nightmares. Getting hurt at the Cortes Bank, a hundred miles out to sea and a long helicopter ride and an even longer boat ride is heavy – you'll probably bleed to death before you see land. Towing into a giant wave at Jaws and wiping out deep inside the tube is one of the heaviest things imaginable – Laird Hamilton described it as getting hit by three dump trucks, all at the same time.

Wiping out at Dungeons means being helpless, 30 feet under water, over a reef in the middle of an area that is like a food court for white sharks and other giant critters. What surfers have considered "heavy" has grown in intensity over the years, but it was right around the turn of the century that Laird Hamilton rode his "Millennium Wave" on a barrier reef of Tahiti, and sent the surfing world spinning into a new definition of what could be done, and survived.

THERE ARE NO WAVES IN TAHITI!

Seventeen degrees south of the equator, about an hour's drive from the Papeete airport, on the southeast corner of the main island of Tahiti, at the end of the main road and a 20-minute paddle out to sea, Teahupoo is a left-breaking reef pass that explodes on a coral reef with an intensity that is, in the words of Lieutenant King of His Majesty's Navy: "scarcely to be credited".

Pronounced "cho-poo", the Tahitian word translates to "the hot head", supposedly to honour the son of a murdered king, who avenged his father's death by feasting on the fresh brain of the son of his father's murderer. An appropriately heavy

PREVIOUS PAGE *An extreme bit of nastiness, even when seen from above, which still gives you chills. This mass of the old ultra violent is Teahupoo, a reef in the Society Islands that has redefined "heavy" in the surfing world.*

"Teahupoo is the balls to the wall, craziest wave in the world for sure."

World Champion Andy Irons

name for a wave that has emerged in the last 20 years as the new Golgotha, an almost impossibly hollow, thick, nasty beast of a wave.

Teahupoo is a freak of nature, formed when powerful open-ocean swells born deep in the southern ocean suddenly trip over a shallow reef in the middle of the South Pacific. The reef at Teahupoo is more than 10 feet under water, but swim to the edge of it and look over and you are looking at an underwater cliff that runs off into the blue, and then into the black. Steep and deep, with sharks cruising the ridgeline.

BELOW Teahupoo aka "Chopes" might not be the biggest or the deadliest wave in the world but it is arguably the heaviest, where heavy = height x width divided by the shallowness of the reef and squared by the power of open ocean swells. That is Carlos Burle in the danger zone and heading for the light.

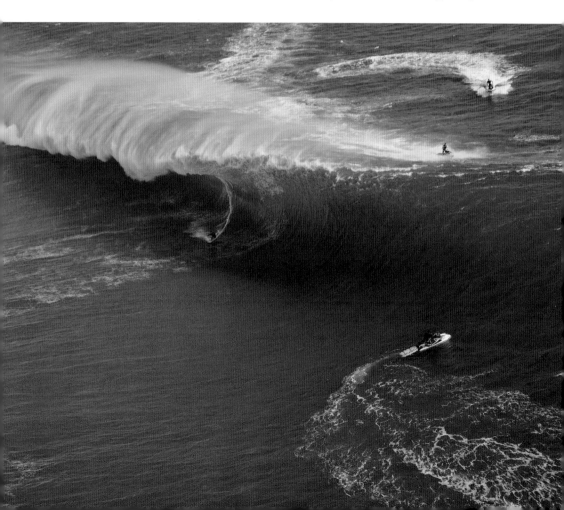

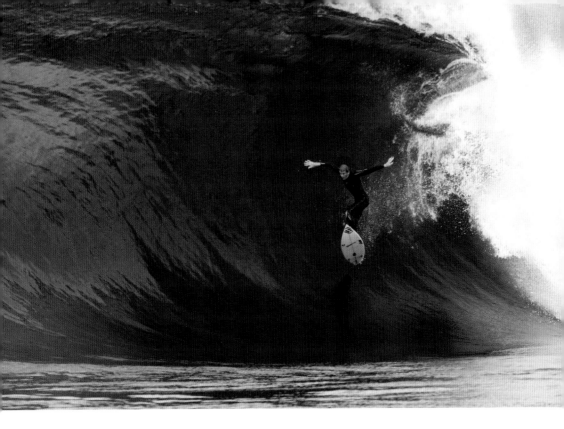

Incoming swells roar in protest at their sudden, unexpected demise, and riding these waves on the biggest days has become the most extreme pleasure of modern surfing – a challenge different from monster waves like Jaws, Mavericks and Dungeons, but arguably the biggest challenge of them all: "Teahupoo is the balls to the wall, craziest wave in the world for sure," World Champion Andy Irons said before the 2005 Billabong Pro. "The depth of the water out the back, and how shallow it gets, and how quick make the wave's lip just so much thicker and more powerful. Pound for pound, it's the scariest wave in the world!"

Depending on whom you talk to, local surfers began paddling out to this barrier reef at the end of the road in 1985 and called the spot End of the Road. Because the wave leaps so abruptly over the reef – too fast for most surfers to get to their feet – End of the Road was a bodyboard spot through most of the 1980s, with Mike Stewart leading the charge through long, twisting tubes.

In the first issue of *Surfer* magazine of 1992 there is a sequence of Vetea "Poto" David using a jet ski to tow into a massive wave, somewhere in the Society Islands. The wave was unnamed, but soon the world would know its identity: Teahupoo.

ABOVE *During the winter of 2003–2004, local Tasmanian surfer Andy Campbell was nominated for Monster Tube at the XXL Awards. The world saw two photos of Shipstern doing the* Beauty and the Beast *thing. The first photo was Campbell at the bottom of a nightmarish, roiling glurge of a wave that looked like the world was coming to an end on his head. The second photo was prettier and showed Campbell about halfway down the face of a big barrel, his board going airborne. Those photos shook up the world, but there were more to come. This is Laurie Towner, hoping for a safe landing.*

In August 2000, only a few weeks after a local surfer named Briece Taerea was killed on the reef, Laird Hamilton chased a giant southern hemisphere swell to the end of the road at Teahupoo. With cameras in the channel, Darrick Doerner whipped Laird into a huge lump of water that roared over the reef with great vengeance and furious anger. Laird made physical adjustments that came from who knows where, his weight on his back foot, his right hand dragging for stability, and he came out in a huge cloud of compressed "spit", gliding to safety alive, and into immortality.

That wave had the same effect on the surfing world as Cortes bringing horses to the New World, or Captain Cook's arrival in Hawaii. One frame of that ride ran on the cover of *Surfer* magazine, with the words, "OH MY GOD!"

Laird's unbelievable ride was the grand finale in Stacy Peralta's big-wave documentary *Riding Giants*. That wave brought audiences to their feet when the documentary premiered at the Sundance Film Festival as Greg Noll, Pat Curren and many big-wave surfers expressed their incredulity about what Laird had done: "In my prime, at my best, I could have never ridden a wave like that," Pat Curren said onscreen. But the ride was summed up best by former *Surfer* magazine editor Matt Warshaw: "I think it's the single heaviest thing I have seen, in surfing," Warshaw said. "What could be heavier than that?"

Surfers have been trying to answer that question ever since. Laird's wave at Teahupoo was like the firing gun at the start of the Oklahoma Land Rush and now surfers are boldly going to ocean places where angels fear to tread, looking for even heavier waves and situations.

SHIPSTERN'S BLUFF

In the early 1990s, Association of Surfing Professionals (ASP) President Graham Cassidy was poking around in Tasmania, working on local authorities and promoters to run a World Qualifying Series event somewhere on the island. During his tour, Cassidy was led by local surfer David Warbank, who gave him a glimpse of an insanely heavy right reef that broke under the shadow of a 100-foot cliff shaped like the backend of a giant ship.

The wave was nuts, a reef taking in raw energy from the Roaring Forties – and exploding huge, warbling, gaping barrels on a shallow, jagged reef. The place was almost as hard to get to as it was to surf: a short boat ride, or a two-hour walk through a National Park and farmlands. "Nobody was surfing," Cassidy said. "I remember Dave saying hardly anyone knew about it. It's pretty haunting stuff. The rock is so chunky and sharp, you start thinking about the possibility of something going wrong out there."

The buzz about Bluff Reef – aka Shipstern's Bluff – began around then, but it took another 10 years until the remote reef would inspire the world. Local surfers considered Bluff Reef mostly unrideable: too much trouble and strife to get to a place that would most likely break your board and/or drown you.

"The wave was nuts, a reef taking in raw energy from the Roaring Forties – and exploding huge, warbling, gaping barrels on a shallow, jagged reef."

Justin Gane is a videographer from northern New South Wales who first showed images of Shipstern's Bluff to the world in the surf movie, *Pulse 2001*. But Gane had only been let in on the secret by local Andy Campbell on the understanding that he didn't publicize the location.

Andy Campbell walked in fully armed and equipped, with outsiders Brendan Margieson and Dave Rastovich. Justin Gane captured two epic days in 10- to 12-foot conditions, but when *Pulse 2001* was released, the spot was identified as "Fluffytonka" and that is why it took the rest of the world a while to find: "We told the media it was on the West Coast to throw them off the location," Gane said, "and renamed it so no one could find it on the map. We all know what happens when the media gets hold of something: They gotta let the whole world know and

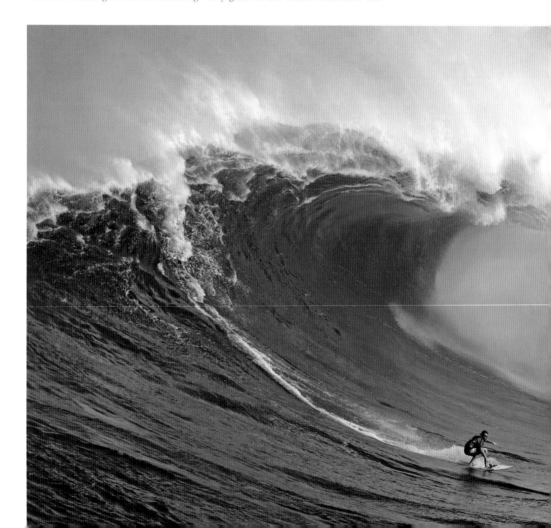

claim the wave was their own discovery, and the truth is so far away from how everything started."

Sean Davey is a natural-born Tasmanian, and he was determined to be the photographer who presented the Bluff to the world. Davey and *Tracks* magazine assembled a crew that included Kieren Perrow, Drew Courtney and Mark Matthews.

From Hobart they drove a paved highway to a dirt farmer's road and at the end of that, they geared up for a long walk through the bush to one of the ends of the earth – guided by two local rogues who knew the way. The tyranny of distance is one factor that kept Shipstern's out of the world's view for so long.

Kieren Perrow proved he was young and fit enough to survive a total freefall over one of those stair-stepping ledges that launched his entire surfboard completely out of

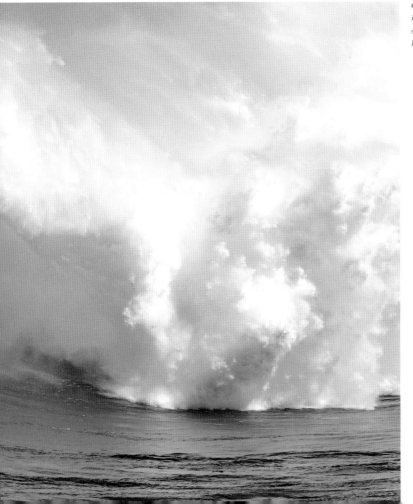

LEFT *The power and the glory that is surviving a trip down the face of Jaws, or Peahi, as it is officially known, on a 35-foot day.*

the water as the lip was descending. Landing at the bottom with no speed, Perrow leaned into a half-baked bottom turn, somehow got an edge set and pulled into an enormous barrel that spat him out to the channel. That sequence appeared in *Tracks* and *Surfer* and *Surfer's Path* magazines, and against Davey's wishes, the spot was named: "I made it a point that no mag was allowed to even call it Tasmania with my images," Davey said. "We simply referred to it as Southern Australia. It was actually local photographers that first named it in *Australian Surfing Life* magazine, ironically with pictures from our session. So, you can go with the best intentions and insist on certain conditions, but if there's others about, all guarantees end up out the door."

In March 2006, Hawaiian surfer Andy Irons was part of a crew that included Queenslanders Brendan Margieson, Joel Parkinson, Angourie local Laurie Towner and a guy with a name that sounds like he came from Middle Earth: Dylan Longbottom. They caught Shipstern's as big and mean as it can get. Joel Parkinson survived a horrendous closeout that fortunately exploded him up and away from the shallow reef.

Andy Irons became a believer: "Shipstern's is radical, it's a really challenging wave, one of the toughest I have ever surfed," Irons said. "With the staircases in it and the way it hits the reef, it is so powerful, and with the cold water you're not really penetrating the surface when you fall. I have never really surfed a barrel that changes so much as it goes along."

EYE WIDE SHUT

The coastline of mainland Western Australia goes as low as 35 degrees south and as high as 13 degrees south. In between, the mainland coastline is 12,889 kilometres, with islands adding another 7,892 kilometres to that total, which gives surfers more than 20,000 kilometres of coastline to explore.

In 2003, a crew of surfers spanning the globe on the Billabong Odyssey went looking for waves in a corner of the Western Australian coast that was not so obvious. Instead of going to the badlands north of Perth, they went the other way, close to Esperance, chasing a wave that even the bodyboarders whispered about.

The Billabong Odyssey was the invention of Bill Sharp, who used science and local knowledge to track down big waves and heavy situations that had been overlooked by the outside world. He was searching for places in the world where coastlines were oriented so they received a ton of swell, and the prevailing storm winds were offshore.

GARRETT McNAMARA'S HEAVIEST

Garrett McNamara has made spectacular waves at most of the world's heavy spots, and he has also taken some harrowing wipeouts. During the late November swell of 2007 at Teahupoo, McNamara towed into a wave behind Raimana van Bastolear and travelled through an incredibly deep wave before it gobbled him up. What could be heavier than that?

"Teahupoo is violent and powerful but only for a short time. It dissipates relatively quick," McNamara said. "Peahi – or the famed Jaws – takes you for a long ride up, down and all around for what seems like eternity. Tahiti will scrub you to death and Peahi will drown you. Take your pick; they are both a very bad place to wipe out. I feel the "hold my breath" exercises I do have enabled me to feel comfortable with all the wipeouts I have faced. Most of all I have a close personal relationship with God."

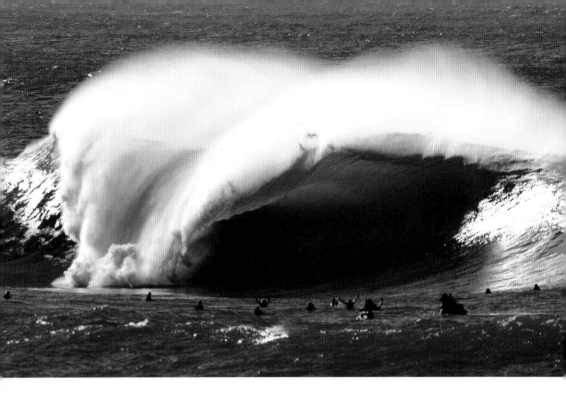

The whole bottom of the country had potential, and Sharp's research led him to the Archipelago of the Recherche, in Western Australia. A hundred and five islands off the coast, tons of swell, offshore winds. Sharp aimed a Billabong Odyssey expedition to that obscure corner of Australia. They chartered a 65-foot boat out of Esperance, loaded it up with four jet skis and took on local diver Greg Spouse to guide surfers Mike Parsons, Brad Gerlach, Layne Beachley and Ken Bradshaw: "Greg knew the area as well as anyone but hadn't surfed much in the islands," Sharp said. "The wave I thought had the most potential turned out to be not so good. But Greg said he had seen a pretty sick wave a couple of islands over so we went and had a look and there was that wave."

The crew of the Billabong Odyssey were also gobsmacked, checking out this hideous thing, breaking way out to sea, in the middle of nowhere. Getting hurt looked like a sure thing, but Esperance was eight hours away by boat, "and their emergency room was not exactly the Mayo Clinic," Sharp said.

Because the Billabong Odyssey had found the spot, they claimed the naming rights. The first name was Goldmines and then Greg's Knoll in honour of Greg Noll, the godfather of all big wave surfers. But their "Odyssey" theme steered them toward Homer's mythic beast Cyclops, the one-eyed monster of Greek mythology that would just as soon eat men or throw them over ledges.

ABOVE *Laird Hamilton's Millennium Wave at Jaws in 2000, and the ongoing XXL Awards have inspired surfers around the world to look for thicker, nastier, heavier waves and to reconsider spots they had written off as too dangerous. Australia's gazillion miles of open coastline are loaded with spots, like this bombora going off in Southern Australia. Check the guys in the channel, throwing up their arms to salute this epic barrel on the best day they had ever seen.*

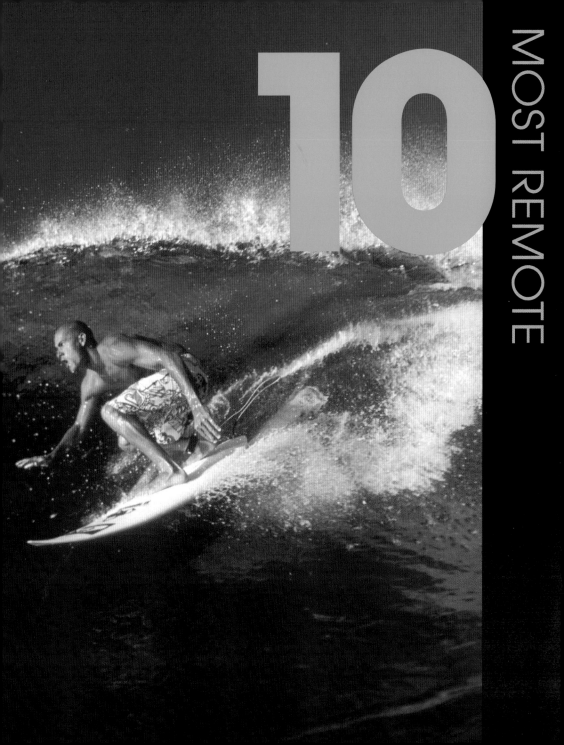

FARTHEST FLUNG

IN 1974 A TRAVELLING Australian surfer named Tony Hinde and his mate Mark Scanlon were on a walkabout, looking for surf in obscure corners of the world and found themselves in Sri Lanka. Looking on the map, they wanted to get to the surf hotspots of South Africa and the cheapest and most direct route was across the Indian Ocean by sea. They shipped out on a yacht called *White Wings*, crewing for a skipper who "seemed to know what he was doing," Hinde said. Until *White Wings* ran aground on a reef in the middle of the Indian Ocean.

They had run into the Maldive Islands, about 40 miles north of the capital of Male. The islands' main industry came from the sea, and tourism was almost non-existent. Hinde and Scanlon spent nine months in the Maldives salvaging the yacht, and in their coming and going they couldn't help but notice the place was absolutely loaded with perfect surf, breaking in crystal clear water over pristine coral reefs.

Back in the real world they couldn't shake the images of all that perfect surf. Hinde came back the following year with a surfboard and for the next 15 years surfed all those perfect reefs mostly alone.

Hinde married a local girl, converted to Islam and became Tony Hussein-Hinde. In the 1980s he began discreetly guiding groups of Australians around the Maldives, swearing his clients to secrecy. Of course that didn't work, and in 1989 Hinde founded Atoll Adventures and started the Maldives' first surf camp at Tari Village on the island of Kanu Huraa.

WEST OF JAVA

Ignoring the dangers of tropical diseases and tsunamis and the vague threat of Islamic, anti-western feeling that runs through the east, the Maldives are now a major surf destination, as are the Mentawai Islands of Sumatra. Despite two horrific bombings in Bali, surfers continue to travel to the archipelago and surf the coast from Timor all the way across to the top of the Mentawais.

According to the *Encyclopedia of Surfing*, American hotelier Robert Koke introduced stand-up surfing to Kuta Beach in the 1930s, but it wasn't until the 1960s that surfing caught on, imported by travelling Australians and Americans. Indonesian surfing began appearing in surf movies in the early 1970s, but it was the mesmerizing images of Stephen Cooney and Rusty Miller riding the long lefts of Uluwatu in *Morning of the Earth* that fired the starting gun.

PREVIOUS PAGE *Kelly Slater, surfing in the Mentawai Islands off Sumatra. Inhabitants of many of the islands still live a primitive tribal lifestyle.*

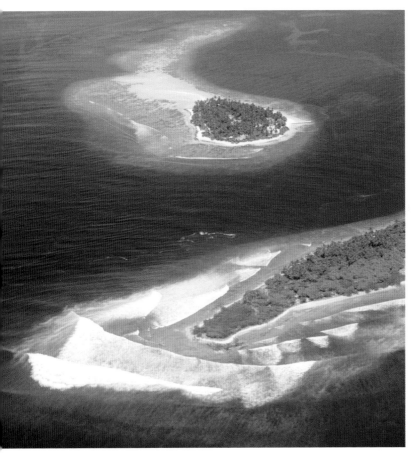

"They couldn't help but notice the place was absolutely loaded with perfect surf, breaking in crystal clear water over pristine coral reefs."

The first surf shop appeared in Kuta in 1974, and surfers began fanning out from there, moving east and west through some of the 13,000 islands of the archipelago, looking for the magic.

In the 1980s, foreign surfers went "feral" in the Mentawai Islands, taking arduous bus rides, catching rides on yachts or moving around in native canoes to surf the same variety of incredible breaks that Tony Hinde found in the Maldives. The Australians tried to keep it quiet, but that didn't work, and in 1991, an Australian salvage diver named Martin Daly began operating his boats *The Volcanic* and the *Indies Trader*, poking around in the Mentawai Islands and finding great surf spots.

In only 30 short years, Indonesia has become one of the surfing capitals of the world, home to thousands of native surfers, hundreds of surf spots, dozens of surf shops

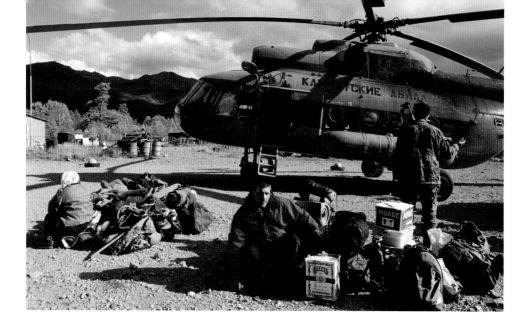

and a wide variety of surf travel companies and surf companies, providing access to the islands in vessels and camps ranging from sketchy to luxurious.

Surfers are always looking for that perfect wave though, and as the once-feral surf spots of the Mentawais began to look like a scene out of *Water World*, with a dozen boats and scores of surfers battling for waves, some surfers began looking ever deeper into the Indian Ocean, to the Nicobar and Andaman Islands.

OFF LIMITS

The Nicobar Islands are administered by India and lie 1,300 kilometres east across the Bay of Bengal. The Andamans are separated from the Nicobars by the Ten Degree Channel. In October 1999, John Callahan was trip photographer with a group of surfers who had set out from Port Blair in the Andamans and wanted to make the jump to the Nicobar Islands. They were on board the yacht *Crescent* for several weeks, out of Patong Bay in Phuket in distant Thailand. The skipper was an ex-SAS commando named Graham Frost, along with a crew of UK and Thai internationals looking after the boat and the surfers.

Dealing with a tropical, Third World, isolated bureaucracy is always fun, so Callahan and friends were having a great time, anchored in Port Blair for a week, going from steaming office to bored official, hoping to get elusive Nicobar Islands access. Officials in the Andaman Islands had no problem with the *Crescent* crossing the Ten Mile Channel, so long as the surf charter stayed 12 nautical miles offshore. "We were in the Nicobars to find new waves," Callahan said. "Within 24 hours, we were

ABOVE *Kamchatka juts into the north Pacific from Siberia. The volcanically active island was off limits to Russians until 1989, then opened to the world in 1990. Naturalists, steelhead fishermen and snowboarders rushed in to see what Kamchatka had to offer. They found 472,300 square kilometres of almost pristine wilderness, tempered by shipyards where liquid and solid radioactive wastes were stored. Kamchatka separates the Sea of Okhotsk from the Pacific Ocean, which means it's directly under the flight path of all those winter low-pressure systems moving into the Gulf of Alaska. Surfers ignored the Kamchatka Peninsula until early this century when the Rip Curl Search sent Tom Curren and Brian Toth to the land of active volcanoes and hot lakes and mega-brown bears to see if there was any surf worth travelling for.*

a lot closer to the beach than 12 nautical miles. The boat was anchored about 100 metres from shore, and we took a dinghy to the beach. There was a decent setup on the east side of this island, sheltered from the relentless southwest wind, and the boys were ready for a few waves."

Callahan went to shore with his camera gear and a VHF radio in a plastic bag. They found some decent waves: chest high and fun, but nothing that would cause a big sensation. Callahan shot a few photos while the others surfed and then took a nap. Emergency noises coming from the VHF radio signaled all was not well with Captain Frost, who was sounding a little anxious: "Get back to the boat now! Big ship coming, straight up the channel. I don't think they've seen us yet." The shore party high-tailed it back to the boat.

In a scene out of World War II, a big Indian Navy ship was steaming straight at the interlopers. The Thai crewmen were freaking out a little, and Callahan got the surfers and his gear back in the dinghy. They motored back to the *Crescent*, as Callahan worried about the implications of arrest. In Port Blair, they had all seen several impounded fishing boats tied up in the harbour, and along the roads, miserable Thai and Indonesian fishermen, in leg irons, convict road crews "breaking rocks in the hot sun".

Back on the boat, the Navy ship was visible with the naked eye and on radar, but the big question was, had the Navy ship seen them?

"With where he is and where we are, we are going to be hard to spot," said the skipper. "We're close to shore, and the sun is setting behind us. He has to look into the sun, with binoculars, to pick us out. And, he's not expecting to see a boat here. Where he can see us is on the radar."

For an hour Nong, the Thai deckhand, nudged *Crescent* around using the dinghy while the rest of the crew kept their ears on the radio, trying to interpret words of alarm and action from the Indian bubbling over the radio. The Indian Navy weren't looking for a boatload of surfers a couple hundred yards from shore, so they missed them. After a very tense, sweaty hour, in which the skipper and the surfers and the photographer had nightmares of losing everything and going to jail, they began breathing again. And then got the hell out of there.

Callahan's story is a cautionary tale to other surfers tempted to probe the Nicobar Islands looking for secrets. He suspects these abandoned airstrips and naval bases are storage areas for chemical and nuclear weapons for the Indian Army. "A distant, offshore island group is the ideal storage solution, and they don't want anyone messing around in the Nicobars for any reason. Not even for perfect, unridden tropical waves."

Some surfers find solace that in this crowded world, the surfer can still seek the perfect wave on the perfect day, and be alone with the surf and his thoughts – even if those thoughts include being speared by headhunters, arrested by the Navy, killed by volcanoes or tsunamis, poisoned by radiation or bad water or bad food, eaten by a shark or bitten to pieces by malarial mosquitoes.

"Get back to the boat now! Big ship coming straight up the channel. I don't think they've seen us yet."

Graham Frost

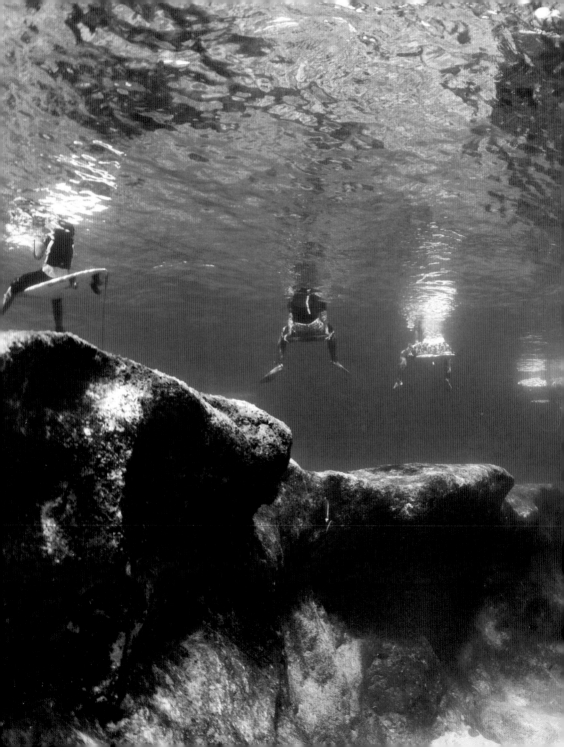

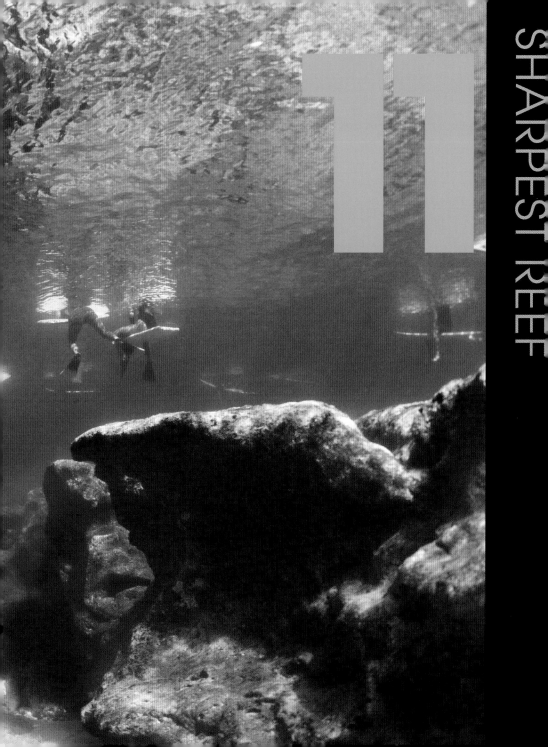

11

LOOK SHARP

DR. RICKY GRIGG IS ONE of those brainiac surfers with letters after his name. Originally from Santa Monica, while Grigg was earning a bachelor's degree at Stanford University in 1958, he was surfing the big waves of Santa Cruz. He earned his masters degree from the University of Hawaii in 1964 and also mastered the Hawaiian surf, becoming one of the pioneers of big-wave performance surfing through the 1960s. While earning his PhD in Oceanography from the University of California at San Diego, Scripps Institute of Oceanography, he rode big waves at Black's and La Jolla.

In 1967 he interrupted his studies to fly to Hawaii to compete in the Duke Invitational held at Sunset Beach in absolutely perfect surf. Grigg showed up with no tan, hit the water cold turkey and won the whole thing. Grigg is now a professor in the Department of Oceanography at the University of Hawaii at Manoa, where he is one of the world's experts in coral reef ecology and has published over 100 scientific papers including *The Biology of Coral Reefs of the Northwestern Hawaiian Islands* (2008).

This guy knows what's up, and when Dr. Grigg speaks about what lies beneath, people listen. "Actually for coral I can give you two categories of superlatives," Grigg said. "Hardest = Teahupoo and the Banzai Pipeline and that is because the bottom in both places consists of a fossilized super-hard limestone covered with a thin layer of living coralline algae that is equivalent to cement. As for the sharpest, I would lump all the atoll passes in the South Pacific that have low to moderate surf wrap-around breaks. There you get live species of *Acropora* and *Pocillopora* corals that will cut you to ribbons if you fall on them."

In layman's terms, Ricky Grigg is talking about staghorn coral, so called because the polyps form into branches shaped like the antlers of a male deer. It is the scourge of surfers around the tropical zone. Imagine falling into a pile of rock-hard, razor-sharp deer antlers and being rolled around, helpless, 20 feet under many tons of water, and that gives you an idea of what it's like to surf over coral reefs.

When Dr. Grigg says "low to moderate surf wrap-around breaks", he is talking about a genre of surf spot that includes some of the most famous surfing waves in the world: Restaurants and Cloudbreak in Fiji, Teahupoo in Tahiti and dozens of breaks from Haiti to Hawaii to the Hinako Islands. Kelly Slater has had scrapes with the world's most famous coral reefs and puts up Restaurants as the sharpest he's encountered.

Brock Little grew up on the North Shore and is no stranger to coral reefs: "I wouldn't discount Chopes," Little said, referring to Teahupoo. "If you so much as touch the reef there you are going to get a staph infection, guaranteed. I have gone diving there and yes the reef gets hammered by big surf, but there is still plenty of coral down there."

PREVIOUS PAGE *What lies beneath. This extreme bit of nastiness is the Pipeline reef. A limestone base hard as cement, topped with coral heads. The water depth is at best six feet, and there are 8- to 10-foot waves breaking over it. Bad, but other reefs are as bad or worse.*

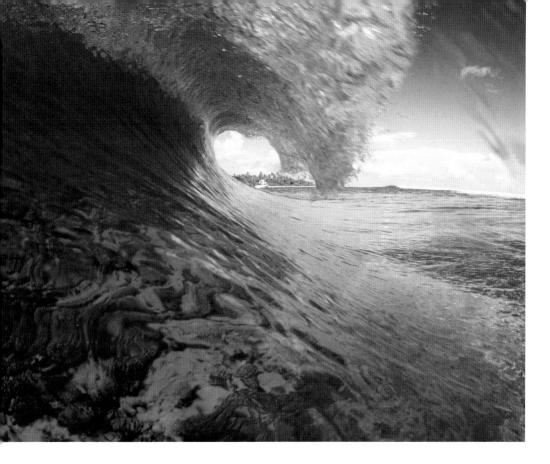

What is true of Scar Reef is true of hundreds of Indonesian reefbreaks from East Timori to Western Sumatra. The staghorn coral that thrives in the South Pacific also thrives in the Indian Ocean, and the reefbreaks of Indonesia and the Mentawai Islands are every bit as perilous as Restaurants or Teahupoo.

And if the reefs of the Mentawai weren't dangerous enough already: "Now, in the Mentawai some of the reefs are even shallower because of uplift caused by the tsunami," Dr. Grigg said, "so they are even more dangerous than before. But again, you can find similar dangerous coral shoals all over the world. Caveat emptor."

The tropics don't have the exclusive on sharp reefs. The barnacles and mussels that grow on rocks in the temperate zone can be every bit as sharp as coral, and surfers who have bounced off the bottom at Shipstern's or Aileens in Ireland can only shake their heads and be glad they were wearing wetsuits when they see what all those calcium coverings did to their expensive neoprene.

ABOVE *The reef passes of the South Pacific don't have an exclusive on sharpness. Follow the equator around the world, and you'll find plenty of trouble from Haiti to Sumbawa to the Maldives. This is the beast under the beauty in the Maldives.*

ROCHELLE BALLARD: AN ESSAY ON EXTREME PAIN

When Rochelle Ballard walked away from a long pro surfing career in the winter of 2007, it was almost a miracle she could walk. At the age of 36 Rochelle competed on the ASP Women's Tour going back to 1991. She was one of the women who led the charge in gnarly, dangerous waves, doing things the world didn't think women were willing or able to do.

Growing up on the North Shore of Kauai, Ballard was no stranger to sharp coral reefs. But in 20 years of travelling to compete and to surf, she became closely familiar with sharp reefs around the world. Rochelle has had more than a few scrapes, sprains, collisions and near-death experiences. Her injury list is enough to make a rodeo cowboy swoon.

NECK: During the *Blue Crush* movie, I was listed in critical condition after a stunt shoot. It was the scene where Anne Marie is cut off by her ex-boyfriend and they collide. I was surfing for Kate Bosworth and Chris Won was the ex-boyfriend. We were out at perfect Lani's. First wave, riding down the line, I see the camera set up for the shot, but no Chris. So I kicked out. At the same time that I was kicking out, Chris was trying to catch up and come down in front of me. We collided so hard that both of us went flying. It was an instant slamming pain to my neck, and sudden paralysis to my left arm and neck. Brock (Little) rode in with the ski to pick me up and had to grab me out of the water. I couldn't get up myself. Took me a couple years to recover from the nerve damage in my neck.

NECK: When I rode for Swatch, they sent me to Italy to ride the Bruticus Maximus on the top of the hill in Florence. It was gorgeous, riding at night with the stars above the statue of David and guys riding into the sky doing big airs and tricks. I was the only girl. It was an amazing setup but I was having a hard time with it. I kept getting pitched over the barrel and slammed against the back wall. Christian Fletcher felt bad, so he told me to jump on his back on the body board and stand up on him when we got in the barrel. I finally was riding in the barrel, everyone was cheering. We were in it for a while and didn't know one of the riders was standing above the barrel on the frame. He didn't see that we were still in the wave and jumped from the top and landed right on my head and shoulders. I went home that night with an amazingly sore neck and a swollen bruised ass!

HEAD: The '97 US Open at Huntington Beach was held during a bombing south swell. In the semi-finals I got caught in a bad position – I tried to dodge through the pilings: baaad move. I dodged one piling and hit the next one head on! The whitewash was so big it lifted me up above the water level about 4 feet (which was a good thing considering the lower area on the piling was full of barnacles that could have sliced me up). I hit smack dab on the left side of my forehead and passed out for a couple seconds. Pam Burridge was paddling out on the other side of the pier and saw it happen. She instantly grabbed me. I came to and immediately got on my board and tried to paddle back out. Pam was like: "What are you doing? The shore is the other way! You hit the pier! You're not okay!" It wasn't until I set foot on the sand and was

immediately surrounded by lifeguards and paramedics that it all hit me. My Dad, Grandma and ex were all standing over in tears. I think that's what scared me more. I was like: If they're crying I must be in pretty critical condition. I started to panic and passed out a couple times. They postponed the contest until the next day, just in case I was well enough to surf. So I decided to do it. My family was not too happy about my decision, but I was amped. I won the contest and the next WCT in Lacanau. It took about four years of chronic headaches and neck pain until I recovered.

FACE: When I was 14, the nose of my board hit me in the face, on the right side of my nose and fractured my right orbital rim. I had to get surgery and a tiny plate put in.

NOSE: I broke my nose three different times until I finally had reconstructive surgery on it. The first time was on Kauai when I was 16. I pulled into a closeout barrel and when I fell off, it tossed me straight to the bottom and I banged my nose on a flat rock.

SHOULDER: I went surfing with friends when I was 22. We were out on the north side of Kauai surfing a barrelling left. I pulled into a closeout and got sent straight to the bottom. My head and shoulder hit the reef. I was so shook up by it. I was afraid of surfing backside barrels for a few years after that. I was afraid of hitting my head again. It wasn't until Teahupoo became an event for us that I really started enjoying it.

HEAD: During the filming for an O'Neill surf movie in Tahiti, I hit my head in a closeout. It was 6- to 8-foot Teahupoo and I was pretty nervous. I took off on the first wave of a big set, grabbed my rail on the drop and then let go and stood up in the barrel. It was so big and round. I realized a second later I wasn't going to make it out. At the time, I didn't have enough experience to realize it was better to jump off than keep riding it through, because it only gets more shallow. So, I rode it through until the foamball lifted and tossed me off my board. I went under and before I could control my body in the turmoil, it took me and threw me over with the lip. I had this horrible feeling I was going to hit. The instant I hit the surface, my head slammed on the reef. I came up dizzy with blood pouring out of my head. I was on dry reef with sets still coming and an enormous amount of whitewash heading straight for me. The only chance I had of not being cheese-grated on the

reef was to bellyride the board straight in. The doctor said he couldn't stitch it because it was a little hole not a gash. I don't willingly pull into closeouts at Chopes now.

RIBS: We were filming for the original *Blue Crush* all-girls surf video in Samoa. After kicking out of a wave at Salani's, a bomb broke right in front of me. I tried to duck dive it, but the board ripped out of my hand and my leash snapped off and the board got tossed into the cliffside. The wave grabbed me like a dog with a piece of meat. I tore my intercostal muscles, in between my shoulder blades and ribs. Salani's is a good distance from the shore, about a 15-minute paddle out. There I was: no board, torn muscles, and I had to swim in. That sucked!

RIBS: I was out at Sunset, dropping into a 12-foot wave. I hit a bump and got launched forward. I was going so fast that it skipped me down the face and I fractured a rib.

RIBS: I pulled into a barrel out at Backdoor, the foam ball caught up with me, tossed me and the nose of my board spun around and jabbed me in the ribs. It fractured one on my right.

KNEE: When I was 13, I hit the reef with my right knee surfing a shallow left at home. I had to get seven stitches.

FOOT: When I was growing up, I pulled into a sandbar barrel backside at home. The foamball caught up with me and flipped my board up, tossed me around. The fin sliced my right foot. I got seven stitches in the foot.

LEG: I have a Junior Pro that I just started on Kauai last summer. The day that the kids were all coming in for the camp I went out for an evening session at my local break. I was having one of those easy sessions, good timing, avoiding the big impact sections and having fun. This spot usually doesn't barrel, but it was kegging that day! I hooked under the lip in a fat pit, grabbed my rail, and locked in. Then the wave hit a weird water pocket, and the wall of water over the top of me clammed down on me like a can being smashed. I felt my whole leg shove up into my hip. I was in so much pain; it put me in a state of panic, like I couldn't swim. I quickly snapped out of it, realizing if I didn't I could be in a worse situation with sets rolling in over me. I got on my board and belly-rode in. I tore, compressed and stretched my ligaments, muscles and tendons, and hairline fractured my anklebones. Heavy!

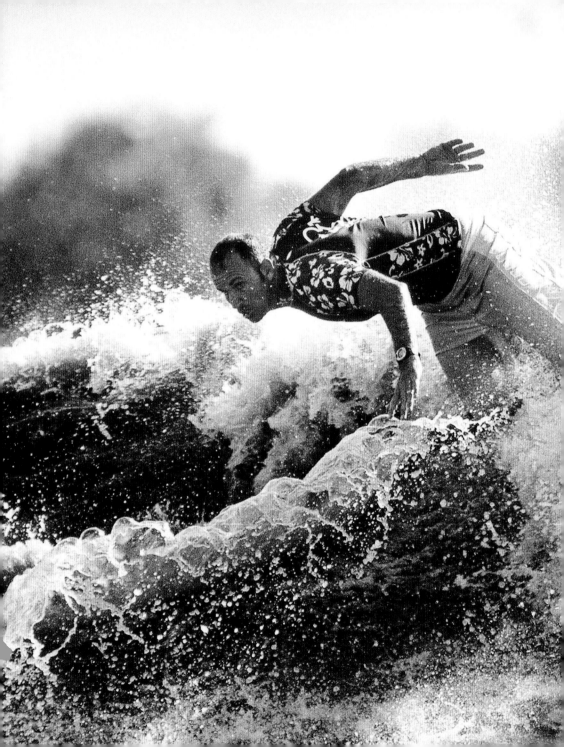

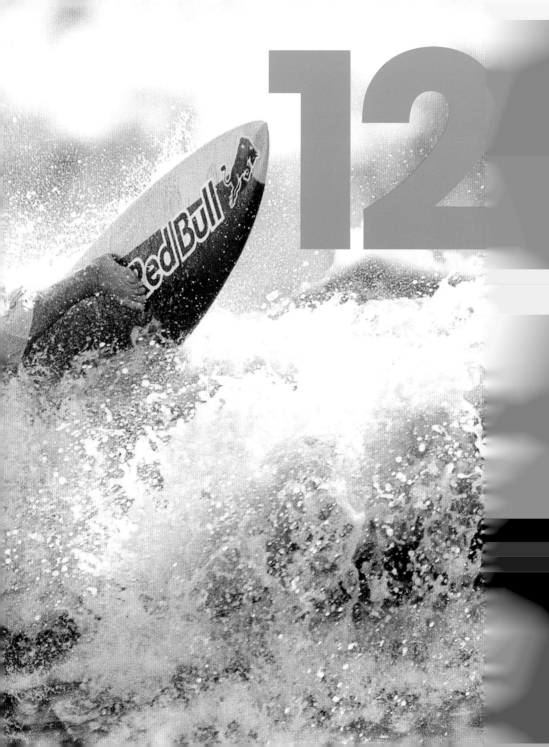

TIDAL BORES

IN OCTOBER 2007, an international group of surfers including Antony "Yep" Colas travelled to Hangzhou, a city 100 miles southwest of Shanghai. Hangzhou is on the Qiantang River, about 40 miles from Hangzhou Bay, which is "trumpet-shaped" according to the official website for Hainan. The bell of the bay where it meets the ocean is about 60 miles wide, but the bay narrows where it becomes the Qiantang River.

The ocean tide enters Hangzhou Bay as a huge mass of water that is funnelled and compressed by the narrowing of the land on both sides. The compression intensifies the gravitational push of the tides so when it moves through Hangzhou Bay into the Qiantang estuary and up the Qiantang River, the tide keeps going up river as a wave. A wave that can be surfed past Toupeng, through Hangzhou and maybe as far as Fuyang and Xindeng.

This effect is described best on the Hainan website: "When the tide begins to flow, the wide and deep mouth of Hangzhou Bay swallows a large amount of seawater quickly. Because the river becomes shallow and narrow suddenly, the surging tidewater has no time to rise in order, resulting in waves urging waves, waves upon waves, and steep walls of water formed."

This phenomenon is known to the world as a tidal bore, but the Chinese have a special name for theirs: The Silver Dragon. This regular, aquatic phenomenon happens twice a day with every incoming tide, and the Silver Dragon is to China what Old Faithful is to America – a national symbol.

Apart from being the world's deadliest tidal bore, in October 2007 it became a Guinness World Record contender again when French surfer Patrick Audoy and Brazilian Eduardo Bagé took to the waters of the Qiantang on a stand-up paddleboard and longboard, stroked into a wave and kept going, for 17.1 kilometres up the Qiantang River. Audoy and Bagé rode the wave for an astounding hour and 10 minutes.

If those measurements are verified, then Audoy shattered the previous, officially observed Guinness World Record set by Brazilian Sergio Laus on the *pororoca* of the Araguari River in June 2005.

The record ride made the local papers, but that wasn't necessarily such a good thing. Although the *Hangzhou Youth Times* was pretty stoked on the whole deal, the local police were not: "Such is the danger that the police and marshals who patrol the banks when the bore is moving are on high alert," said Antony Colas. "Now here were a bunch of foreigners flouting the law and throwing themselves in front of the waves, yet in doing so they had potentially earned Hangzhou a place in the record books!"

"Now here were a bunch of foreigners flouting the law and throwing themselves in front of the waves..."

Antony Colas

The police found the law-flouting foreign surfers at their hotel and had a meeting. An officer held up the Chinese law forbidding entry to the river as the bore is roaring through. That law was designed to protect over-zealous tide teasers, but the cops made it clear that it applied to foreign surfers as well. Colas said: "They warned everyone in the group explicitly that they would be arrested, their passports confiscated, and that they faced a possible jail sentence if they entered the river again."

That didn't stop the surfers, who were keen to push the record even further. They chose another part of the river, far from the crowds and the cops. Many local Chinese were jazzed at the thought of men who could walk on water taking their recreation on this natural wonder of the world. Defying cops and laws is not something Chinese do easily, but the foreign crew of bore surfers found themselves with lots of willing allies who smuggled them down river in car trunks and scooters and tricycles.

BELOW The Silver Dragon bore has been famous since the Han Dynasty (206 BC to AD 220). Today, the Silver Dragon draws more than 250,000 people to the banks of the Qiantang for an annual "tide teasing festival". Many Chinese risk their lives by getting as close to the jaws of the Silver Dragon as they dare. Sometimes too close. In 1998 the bore was supersized by a typhoon and crested at 30 feet, killing over 100 people. They knew it was coming, and it still got them.

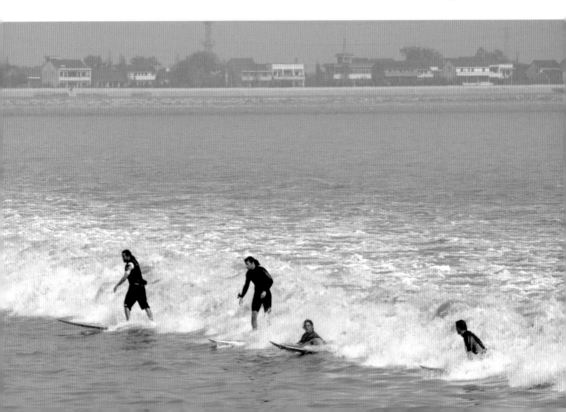

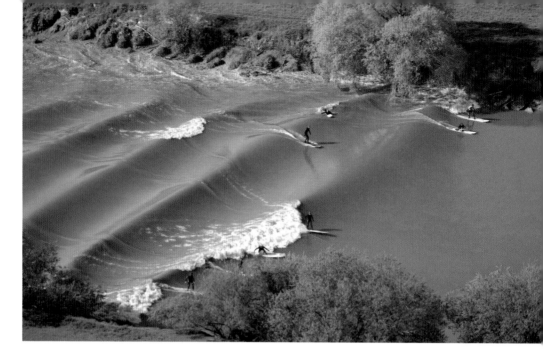

The Silver Dragon is capable of setting the world records for distance and height, and now it appears Colas and crew will have a second chance: "Bleuenn, our translator, is meeting the government of Hangzhou next week with Sam, the jet ski owner," he said. "We've written and signed a long proposal of a surfing and jet ski demonstration show for four days during the Tidal Bore Festival in September, 2008."

A COUNTRY GENTLEMAN: THE RIVER SEVERN

The Severn Bore is not the longest of all tidal bores but it has the longest history of being surfed. The word "bore" derives through Old English from the Old Norse word *bara*, meaning a wave or swell, and the Severn Bore may or may not have been the "divine tide" that saved Caratacus from a Roman Legion in AD 47.

The Bristol Channel is almost 50 miles across from Saint Govans' Chapel in Wales to Hartland Lighthouse in Devon, and the Severn estuary has the second biggest tidal range in the world. The tide is a massive volume of water that funnels to just over 3 miles at the Second Severn Crossing, where the body of water becomes the Severn Estuary. The bore first appears in the estuary channel at Newnham, where it is rideable for a distance and then disappears in deeper water. According to Tom Wright: "The bore can be seen breaking (very small) from Sharpness and then continues to break all the way to Maisemore weir. The first point at which it is 'safely' rideable is Newnham-on-Severn – 45 minutes upriver from Sharpness and an hour downstream of the Severn

ABOVE *According to Tom Wright, the hazards of Severn Bore surfing are "trees, fridges, dead sheep, dead cows, abandoned salmon putchers, five foot eels, and disrespectful grockels!" A grockel is not a fish or an eel, but southwestern English slang for "tourist", because now the Severn Bore has become as fashionable and sought after as elver. At some points along the Severn, bore-riding looks like a destruction derby, as surfers on shortboards, longboards, bodyboards and standup paddleboarders compete with grockels in kayaks and canoes – all of them trying to grab a piece of energy moving upstream.*

Bore Inn. The significance of the Severn Bore Inn is it is just up river (one mile or so) from the point the bore first enters the river proper and takes on its more memorable form as a moving surge."

The Severn Bore was first ridden by Lt. Col. Jack Churchill, nicknamed "Mad Jack" or "Fighting Jack Churchill". A military eccentric of the same vintage as T. E. Lawrence (of Arabia), he was renowned for making it through many perilous engagements in World War II. Mad Jack's adventures from Burma to Germany to Norway to France, back to Burma and then Palestine were the stuff of legend. By the 1950s Colonel Churchill was an instructor at the land-air warfare school in Australia and learned to surf in the land down under. Back in England in 1955, Colonel Churchill was ahead of his time when he saw the surfing potential of the Severn Bore, and he was the first to have a go, taking off at Stonebench and riding the tide upstream.

Donny Wright is a bore rider who made a documentary on bore riding called *Longwave* and who knows his Severn history: "In 1970 the first official record of 3.2 kilometres was set by a team from *Drive* magazine," Wright said. This record was challenged through the 1970s, and the profile of the bore was illuminated by the 1977 surf movie *Playgrounds in Paradise*, which showed British surf champions riding the bore. It wasn't until the spring of 1980 that Welsh surfer Pete Jones and Severn Bore specialist Stuart Matthews both achieved a distance of 4.16 kilometres. Two years later, the British surf champion of the time, Colin Wilson, extended the record to 4.7 kilometres using a retractable fin and a board custom-shaped for bore riding.

The new era of bore surfing began when a surfer named Dave Lawson from Rea picked up the bore fetish. Lawson first set a mark of four kilometres in 1988 from Lower Rea to the Lower Parting, which he later extended to 4.16 kilometres in 1995 for the popular children's TV show *Record Breakers*. Then, in August, 1996, Steve King shattered the record with a ride of 8.86 kilometres, only for Lawson to extend it to 9.12 kilometres the following month: "The official record distance of 5.7 miles as Dave Lawson held it in the *Guinness Book of World Records* was done in the top stretch of the river," Tom Wright said. "This involves crossing the river five times and negotiating several very tight bends but also includes several straight sections of a mile-plus where the wave breaks bank to bank."

Dave Lawson and Steve King were the bore lords out of the 1980s and into the 1990s, when bore riding became popular with just about everyone, from bodyboarders to canoeists to jokesters riding inflatable elephants.

The Severn Bore changes with the shape of the river bottom and the river bank, and a rider needs manoeuvring room to stay with it, but manoeuvring is hard when there are a dozen small craft bumper to bumper.

That crowd was enough to drive Tom Wright back to the ocean, and he now surfs the southwest Cornwall coast. There is now a yearly competition between tidal bore surfers on the Severn and those who travel to the *pororoca* of the Amazon. According to

"When the boar comes, the stream does not swell by degrees, as at other times, but rolls in with a head…foaming and roaring as though it were enraged by the opposition which it encounters."

Thomas Harrel describing the Severn Bore in 1824

Tom Wright, Brazil has the edge: "There are a few people regularly going for the record on the Severn, but frankly there are just too many people on the river most of the time to make it feasible," Wright said. "During the spring of 2006, Steve King did close to Picuruta Salazar's unofficial record set during the Red Bull tidal bore event in 2001, which was approximated to be 12.2 kilometres. King did it by the rules and that became the unofficial long distance record on the Severn."

King's amazing effort saw him surf continuously for an hour and sixteen minutes, but the feat was not recognized by the British Surfing Association, so it was not confirmed by the *Guinness Book of World Records*.

ALASKA

Modern tidal bore surfing was born on the River Severn, but Colonel Churchill and the happy few who followed him were not the first Englishmen to have to deal with these odd phenomena – Captain James Cook discovered a nook of Alaska with a tidal range similar to the Severn. The Turnagain Arm Tidal Bore appears at Bird Point and is a rideable wave for 2 to 3 miles, running right along the busiest highway in Alaska. It could not be more convenient, in a state where nothing is convenient.

The Turnagain Arm is an hour's easy drive south of Anchorage. It parallels the Kenai Highway, and there are several parking pullouts which allow the curious to view yet another bizarre Alaskan natural phenomenon. This easy access brings platoons of surfers and kayakers to ride the Turnagain Tidal Bore.

There is an observation area at Bird Point that has a chart rating the arrival time and intensity of each bore – from one to five stars. The incoming tide can be seen as an eerie, shifting line of whitewater, which moves down the Arm like army ants. The incoming tide disappears in deep water as it bends around Bird Point then reappears as a breaking wave for 2 or 3 miles along the highway toward Girdwood.

The bore is powerful but not dangerous; the Turnagain Arm, however, has claimed the lives of unsuspecting people who wander onto the tide flats during low water, only to get trapped in quicksand-like glacial silt as 40 feet of tide race at them at 12 mph. These incidents are local legend, and visitors are warned to stay off the mudflats. Surfers and kayakers riding the Turnagain Arm do their best to keep their feet off the bottom. The bore passes hills dotted with beaver, porcupines, moose, grizzlies and other wildlife, and in certain seasons, the wave sweeps in scores of small, white beluga whales, which flow up the Arm on the hunt for a local fish called a Hooligan.

GARONNE AND DORDOGNE

The Gironde River empties into the Atlantic Ocean about halfway up the Bay of Biscay. Its estuary is 70 kilometres long but only 3.2 to 11.3 kilometres wide. The Gironde looks like a giant squid, and it branches off into two rivers, the Garonne and Dordogne at the "Ambes beak". The Garonne takes shipping into the landlocked port

"The wave sweeps in scores of small, white beluga whales, which flow up the arm on the hunt for a local fish called a Hooligan."

city of Bordeaux, while the Dordogne wanders off into some of the finest wine country on the planet.

The incoming tide is visible as it moves through the estuary, and then the *mascaret*, the French term for tidal bore, can be seen where the rivers branch off. Between Cambes and Cadillac the Garonne *mascaret* breaks fast and hard over shallow mudbanks, reforming regularly. In contrast, the Dordogne *mascaret* surges upriver with a well formed wave train, best observed at Saint Pardon, and still observable another 30 kilometres upstream at Branne.

According to Tom Wright, *mascaret* surfing began in the late 1970s when pioneering kayakers explored the waves along the Garonne between Cambes and Cadillac. It was only when the Garonne became crowded that the kayakers moved north and discovered the Port Saint Pardon sitting along a 2-mile straight of the Dordogne. In 1990, Jean-Francois Lalle became the first to ride a surfboard at Saint Pardon. Since then the number of surfers and kayakers has grown immensely. Although there is only a small group of regular surfers on the river throughout late summer and autumn.

High media exposure has drawn increasing numbers of kayaks, canoes, motorboats and even waterbikes to Saint Pardon. With as many as 100 people in the water, locals have again started looking farther afield for surfable waves on the Garonne.

BELOW Beaucoup des gens, sur le mascaret. *Whatever the English do, the French just have to do better, so here are a whole bunch of French bore surfers and one SDP (sit down paddlerboarder) surfing up the Garonne river.*

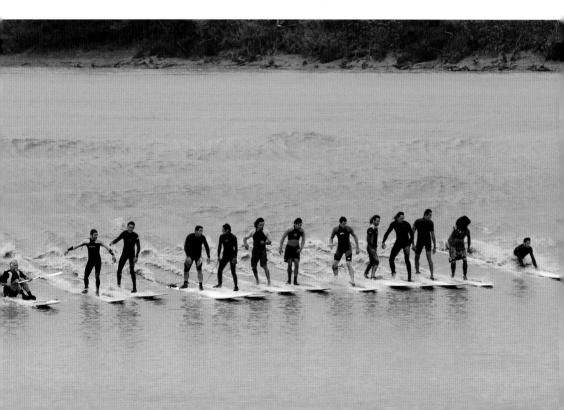

At Saint Pardon the head wave can reach 1.3 metres over a 4-kilometre course, generally breaking out from the tree-lined west bank. As many as 10 of the trailing waves are also surfable over considerable distance, and sometimes break larger than the head wave. Waves of a similar height have been reported on the Garonne River beyond Arcins island, although these spots are highly secret by the locals.

The Garonne was first surfed in 2001 by Tom Wright and friends. They were guided there by Fabrice Colas – brother of Antony Colas – who had been scouting spots: "We first surfed spots on the Garonne in 2001 and then went back there two years later," Tom Wright said. "Spot X was

crowded with 30 or more surfers. After riding the wave a French surfer came up to us and said, 'Oh you are lucky to have discovered this place as it is a bit of a secret!' to which of course we said, 'Well we were surfing it two years ago!'"

THE ENDLESS RUMBLE: BRAZIL'S POROROCA

Gary Linden thinks the *pororoca* is the best wave in the world, and he might be right. The 50-something surfboard shaper from north San Diego County has been surfing for more than 30 years. He has been there and done that from Mavericks to Dungeons, and he still says the tidal bore that moves up the Amazon River and its tributaries is the best wave he has ever surfed.

It's a wave that breaks for miles, up a wide river, and can be ridden for as much as 40 minutes. The *pororoca* of Brazil isn't just a long wave, it's also a perfect wave in places, and Linden, like many others, considers the most supreme pleasure of a *pororoca* to be well worth the risk of drowning, tropical diseases, crocodiles, piranhas and spiny catfish getting lodged in his John Thomas.

Professional surfers Gugu Arruda and Eraldo Guieros are said to be the first to have ridden the *pororoca*, challenging the tidal bore of the Araguari River in 1997. The Araguari is not a tributary of the Amazon but runs parallel to the big river about a hundred miles north of Macapa. The Tidal Bore Research Society claims that the bore has been seen breaking 10 kilometres out to sea. As word and photos of these incredible waves breaking into the heart of darkness circulated around Brazil and the outside world, more and more surfers took the long trek to check it out.

Like all tidal bores, the shape of the *pororoca* shifts with the depth of the water and the width of the river, but for long, long stretches, the wave is a long, perfect wall that allows surfers to do everything in their repertoire, hundreds of turns, all the while

ABOVE Pororoca *is a word from the native Tupi language which translates to "great destructive noise". The people living along the lower reaches of the Amazon have been dealing with the* pororoca *for centuries, but it's not until recently that surfers have tried to ride it. The wave passing the riverbanks dislodges poisonous snakes, which get caught up in the flow along with piranhas, crocodiles and a spiny catfish called a Candiru. Sergio Laus leans into an endless wall.*

cautious not to blow a turn because as Antony Colas said: "The bore is like a train. You don't want to miss it."

In March 2005 Antony Colas organized a multi-national trip to Brazil which included his brother Fabrice and Bruno Boue, and Englishmen Tom Wright and Steve King. They surfed the Mearim, a river 600 kilometres south of the Amazon basin. Wright saw odd similarities and vast differences between the Severn Bore and the *pororoca*: "The big difference is the Mearim River is straight, whereas the Severn meanders considerably and requires shifting from bank to bank regularly to negotiate the bends. Even the Brazilian regulars were amazed at the skill Steve King demonstrated in negotiating a hairpin bend on the Mearim River when we were over there. That is where the real skill comes into riding the Severn as opposed to some of the other surfable tidal bores. It is considerably easier to clock long distance on the Mearim because it is straight."

Sergio Laus grew up along the beaches of Santa Catarina and first surfed the *pororoca* in 2000, and that put the hook in him. He went back 38 times over the next couple of years, thoroughly exploring the Araguari and having adventures. "He told us one great story from their early exploration when they actually LOST their support boat around the islands at the mouth," Tom Wright said. "The boat didn't have enough power to get over the wave and fight the tide to pick them up! Sergio had to paddle to one of the islands and stayed with a local inhabitant overnight in his hut. Fortunately the boat found them next day."

The record in 2005 was 9.1 kilometres, set by Dave Lawson on the Severn in 1996. In June, Laus travelled to Amapa state with his support crew of a photographer, camera man and jet ski pilots and rescue to set the new record at 10.1 kilometres. To make it official the invigilator was Luiz Fernando Pedroso, the director of Ediouro Publicacoes, the distributor and representative of the *Guinness Book* in Brazil.

The *pororoca* of the Araguari changes from season to season, as the river bottom changes, and the flow of the river affects the tide moving upriver. Meanwhile, back on the Severn, Tom Wright and the growing cadre of English bore riders are waiting for the highest tides of the century, sweeping up the Severn Estuary in 2014.

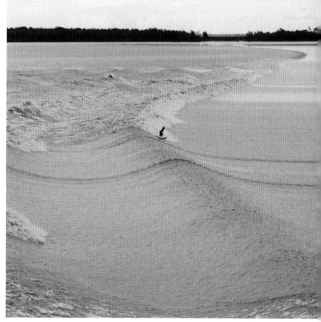

BELOW *Brazil's Araguari river is deep and wide, but the gravitational thumbprint of the Moon is deeper and wider, allowing adventurous surfers to ride the tide upriver for as long as 40 minutes and as far as 10 kilometres. Some say it's rideable for twice that length and time.*

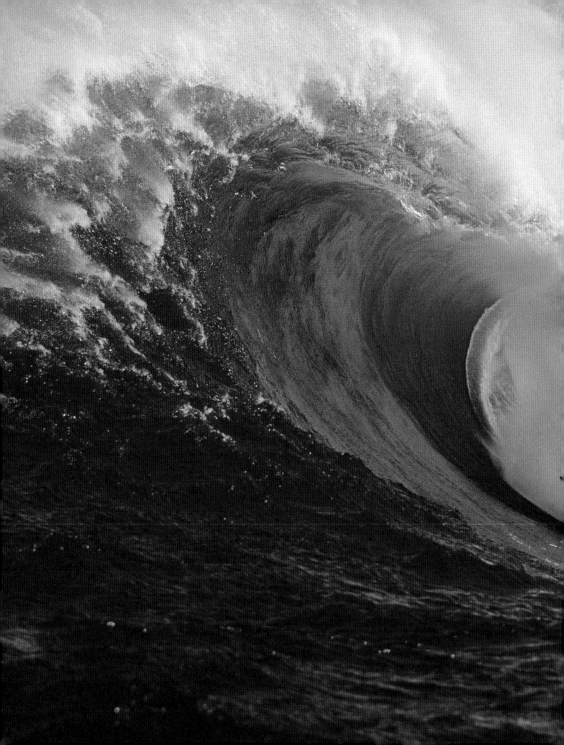

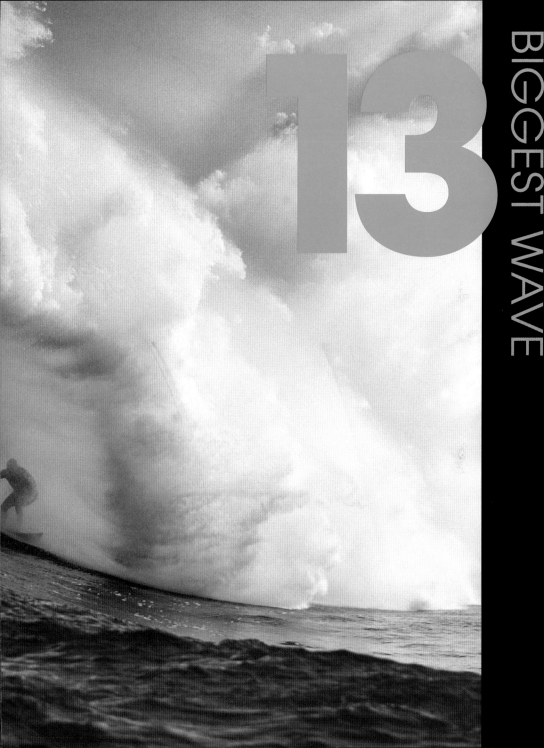

13

BIGGEST WAVE

SIZE MATTERS

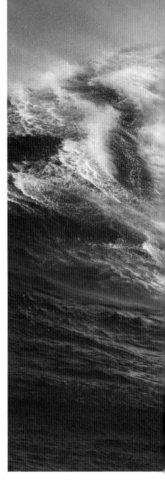

LIKE THE PRIZE FUND for the first privately built craft to enter space or the first completely robotic car, the Biggest Wave awards have concentrated the minds of surfers on a specific goal – the Everest of surfing. The only problem being that Everest keeps on moving. Billabong is the current sponsor of the XXL Awards, taking them over from Surfline, which took them over from Nissan/Xterra, which took them over from K2.

The XXL Awards began as one award for the biggest wave that a surfer paddled into, and the idea was to eliminate rumour and rough guesses, isolate the photos and moving images of the largest wave ridden that year, and let a panel of expert judges calibrate the photos, compare and contrast and decide once and for all how big is big.

The original idea came from Bill Sharp, a former editor of *Surfing* magazine who grew up riding giant waves at the Wedge at Newport Beach. Sharp gave the idea to K2, a ski company that was making a move into the surf apparel world, and thought that awarding $50,000 to the biggest of the big would be a way to attract attention. The XXL Awards came out of the El Nino winter of 1997–1998, when the entire Pacific Ocean went berserk and threw giant swell after giant swell pulsing from Hawaii to California, setting things in motion that are still resonating today.

In January 1998, the Perfect Swell swept the North Shore of Oahu, closed out Waimea Bay and cancelled the Eddie Aikau contest. On January 28, the North Shore was under a Condition Black – closed to all surfing. As most surfers obeyed and drove for Makaha and the more protected reefs on the west side, about a dozen scofflaws paired up on jet skis and drove to an outer reef just down from Pipeline called Outside Log Cabins. This day was one for the record books, surf as huge and perfect as Hawaii gets. There were horrible wipeouts and disabled jet skis but out of the chaos, Dan Moore towed Ken Bradshaw into a humungous wave that was 40–45 feet from the back, 65 feet on the face or more than 10 times over Bradshaw's head. That was the biggest wave any surfer had ridden up to that point, and it would have been worth $40,000 to $65,000 if anyone had been recognizing tow surfing, but at this point catching waves with jet skis was still considered below the radar.

On February 17 1998, the Reef Brazil Big-Wave World Championships were held at Todos Santos in Mexico. On this day, Taylor Knox sat outside waiting for one of those

"Big waves are not measured in feet and inches, but in increments of fear."

Buzzy Trent

PREVIOUS PAGE *Garrett McNamara, going big at Jaws. Gmac is a North Shore of Oahu resident who has been on the hunt for serious thrills since the big-wave world went berserko at the turn of the century. This is McNamara halfway through an incredibly tense tuberide at Jaws, which remains the tube of the century, so far.*

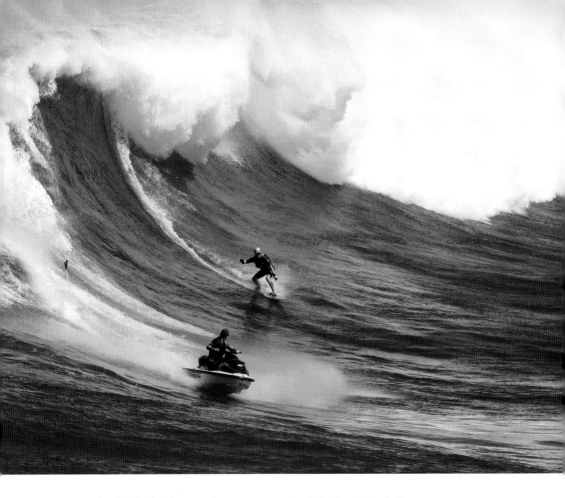

inconsistent bombs that had been catching everyone inside all day long. Knox had timing on his side, and he dropped into a massive, rearing vertical wall of water and held it together for a ride that would be featured simultaneously on the covers of the major surfing magazines.

The first XXL Awards were held on the last day of March, at the Hard Rock Café in Newport Beach. A panel of judges that included big wave surfers Mike Parsons, Jay Moriarity and Evan Slater and organizer Bill Sharp voted seven-to-one to give the prize to Knox. Knox's wave was estimated to be 52 feet high from trough to crest.

From that year, the XXL Awards have expanded to become a more elaborate institution. They now award hard American currency for the biggest tuberide, the worst wipeout and the best combined performance by a big wave surfer. And now, the measurement of waves is crucial, because the sponsors pay $1,000 a foot for the biggest

ABOVE *What tow-surfing looks like a fraction of a second after the drop-off, with the ski-pull trailing behind the jet ski and Greg Schell about to be swallowed up by the pelagic monster that is Jaws on Maui.*

wave, and also dangle a $250,000 prize for the first surfer to conquer that elusive 100-foot wave.

INCREMENTS OF FEAR

In the 1960s, a big-wave surfer named Buzzy Trent furrowed his brow, stared out at the horizon and said, "Big waves are not measured in feet and inches, but in increments of fear."

For many years, there was a lot of debate over whether waves should be measured from behind or in front. There were some surfers who measured waves in feet, but also knees and head using the "body" scale: Toe ticklers, ankle slappers, knee-high, waist-high, head-high, overhead, double overhead, triple overhead, etc. This ambiguous system of weights and measures is one of the surfing traditions that the XXL ended. Beginning with the first XXL event in 1998, the judges used a combination of body scale, combined with feet and inches. If a wave was 10 times

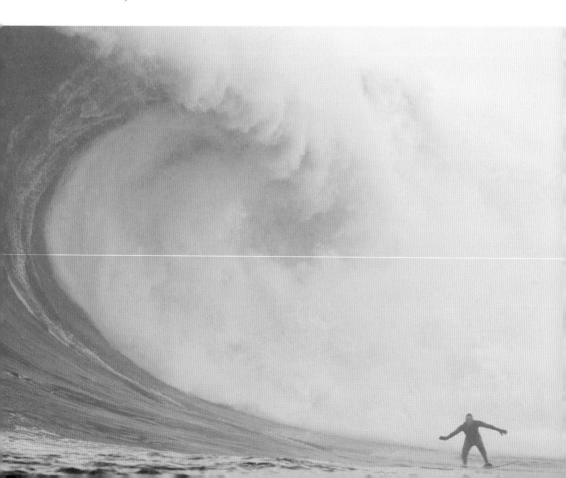

overhead, and the surfer was 6 feet, then the wave was 60 feet from trough to top – as measured from the front.

But even then there were problems, as waves photograph as differently as fashion models: Some waves are tall, some have longer bottoms, some are lippy. And angle is everything: Mavericks photographed from the front looks like T. Rex – the surfer at the bottom looks impossibly small with a wave towering seven or eight or nine times over his head. But Mavericks shot from a boat in the channel looks much smaller.

With 10 years of awards on the books, it is possible to add up all the nominees and winners and come up with a ranking for the biggest waves, depending on how you do the math. If you assign five points for every Biggest Paddle Nomination, and ten points for every Biggest Wave/Ride of the Year nomination and then add in the total prize money won by each spot, the ranking of the World's Biggest Wave looks like this:

1	Jaws, Maui, Hawaii	8	Punta Lobos, Chile
2	Todos Santos, Mexico	9	Ghost Trees, California
3	Mavericks, California	10	Belharra, France
4	Cortes Bank, Mexico/California	11	Teahupoo, Tahiti
5	Puerto Escondido, Mexico	12	Outer Bommie, Western Australia
6	Dungeons, South Africa	13	Playa Gris, Spain
7	Waimea Bay, Oahu, Hawaii	14	El Buey, Chile

IN HAWAII THERE'S A PLACE

In Hawaii there's a place called Waimea Bay that was the reigning big wave for most of the twentieth century. As surfboards improved, 1950s surfers began poking around on the North Shore of Oahu, riding waves from Haleiwa up to Sunset Beach, but always driving around Waimea Bay because of its reputation as the killer of Dickie Cross. Until one winter day in 1957, when Californian Greg Noll shrugged off the voodoo and led a platoon of surfers into a 15-foot day, as Bud Browne filmed from shore: "We paddled out there, caught a few waves and didn't get sucked down a vortex, nothing ate us and that was that," Greg Noll said in *Riding Giants*. "That was not a big day, but there were some hairy days to come."

From the 1970s to the 1990s, Waimea Bay was the most challenging big wave in the world. The undisputed big wave champion of the world, just as Pipeline was the most challenging hollow wave, and Sunset Beach was the premiere performance big wave. In the late 1980s, Quiksilver chose Waimea Bay as the location for their annual big wave invitational event, to remember Eddie Aikau, a Hawaiian surfer and lifeguard who had been one of Waimea's best surfers in the 1960s and 1970s. In 1978, Aikau was part of a group of Hawaiians sailing the traditional Hawaiian canoe *Hokulea* from Hawaii to Tahiti. The canoe foundered in the Molokai Channel, and Aikau volunteered to paddle 12 miles to shore to get help. He was never seen again.

"Mavericks photographed from the front looks like T. Rex."

In 1990, the Quiksilver in Memory of Eddie Aikau Big Wave Invitational was held on a giant, perfect, 25-foot-plus swell at Waimea Bay. The best surfers from three generations tackled the world's biggest wave, and some made history: Brock Little paddled into the biggest wave of the day, had it made, hit a lump halfway down, wiped out, took a horrific trip over the falls and survived. And Keone Downing, son of big wave pioneer George Downing, won by taking off on big waves and making them all.

That 1990 Eddie contest was the pinnacle of the Waimea era, but also the end of it. That same winter swell passed Hawaii and made it to the California coast and lit up a giant, cold, dangerous surf spot that would soon be revealed to the world as the new Golgotha of big wave surfing: Mavericks.

BELOW *Big wave surf spots have cool, tough-guy names: Mavericks, Jaws, Avalanche, Phantoms, Himalayas. Near Cape Town, South Africa, there's an outer reef that breaks off a high cliff in a seal rookery that is like a fast food stand for great white sharks. Wiping out there is not for the faint of heart; it's like getting trapped in an underwater dungeon. So they called it Dungeons.*

JAWS

In 1985, Mark Foo survived a giant wave at Waimea Bay and came to the surface talking about "The Unridden Realm". Foo was talking about waves that were too big and moving too fast for any mortal to catch, no matter how strong or brave they were, how fast they paddled or how big their surfboard was. The Unridden Realm – and crowds at Waimea Bay – drove Laird Hamilton, Buzzy Kerbox and Darrick Doerner to experiment with using rubber boats, then jet skis, to tow into giant waves along the North Shore of Oahu. The three tow-surfing pioneers worked on their new method in the winter of 1992. They started with a small boat at Backyards, a series of reefs north of Sunset Beach that produced 20-foot plus waves that were notoriously hard to catch. Where they might have caught a wave or two an hour, the boat-aided surfers were catching as many waves as they wanted, and riding them from way out the back, all the way through the channel at Sunset, where the boat, and then the jet ski, would scoop them up and take them a mile out the back to get another.

After that winter on the North Shore of Oahu, Kerbox and Hamilton took their act to Maui, away from prying eyes. On the North Shore of Maui, they began tow surfing an outside reef that had been pioneered by sailboarders in the 1980s. The wave was considered too big and fast to paddle surf, and the surfers-turned-sailboarders wanted a way to get into these waves without having a mast and sail to contend with. The name of the reef in Hawaiian was Peahi, but the surfer name for the spot was Jaws.

Jaws was the perfect wave for tow surfing – the same open ocean swells that created giant waves on the reefs of Oahu broke in a perfect peak and with endless speed and power on the reef at Jaws. Far too big, windy and fast-moving to be caught by hand, a 30-mph entry via a water-skiing like pull attached to a jet ski allowed tow surfers to position themselves wherever they wanted on the wave and hotdog waves that wouldn't have been catchable with their bare hands.

Hidden away in an obscure corner of Maui, accessible through a maze of mud roads through the pineapple fields, Jaws was a rumour until 1994, when a sequence of Laird and Pete Cabrinha doubling up on a giant wave appeared on the cover of *Surfer*

magazine. For the second time in a decade, the surfing world had its mind blown as Hamilton, Kerbox and Doerner were joined by Dave Kalama, Rush Randle, Pete Cabrinha, Mike Waltze and a small group of merry men who now could dance up and over and around giant waves that could not have been approached by mortal means.

LAUGHING ALL THE WAY TO THE CORTES BANK

On January 19, 2001, a surf navy of two boats, a single-engine plane, three jet skis, six surfers and six cameramen left San Diego in the early morning and made a 100-mile passage out to sea to surf a spot called the Cortes Bank. A chain of underwater

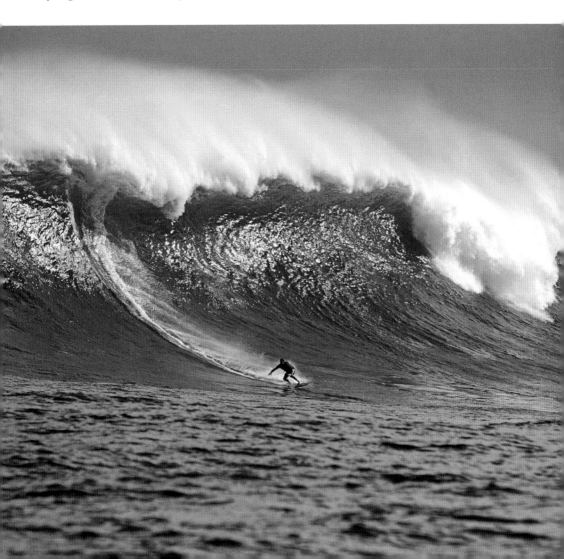

mountains that rise to within six feet of the surface, the Cortes Bank has been sinking ships as far back as 1855 and as recently as 1985, when the USS *Enterprise* collided with the reef and suffered a 40-foot gash, a damaged propeller and a sacked captain.

Cortes Bank was well known to divers and fishermen, some of whom were surfers. This wave had been talked about since the 1960s, but it was 100 miles out to sea and wide open to wind, tide, currents and "360 degrees of chaos" as *Surfing* magazine editor Evan Slater said. There were a couple of flyovers and one attempted surf session there in the 1990s, but it took until 2001 for the surfing world to get their nerve up and their act together to have a go.

Even with all the sophisticated surf forecasting and weather monitoring equipment that existed in 2001, none of the surfers knew what they would find 100 miles out to sea. But the combination of Storm 15 from the Gulf of Alaska and a high-pressure ridge over California created perfect surfing conditions and giant waves. As the cameras rolled, Brad Gerlach towed Mike Parsons into a huge wave that was later measured at 66 feet. This was by far the largest wave anyone had ever ridden outside of Hawaii, and may be the largest wave ever ridden. Mike Parsons and Cortes Bank won the $66,000 ($1,000 per foot) XXL award that year. Because Gerlach towed Parsons into the wave, they split the money 50/50, a tradition that still exists. Cortes Bank blew everyone's mind, once again. A wave breaking 100 miles out to sea? Impossible.

DUNGEONS

By the third year of the XXL, surfers around the world were looking out to their horizon and beyond for their versions of Mavericks and Jaws and Cortes Bank. The South Africans found theirs off Hout Bay in Cape Town, a harrowing giant right-hand break in shark-infested waters that needed a cool name.

The Red Bull Big Wave Africa website claims that Dungeons was first surfed in 1984 by local surfers Pierre De Villiers and Peter Button. Like Mavericks, Dungeons breaks in front of a high cliff, around the corner from a small craft harbour. It is a beautiful, spooky location, like the haunted house at the top of the cliff, with bats flying out of the belfry. Obviously dangerous, but luring people to have a look.

Unlike Mavericks, Dungeons breaks from May to October, when powerful swells born in the Roaring Forties explode on a deep-water, cold-water reef that is in the middle of a seal rookery – which makes it like a McDonald's for white sharks. One local story claims Dungeons was named in honour of a surfer who had been trapped in the reef and held down for two 25-foot waves: He just wanted out.

Dungeons made its first entry into the XXL awards in 2004, when California surfer Greg Long was nominated for the Monster Paddle award. Two years later, a giant day at Dungeons produced three more contenders. In July 2006, Greg Long towed into a wave that somehow made it through Vulcan Rock and Tafelberg with no loss of power, and hit the reef almost a third bigger than anything else that day: "Greg Long's

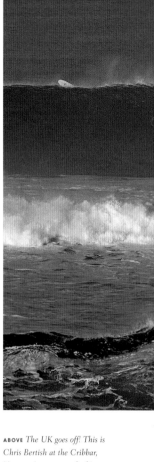

ABOVE *The UK goes off! This is Chris Bertish at the Cribbar, Newquay's answer to the big-wave world. From this angle it looks a little like Mavericks. Britons are as proud of the Cribbar as they are of the Severn Bore, although they don't always understand how such things work. Alistair Mennie explains: "I've been in Newquay and heard people say, 'Is the Cribbar wave coming today? What time will it be here?'"*

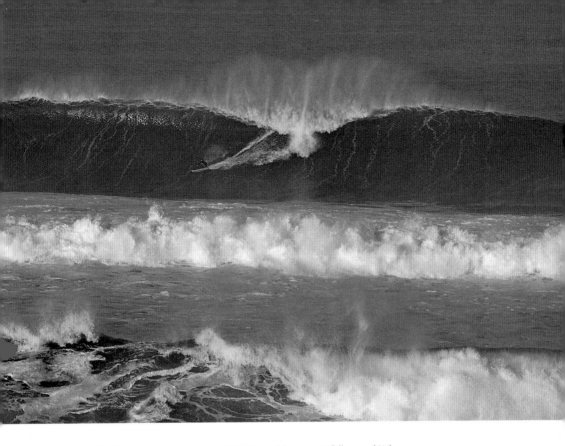

Dungeons bomb seemed to sneak past or pinball through between Tafelberg and Vulcan Rock without losing any energy," Duncan Scott said. "We could see it standing tall from way out and hit the reef from deep without any cross humps in front of it."

Greg Long also did everything right, towed into the right spot, made the drop and to the channel with his life intact. Long's wave was measured at 65 feet. He won the XXL Big Wave Award for 2006–2007, but a rule change gave the big prize to The Ride that year, so Long got $15,000, instead of $65,000.

BELHARRA REEF AND BEYOND

Any surfer who has been to Europe and seen the ocean in full roar at Nazare, Portugal, or Mundaka, Spain, or Guethary, France, knows that the Bay of Biscay and the north Atlantic are more than capable of producing rideable waves 60 feet or larger. All the wondering about the Atlantic came to a head in March 2003, when a group of ten surfers took jet skis out to Belharra Reef, offshore from Saint Jean de Luz in France. The surfers had been tracking a storm that crossed from Newfoundland, hoping local

conditions would be fair when the 35-foot swell hit. Their hopes were realized with a day of perfect conditions and giant surf.

Photos and video of the session went out immediately and caused surfers around the world to yell, "*Zoot alors!*" These were some of the biggest, cleanest waves anyone had ever seen, and they were in ... France? The appearance of these new photos caused a great deal of controversy, as the giant but slopey waves of Belharra Reef seemed to lack the power and risk of Jaws and other spots. The wave looked soft, for a 60-foot wave, and the long, slopey trough made measuring it accurately a problem.

By 2006, the XXL Awards had a Latin flavour as a giant day at Todos Santos produced two nominees for Biggest Wave and two for Monster Paddle. The Bay of Biscay chimed in again with a Biggest Wave contender from Playa Gris, a pseudonym for a reef called Planeixa on the northern coast of Spain, near Zarautz.

BELOW *In December 2007 Mike Parsons and Brad Gerlach snuck out of Dana Point harbour in the middle of a storm, and by the time they got 100 miles out to sea, they found perfect, clean surf at Cortes Bank. This was the leading XXL contender as 2007 rolled into 2008, and Gerlach and Parsons were hoping to win their third Biggest Wave award, and split the $60,000+.*

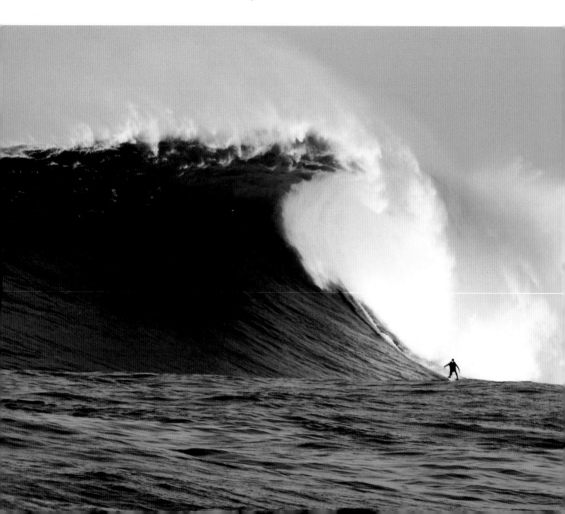

Like those who knew Europe was capable of producing giant waves, the same was true for Chile and Peru, countries on the Pacific coast of South America that receive giant swells from the Southern Ocean to the North Pacific. And then South America made it into the big time when Chilean surfer Diego Medina won the $10,000 Monster Paddle prize by scratching into a giant left at Punta Lobos in Chile.

Brad Gerlach won the 2006 XXL Biggest Wave award and took home a cheque for $68,000 and Todos Santos was a legitimate contender for World's Biggest Wave.

A WINTER'S TALE

In November 2007, Ireland made it on the big-wave map when UK surfers Duncan Scott, Alistair Mennie, Gabe Davies and Richie Fitzgerald stood their ground when a swell generated by a giant low pressure off Greenland sent large and small craft running for safe harbours. Those surfers ignored warnings and made their way to Mullaghmore, a historic location on the Irish coast in County Sligo. Mullaghmore is like a reverse Mavericks with a bit of Monty Python thrown in: a giant left that breaks off a point overlooked by Classiebawn Castle.

Aileens in County Clare is also one that has XXL potential, and no small amount of risk: "Aileens really resembles Mavericks and it is one scary place," said big wave surfer Alistair Mennie. "Aileens comes out of deep water and unloads with neck breaking force, just like Mavs. But at Mavericks you are paddling way out to sea; Aileens breaks at the foot of a 700-foot cliff. It breaks within 100 feet of the bottom of the cliff onto an uneven, slabby reef with boils all over the inside. When you are surfing down the face of a wave at Aileens you have two things to think about, the wave and the cliff."

During the first week of January 2008, one of the biggest winter storms in 20 years swept the California coast. On January 5 conditions were right for an attack on Cortes Bank. Californians Mike Parsons, Brad Gerlach and Greg Long were joined by South African Grant Baker in photographer Rob Brown's 36-foot Twin Vee catamaran powerboat. They left Dana Point harbour at 7:00 a.m., driving through squalls and rough seas and having faith there would be clear skies 100 miles out to sea.

Surprisingly, it was clean 100 miles out. Clean and humungous, and four of the most talented big wave surfers towed the biggest day ever attempted at Cortes. "We all rode the biggest waves of our lives by far," Greg Long said. "Compared to the wave Mike had out there in 2001, this was so much bigger. I don't know how it looks in the photos, but I know I saw a lot of 80-foot-plus waves out there. It was the most incredible thing I've ever seen in my life."

"It's getting closer and closer now . . . I guarantee you there will be a 100-foot wave ridden out there," Mike Parsons said. "For sure. There were several big peaks that jumped up at the top of the reef outside of us that could not have been too far off that size. If you put yourself in the right place at the right time, it will happen. It's only a matter of time now."

"It's getting closer and closer now . . . I guarantee you there will be a 100-foot wave ridden out there."

Mike Parsons

INDEX

ACKNOWLEDGEMENTS

Three months of writing and pestering surfers around the world for their opinions is all done, and now I'll go back to the beginning and thank Evan Slater and Matt Walker for handing this off to me. The first email from Evan was dated August 30, 2007. Evan and Matt Walker said there was a publisher in London who wanted someone to do a book on "Extreme Surfing."

"What are the hours?" I asked, and they put me in touch with Frank Hopkinson, whose hair was much less gray, five months ago.

One hundred and twenty thousand words, 1,400 photos and 3,261 emails later, I turned 18 chapters over to Frank, Senior Editor David Salmo, and his Art Director John Heritage. They did a stalwart job of compressing all that material into a diamond of a book—which you have in your hands now, and have most likely read through, unless you are Japanese and are reading from back to front.

In between that August 30 email from Evan Slater and today, there are many many people to thank, and some of them have funny letters before or after their names. Thanks to Dr. Ricky Grigg for chiming in on coral reefs, Dr. Jose Borrero for adamantly insisting tsunamis can't be ridden, and Dr. Shaw Mead and Dr. Kerry Black for giving a lot of information on artificial reefs (which was cut from the Longest Wave chapter).

While writing the Fastest Wave chapter I found a surfer on Maui who had a PhD in Physics. I contacted Dr. A. Garrett Lisi, who chimed in on what he thought the fastest wave in the world was. He spoke as a surfer and as an egghead and then a few weeks later, Dr. Lisi made headlines as the surfer dude who might have cracked Unified Theory. So good luck with that.

Roy Stewart raised his voice to express his discontent with artificial reefs, and we appreciate his rebellion.

Mark Sponsler doesn't have funny letters before or after his name, but he has a PhD-level knowledge of how the ocean creates waves, and what the shoreline does with those waves. Sponsler was invaluable in all 120,000 words of this book—and that includes captions—so check out his expertise at www.wavewatch.com.

Sponsler was very helpful with the Poetry and Physics intro, as were Duncan Scott, Mickey Smith, Alistair Mennie, and Kelly Allen, who all risked their necks (as well as their PWC and camera gear) to make history at Mullaghmore on December 1, 2007.

Off the top of my head, thanks to Laird Hamilton for his sermon on Fastest Wave in the parking lot at Ralphs in Malibu. Same to Gene Rink, Dave Parmenter, Reno Abellira and many others for their opinions on Fastest Wave.

Thanks to Rochelle Ballard for exposing all her cuts and sprains and bumps for Sharpest Reef. And thanks to John Philbin for exposing some of the secrets of Palos Verdes localism. The same to Fred d'Orey and Rosaldo Cavalcanti for doing the same about localism in Rio de Janeiro.

Thanks to Garrett McNamara for correcting my spelling of his name, and his input on Heaviest and Fastest, and just in general. Also, thanks to Joel T. Smith for chiming in about localism, his help with Chicama, and just history in general. Peruvian pioneer Felipe Pomar helped with Fastest Wave and still swears he surfed a tsunami in 1964—no matter what the PhDs say.

I want to thank Mattias Hornquist, Ted Grambeau, Doc Renneker, Jamie Meiselman, and Steve Hawk for freezing their yarbols off for the sake of this book.

Bill Sharp was helpful with the story about Damon Harvey at Superbank, and also with XXL background and the story behind naming Cyclops.

Serge Dedina went to great lengths to help with the Extreme Danger chapter, as did Ben Siegfried, Leslie McCollum, and Will Henry. Sean van Sommeran, Ralph Collier, Dr. John West, and Marie Levine were also a big help with the Extreme Danger chapter.

Thanks to Mark Cunningham for talking about Pipeline and proofing Deadliest Wave for mistakes, and just for being there.

Bob Campi wrote a great piece on surfing Gaza that mostly went on the cutting room floor, but thanks to him for taking the trouble.

Who else? Who else? Oh yeah the photographers. Lots and lots of surf photographers. Where there used to be a dozen guys, now there are scores and hundreds. There are a lot of surf photographers in this world, and they all have the good stuff. Sean Davey was on top of it and answered all my pleas and also gave the good oil about the first trips to Shipstern. David Pu'u also came through at the drop of an email, as did Steve Wilkings, Ted Grambeau, Nick LaVecchia, Mickey Smith, José Vicente González Pérez, Jim Russi, Ron Dahlquist, Jack English, Jeff Hall at A-Frame Media, Lucia Daniella Griggi, Joe Curren, Antony "Yep" Colas, Tim McKenna, Oscar Tramontana, Beto Santillan, Brent Bielmann, Steve Fitzpatrick, Ben Siegfried, Tad Craig, Tim Jones, John Bilderback, Tim Nunn, Tony Harrington, Rob Brown, Alan van Gysen, Gregg Newton, and Mark Humpage.

Special thanks to John Callahan and Antony "Yep" Colas for responding to my countless requests, and I will try to make it up to them by getting the tidal bore book published. Also, to Frederico Pompermayer for sending the Mavericks shot of Garrett and the Flea Flicker.

I did speak to John Severson directly—or at least emailed him—and thanks to him for the background on his "crowded world" quote.

Thanks to Duncan Norris for his story about surfing Bantham during the foot-and-mouth outbreak. Wingnut Weaver and Zuma Jay for their Iceland stories. Vic Calandra and Joey Everett for their Malibu shark story. Chris Bertish for the inside scoop on South Africa's shark watch program. Also Steve Pike for his information on South Africa's sharks.

Sheesh, almost forgot to thank Wayne "Rabbit" Bartholomew, who certainly is an eloquent guy and we wish we could have printed all he had to say about Superbank, and crowds, and fast waves.

Oh and Nick Carroll, too. He is busy with writing and surfing and his family, and has better things to do than answer trans-Pacific emails, but he did, and we thank him.

Matt Warshaw, of course, for writing *The Encyclopedia of Surfing*—the New Testament of surfing—and for answering those few questions that aren't answered in the pages of that invaluable book.

Bobby Owens for his tsunami story, Derek Hynd for his thoughts on J Bay, Ron Romanosky and Tom Southern for their River Jetties horror stories, and Justin Gane for his background on the discovery of Shipstern.

Brock Little said a few things through his *wahine* Kelly Chan, so thanks to both of them.

Magnus Wolfe-Murray sent a lot of words and photos about his experience in Monrovia, Liberia as Charlie Taylor was coming to town and I wish I had more space for them.

Cultural icon Kathy "Gidget" Kohner was nice enough to answer some emails about the early days in Malibu, so thanks, Gidge.

The chapter on tidal bores could easily be a book on its own and if Frank Hopkinson doesn't have me killed after finishing this book, I might try to persuade him to turn tidal bores into a book. Thanks to Tom Wright, Stuart Matthews, Donny Wright and Stuart Ballard for giving their two pence about the international tidal bore scene, and also Sergio Laus and Gregg Newton in Brazil.

Is that the lot? Kelly Slater did email his list of Fastest, Biggest, and Longest waves, and those have been dutifully sprinkled through the book.

Thanks to Bruce Brown for ending his movie, *The Endless Summer*, in the same way we are ending this overly long thank-you page: "Thank you to King Neptune for making possible the waves you have seen in this book."

Ben Marcus
Malibu, California
February, 2008

PICTURES

6–7 Anova Image Library. 9 North Wind Pictures/PhotoLibrary. 10 Bettmann/Corbis. 11 LOC (LC-DIG-ggbain-0654). 12 Anova Image Library. 13 Surfing Heritage Foundation. 14 Surfing Heritage Foundation. 15 John Springer Collection/Corbis. 16–17 Warren Bolster/Getty Images. 19 NIC BOTHMA/epa/Corbis. 20 Vince Cavataio/PhotoLibrary. 21 JS Callahan/tropicalpix. 22 Nick LaVecchia. 24–25 Mickey Smith. 26–27 Jim Russi. 28–29 Jim Russi. 30–31 Ron Dahlquist. 32 David Pu'u. 33 John Martin/Alamy 34–35 Getty Images. 36 José Vicente González Pérez. 38–39 Mickey Smith. 41 D. Hump/A-Frame. 42 Mickey Smith. 43 Lucia Griggi. 44–45 Joe Curren. 47 John Callahan. 48–49 Tim McKenna. 50–51 Chris McLennan/PhotoLibrary. 52–53 Beto Santillan. 54 Buzz Pictures/Alamy. 55 Pedro Romo. 56–57 Joel T. Smith. 58 Getty Images. 60–61 Frederico Pompermayer. 62–63 Jim Russi. 65 Jim Russi. 66–67 Frederico Pompermayer. 68 Robert Galbraith/Reuters/Corbis. 69 Sean Davey. 70–71 Kirk Aeder/Icon SMI/Corbis. 72–73 Ralph A. Clevenger/Corbis. 75 MIKE HUTCHINGS/Reuters/Corbis. 76 AFP/Getty Images. 78–79 Jim Russi. 81 Jeffrey L. Rotman/Corbis. 83 Ben Marcus. 85 Shubroto Chattopadhyay/Corbis. 86 Pierre Merimee/Corbis. 88 Getty Images. 91 Ciro Fusco/ANSA/Corbis. 92 David Pu'u. 93 David Pu'u. 94–95 Ben Siegfried. 96 Getty Images. 97 Seth Joel/Corbis. 99 Antony "Yep" Colas. 100 AFP/Getty Images (top); Bob Campi (bottom). 101 AFP/Getty Images. 102–103 Tim McKenna. 104–105 Les Walker/NewSport/Corbis. 107 Sean Davey. 108–109 Getty Images. 110 Ron Dahlquist/PhotoLibrary. 112–113 Tim McKenna. 114–115 Tim McKenna. 116 Tim Jones/ZUMA/Corbis. 118–119 David B Fleetham/PhotoLibrary. 121 Photo:Brent. 122–123 Jeff Flindt/NewSport/Corbis. 125 Tim McKenna. 126 Danita Delimont/Alamy. 128–129 Sean Davey/Getty Images. 130–131 Tim McKenna. 132 John Bilderback. 134–135 J rgen Skarwan/Reuters/Corbis. 136–137 JS Callahan/tropicalpix. 138 Mark Humpage. 141 Hemis/PhotoLibrary. 142 Gregg Newton. 143 Gregg Newton. 144–145 Ron Dahlquist. 146–147 Ron Dahlquist/PhotoLibrary. 148 Tony Harrington 150–151 Alan van Gysen. 152–153 Tim Nunn. 154 www.robertbrownphotography.com

QUOTATIONS

33 Gerry Lopez, *Frequency* snowboard magazine (2.3 issue). 36 Andrew Kidman, *The Surfer's Path* (2004 issue). 43 Zuma Jay, "Surfing Stunts: Icelandic Adventure on Eastwood Movie Set" by Ben Marcus, www.surfermag.com. 62 Greg Long, "Pro Surfer Malik Joyeux Dies at Pipeline," www.surfermag.com. 65 Jack Johnson, "Jack Johnson Surfs In Between Dreams," *TransWorld Surf* (March 2005). 65 Tamayo Perry, from Chris Cote interview, *TransWorld Surf* (November 2005). 65 Moto Watanabe, "Tragedy at Pipe" by Scott Basham, www.surfermag.com. 68 Don Curry about Peter Davi, "Mammoth Ghost Trees Turns Horrific as Local Surfer Drowns" by Scott Bass, www.surfermag.com. 74 Fin File shark attack statistics are from the Global Shark Attack File, www.sharkattackfile.net. 74 Vic Calandra, "Close Encounters With Mr. White," www.surfermag.com. 81 Dale Webster, *The Surfing Guide to Central and Northern California*. 81 Tom Zahn, "Pulling Seaward: Tommy Zahn" by Malcolm Gault-Williams and Gary Lynch, *The Surfer's Journal* (Spring/Summer 2000). 88 Rabbit Bartholomew, "Rabbit Bartholomew Speaks Out Against Formation of Surf Police" by Alex Wilson, www.surfermag.com. 90 Malibu surfer dying from coxsackie B virus, taken from *Water Recreation and Disease. Plausibility of Associated Infections: Acute Effects, Sequelae and Mortality* by Kathy Pond and the World Health Organization (2005). 90 Mark Gold, from a story by Kevin Pang, *Los Angeles Times* (May 27, 2004). 116 Andy Irons on Teahupoo from an ASP press release (May 2005). 117 Graham Cassidy, "The Price of Waves" by Nick Carroll, www.surfline.com.